ADOBE®
PHOTOSHOP® 7
CREATIVE
WORKSHOP

ADOBE® PHOTOSHOP® 7 CREATIVE WORKSHOP

Premier Press

ANDY ANDERSON

Publisher: Stacy L. Hiquet

Marketing Manager: Heather Hurley

Acquisitions Editor: Kevin Harreld

Project Editor: Fran Hatton

Editorial Assistants: Margaret Bauer
 Elizabeth Barrett

Technical Reviewer: Michelle Jones

Interior Layout: Bill Hartman

Cover Designer: Mike Tanamachi

Indexer: Sharon Shock

Proofreader: Jeannie Smith

ISBN: 1-59200-011-8

Library of Congress Catalog Card Number: 2002106532 Printed in the United States of America

02 03 04 05 BH 10 9 8 7 6 5 4 3 2 1

Premier Press, a division of Course Technology
2645 Erie Avenue, Suite 41
Cincinnati, Ohio 45208

This book is dedicated to the one person that is never far from my heart. I often think what life would have been like if we had never met; thankfully, thoughts of that nature are buried deep in the world of speculation. Thanks, Bonnie, for twelve wonderful years and a hundred more to come. – A.A.

ACKNOWLEDGMENTS

This book was not produced by one lone writer. There are always people working behind the scenes without whose help this title would never have seen the light of day. I would like to thank my agent Carole McClendon for being the most understanding agent in the business, and Kevin Harreld, acquisitions editor at Premier, for keeping me on time and on track (well, almost on time). Thanks, Kevin, they don't come any better than you.

In addition, I had the tremendous luck of working with the best editors in the business: Fran Hatton and Michelle Jones. A big thanks for making sure every *i* was dotted and every *t* crossed. They also helped me untie some mighty big literary Gordian knots.

ABOUT THE AUTHOR

Andy Anderson has been a Photoshop user for over ten years. In that time, he has used Photoshop to create images and branding for his clients, as well as using Photoshop's excellent set of tools to perform complex photo-restoration techniques. Andy is a published author and university professor, whose high-energy seminars have gained him respect on an international level. Andy's publishing credits include *1001 Photoshop Tips*, Premier Press (2001), *HTML & Web Design*, Osborne McGraw-Hill (2002), and *CIW Site Designer Certification*, LearnKey Interactive CD's and Video (2002).

Andy has also contributed to numerous magazine publications, and has appeared on local television stations and NPR as a graphic arts and Web design special consultant. In addition, Andy wrote and produced two talk shows for a local Knoxville, TN cable station.

CONTENTS AT A GLANCE

CONTENTS

INTRODUCTION

INTRODUCTION: A TOOL FOR THE NEW MILLENNIUM

ASK ANY DESIGNER OR GRAPHIC ARTIST ABOUT IMAGE-MANIPULATION SOFTWARE, AND THE NAME PHOTOSHOP WILL UNDOUBTEDLY ENTER INTO THE CONVERSATION. NOT ONLY DO MOST DESIGNERS KNOW ABOUT PHOTOSHOP AND ITS TREMENDOUS CAPABILITIES, IN THE ELEVEN YEARS OF ITS EXISTENCE, PHOTOSHOP HAS BECOME THE MOST WIDELY USED GRAPHIC-BASED SOFTWARE PROGRAM ON THE PLANET.

PHOTOSHOP HAS THE UNIQUE ABILITY TO CHANGE OR MANIPULATE A GRAPHIC IN ONE OF MILLIONS, IF NOT BILLIONS, OF WAYS. THE FAMOUS PHOTOGRAPHER, ANSEL ADAMS ONCE SAID:

"THE NEGATIVE IS COMPARABLE TO THE COMPOSER'S SCORE AND THE PRINT TO ITS PERFORMANCE. EACH PERFORMANCE DIFFERS IN SUBTLE WAYS."

When you open an image in Photoshop, you (as the composer) decide how to change, manipulate, or restore that image...no two Photoshop users will do exactly the same thing. Each Photoshop document, therefore, is a unique blend of your skills and knowledge combined with the almost endless assortment of the tools and adjustments within the Photoshop program.

WHY THIS BOOK?

This book was written to help satisfy the curiosity of all the Photoshop users out there that open a magazine, or see a print created by a Photoshop designer, and ask themselves: How did they do that? How did they make that text curve in a graceful arc? How did they restore that old photograph? What technique was used to remove that lens flare? A picture may be worth a thousand words, but to Photoshop users and graphics artists, each picture contains a thousand questions and for every question, there is an answer.

Each image created in Photoshop is unique, and comes with its own set of "How did they do that?" questions that deserve answers. While this book does not promise to solve the meaning of life, it will help new users and seasoned professionals answer a few of those nagging questions about Photoshop; guess what happens when those questions are answered? You gain a more thorough understanding of Photoshop and its capabilities.

As a designer, the more you know about Photoshop, the more you gain control over the program. When you click buttons in Photoshop without a clear understanding of what you are doing, you are letting the program control you. This book has one purpose; to return control of Photoshop back to you, and in doing so, help make you a better designer.

WHO IS THIS BOOK WRITTEN FOR?

This book is written for the photographer as well as the creative designer. If you are (like me) a professional designer and photographer, this book will help you understand the relationship between Photoshop and the real world of photography. It will help you make bad images good, or use your design skills to take photographs to a completely new level.

This book addresses readers of all levels:

* People new to Photoshop
* The seasoned veteran interested in the enhanced features of Photoshop 7.
* Users who want to take their images to the next creative level.
* The teacher or educator charged with the responsibility of understanding Photoshop and then passing that information on to fellow instructors or curious students.
* Digital photographers who want to learn how Photoshop can change and enhance their images.
* Designers interested in creating new and unique images.
* Anyone interested in learning more about one of the most creative programs on the planet.

Whether you are a seasoned professional, or just someone that wants to learn how to use Photoshop, this book is for you.

ORGANIZATION OF THIS BOOK

This book is broken down into chapters with individual workshops. The chapters describe concepts, and the workshops explain the steps in detail. The workshop exercises are supported by graphics and files on the companion Web site (www.xxxx.com). You can use the images to become familiar with the techniques described in the workshops, and then apply those new skills to your own photographs and graphic images.

Photoshop 7 Creative Workshop is written in a linear fashion; however, each chapter deals with a specific Photoshop concept, so feel free to pick a chapter and begin working. Chapters 1 and 2 deal with basic digital concepts and what's new in Photoshop 7, and the remaining chapters deal with creative concepts. So, jump in with both feet and start learning. Remember, the more you know, the more you control.

D
I
G
I
T
A
L

I
M
A
G
E
R
Y

A
N
D

P
H
O
T
O
S
H
O
P

DIGITAL IMAGERY AND PHOTOSHOP

WHEN YOU VIEW AN IMAGE ON A COMPUTER MONITOR, THE IMAGE MIGHT LOOK THE SAME AS THE PHOTOGRAPHS YOU TAKE WITH A TRADITIONAL CAMERA AND SEND TO YOUR LOCAL 1-HOUR PHOTO STORE, BUT LOOKS CAN BE DECEIVING. IN TRADITIONAL PHOTOGRAPHY, YOU UTILIZE CAMERAS WITH LIGHT-SENSITIVE FILM THAT IS PROCESSED INTO A NEGATIVE (UNLESS YOU'RE USING SLIDE FILM), AND THE NEGATIVE IS TYPICALLY PRINTED ONTO A PIECE OF PHOTOGRAPHIC PAPER. THAT'S THE WAY TRADITIONAL PHOTOGRAPHY HAS BEEN ACCOMPLISHED SINCE J. M. DAGUERRE INVENTED THE DAGUERREOTYPE OVER 150 YEARS AGO.

HOWEVER, ALL THAT CHANGED WITH THE BIRTH OF DIGITAL PHOTOGRAPHY.

Traditional photographs are normally referred to as *continuous-tone images,* because the quality of the image is determined by the quality of the film used by the photographer. Photographic film utilizes grains of light-sensitive material embedded into a gelatin matrix. Fine-grained films use very small grains, packed into a tight area, producing a better quality image.

Digital photography does not use traditional film. Digital film is actually a storage device, such as a diskette, or flash memory card. When you use a digital camera, you are actually storing thousands to millions of pixels (bits of information about the image) onto the storage device.

When you open a digital image in Photoshop, you are opening what is defined as a *raster image.* A raster image takes those stored pixels and recombines them to produce the image the photographer visualized when the shutter was snapped, as shown in Figure 1.1.

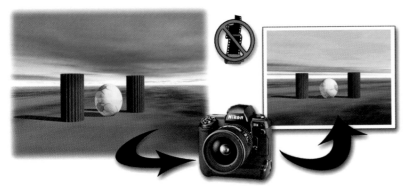

Figure 1.1: *Digital images are viewed without the need of traditional film, chemicals, or photographic darkrooms.*

Although digital photography has improved greatly over the last ten years, it has yet to evolve to the point that it fully competes with traditional, film-based, photography; however, it's getting close. While film may hold a slight edge on overall image quality, the flexibility of digital media is getting the attention of major photographers and Hollywood producers. In a recent interview, George Lucas (father of the Star Wars saga) emphatically stated that he would never shoot another film using traditional film. If the digital media can get the attention of George Lucas, it must be good.

In the following sections, you will explore the role of digital images in today's image-conscious world, and Photoshop's role in managing and manipulating those images to produce the best possible output.

RASTER VERSUS VECTOR – THE DEBATE CONTINUES

A raster, or digital image, is composed of pixels (short for picture element). When you open an image in Photoshop, the stored pixels are reassembled into an organized group, or raster. Visualize a brick wall, with each brick painted a solid color. Now, imagine that each one of those bricks represents a color detail in a photograph. Because each pixel within a digital photograph represents information about that image, raster images are said to be *resolution dependent.* Resolution dependency is best illustrated by opening an image in Photoshop and using the Zoom tool to enlarge the photo. As the image increases in size, the quality of the image suffers.

Vector images, on the other hand, are said to be *resolution independent.* Vector software, such as Adobe Illustrator, creates images out of mathematical statements, not individual pixels. When you enlarge a vector image, the software program simply changes the math to create the new shape. Since vector programs create images based on math, they are not suitable for photographic images. Their hard-edged mathematical lines are best at creating clipart and text, as shown in Figure 1.2.

Figure 1.2: *Vector images created in programs like Adobe Illustrator are best suited for clipart, not photographs.*

When you first open a vector file, Photoshop lets you choose the width, height, resolution, and color mode of a vector file; however, it must convert the file before work (adjustment, filters, etc) can begin. Since Photoshop is a raster program, it converts the image into a group (raster) of assembled pixels, all painted different colors. The more pixels an image contains, the more Photoshop can manipulate the image. Photoshop is driven by information; therefore, supplying more information (pixels) to Photoshop allows the program to do a better job of printing or manipulating the image.

When you view a digital image in Photoshop, you are actually viewing thousands to millions of colored bricks. Because the bricks (pixels) are very small and blend seamlessly, your eyes do not see the individual pixels; they see the overall image. It's only when you take a digital image to extreme magnifications that the individual picture elements become visible, as shown in Figure 1.3.

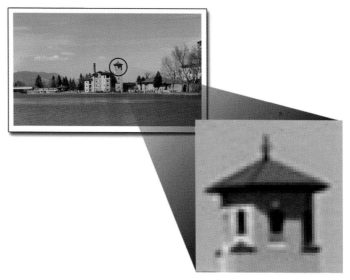

Figure 1.3: *Digital images are composed of individual pixels, which only become apparent at extreme magnifications.*

Because pixels represent the details within the image, it stands to reason that the more pixels in an image, the more detail. The term *low-resolution image* defines an image that lacks information. For example, images used on the Internet are typically saved at a resolution of 72 pixels per linear inch (ppi). An image saved at 72 ppi would look fine when displayed in a Web browser application, but lacks sufficient information for printing. On the other hand, an image saved at 300 ppi would be ideal for almost any printing situation.

If your images are sent to a high-end printing press, the resolution of the image should be 1.5 times the line screen of the printing press. For example, if the line screen (lpi) of the printing press is 133, the final resolution of the image should be 200 ppi (150 x 1.5). Finally, if your images are displayed in a newspaper, the low quality of the paper

requires that image be saved at 80 to 90 ppi. As with anything else in digital photography, changes in the industry require you contact the press operator or news print editor and ask for their recommendations. Figure 1.4 illustrates how an image looks when printed at various resolutions.

 With all digital photographs, it is vitally important to know where the image is to be displayed before starting work. Increasing the resolution of an image after it has been opened in Photoshop might improve its visual appearance; however, it will not increase the image's detail.

THE ROLE OF ANTI-ALIASING IN RASTER IMAGES

As Photoshop images are composed of pixels, they will have a tendency to appear jagged when printed, particularly when images are printed at low resolutions. For example, working in Photoshop to create shapes using the drawing and shape tools, if not correctly saved, can produce less than desirable results when printed, as shown in Figure 1.5.

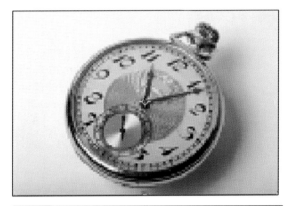

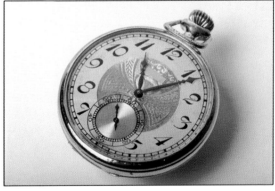

Figure 1.4: *Increasing the resolution of an image creates an image that is visually pleasing.*

Figure 1.5: *Raster images have a tendency to appear ragged at low resolutions, especially when the shapes curve and bend.*

One solution is to increase the resolution of the image. Increasing image resolution forces Photoshop to create more pixels for the image while using the same linear dimensions, thus minimizing the image's jagged appearance.

Say, for example, you create two 5-by-5 red circles; one is saved and printed at a resolution of 72 ppi, and the other is saved and printed at a resolution of 300 ppi. The image saved at 300 ppi would have almost 4 times as many pixels within the same linear space (5-by-5), and the increase in pixels would reduce the jagged appearance of the circle, as shown in Figure 1.6.

Figure 1.6: *When raster images are printed, increasing the resolution of the image minimizes its jagged appearance.*

Another solution is to apply *anti-aliasing*. When you apply anti-aliasing, Photoshop paints the edges of the text or shape with transitionally colored pixels. The inserted pixels create a softer-looking edge to the Photoshop object, as shown in Figure 1.7.

Text without Anti-aliasing
Text with Anti-aliasing

Figure 1.7: *Anti-aliasing creates Photoshop objects and text with a visually softer appearance.*

 Since anti-aliasing techniques add additional colors to an image, they will increase the size of the file. This does not become a concern unless the image is saved for use on the Internet. The GIF format (the most common format for converting text into a graphic) compresses the file according to the number of colors within the image. Applying anti-aliasing techniques can increase file sizes by up to 10 percent.

The following Photoshop tools allow for the use of anti-aliasing:

Selection Tools
- Elliptical Marquee
- Lasso
- Polygon Lasso
- Magnetic Lasso
- Magic Wand

Drawing Tools
- Rectangle
- Rounded Rectangle
- Ellipse
- Polygon
- Line
- Custom Shape

To use anti-aliasing, select any one of the defined tools, and select the Anti-aliased option on the Options Bar, as shown in Figure 1.8.

Figure 1.8: *Selecting the Anti-aliased option creates a visually smooth object by painting the edges of the object with transitionally colored pixels.*

Applying Anti-Aliasing to Text

In addition to shapes and selections, anti-aliasing can be applied to text. To apply anti-aliasing to text, select the Type tool and enter a line of text. Then choose from the anti-aliased options on the Options bar, as shown in Figure 1.9.

72ppi text
150ppi text
300ppi text

Figure 1.9: *The anti-aliased options create text that appears smooth, even in low-resolution images.*

BREAKING IMAGES INTO PIECES – THE ROLE OF A SCANNER

Not all images are created directly inside a Photoshop document window, and not all images are taken with a digital camera. Sometimes you will need to move a traditional photograph into Photoshop. For this, you will need the services of a scanner.

Scanners convert continuous-tone photographs (images taken with a film-based camera) into raster files. As mentioned in the previous workshop, raster images are composed of pixels. It is the job of the scanner, based on input from you, to rasterize the image, or break it into pieces, as shown in Figure 1.10.

Understanding the Relationship between Resolution and Information

When you scan and digitize a photograph, it's the scanner's job to create the digital file, and your job to determine the resolution of the scanned image. When you define the resolution of the image, you're instructing the scanner how much detail to save.

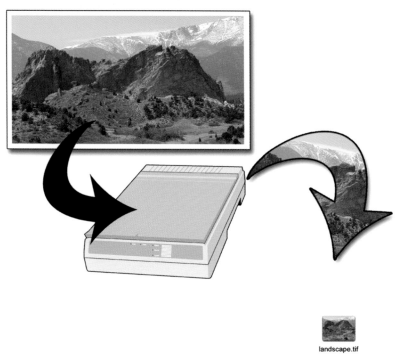

landscape.tif

Figure 1.10: *Scanners convert continuous-tone photographs into digital images.*

⊕	72ppi	72ppi	72ppi	⊕
1				72 ppi
2				72 ppi
3				72 ppi
⊕	1	2	3	⊕

◄── 46,565 total pixels ──►

Figure 1.11: *The number of pixels within an image determines the amount of information sent to Photoshop.*

Photoshop can only work with the information you send it. The only time you have access to the original image is during the scan process, so it's important to start with the best possible scan, and then let Photoshop do its magic.

When you scan an image, the resolution determines the number of pixels that are saved and passed on to Photoshop. Say, for example, you scan a 3-inch-by-3-inch photograph at a resolution of 72 ppi. That means there are 72 pixels, or separate pieces of information, per linear inch, for a total of 5,184 pixels in a square inch (72x72). The image contains 9 square inches, so that's a grand total of 46,565 pixels (5,184 x 9), as shown in Figure 1.11.

Using the analogy of a brick representing a pixel, the more bricks in the wall, the more information available to Photoshop. If you supply Photoshop with more information, it will do a better job displaying or printing the image, particularly if the image requires restoration. Check Chapter 6, "Photographic Restoration," for more information on making bad images look good.

Increasing the resolution of an image and sending that information to Photoshop is a good thing; however, there is a trade-off. Again, think of an individual pixel in a scanned image as a brick in a wall. The more bricks in a wall, the heaver the wall becomes, and the more pixels in an image, the larger the file size. Larger files take longer to open in Photoshop and consume more time performing simple edits and adjustments.

If bricks add weight to a wall, pixels add weight, or file size, to a scanned image. For example, our 3-inch-by-3-inch scanned image containing 46,565 pixels would have a file size of only 137k. The same image scanned at a resolution of 300 ppi would contain 810,000 pixels and have a file size of 3.32mb. The image scanned at 300 ppi contains 17 times more pixels, 17 times more information, and is 17 times bigger than the image scanned at 72 ppi.

In addition to resolution, the scanned image's color mode impacts the size of the file. For the purpose of this workshop, all file sizes are based on an image scanned in the RGB (red, green, blue) color mode. You will learn more about Photoshop's color modes later, in "Color Modes – A Rose by Any Other Name (or Color)."

When Photoshop works with larger file sizes, it takes longer to process the information. If you have ever torn your hair out waiting for Photoshop to process a filter or adjustment, you know what's it's like to work with large files. After waiting 15 minutes for Photoshop to perform an operation, you might ask yourself, "Am I working on files that are too big, and do I really need this much information?" Not only will large files cause you delays, but they also can create problems after the file is saved. For example, using large files on a Web page will cause the page to load slowly, they also never send large image files as email attachments to your friends. Your friends might be interested in your recent trip to Hawaii, but not if they have to wait thirty minutes to download the images. Watch those file sizes.

The answer to that question will be determined by asking another question: What is the final output of this image? As mentioned earlier, images saved for display on a Web page require a final resolution of 72 ppi, while images destined for print would require much higher resolutions.

Different output devices require different resolutions for maximum visual quality. However, the *final* resolution of the image might not necessarily be the resolution of the original scanned image. There is an old saying in the carpenter's trade: Measure twice, cut once. In other words, think about what you are doing, because if you cut a piece of lumber too short…well, you can't stretch the wood if you make a mistake.

If you're sure of the image's output, everything is fine; however, if the specific output is unknown (it's going to press, but what kind of press?), the saying should be: Scan high, save low. In other words, it is easer to remove information from an image (lower the resolution) than it is to add information (increase the resolution after saving the file).

As a matter of fact, you cannot add information to an image after scanning because you do not have access to the original image. Adding information to a digital image in Photoshop just adds generic-colored pixels to the image file. The image contains more pixels and the file size increases, but you don't have more detail, you just have more pixels.

If, after scanning an image, you realize that the scan resolution should have been 300 ppi, not 72 ppi, your best bet would be to rescan the image at 300 ppi, not increase the resolution in Photoshop. Figure 1.12 shows an image scanned at 72 ppi and saved and printed at a resolution of 300 ppi, and the same image scanned and printed at 300 ppi.

Figure 1.12: *Images scanned at the correct resolution print better than images scanned at lower resolutions, and then printed at higher Photoshop resolutions.*

As you can see, the image scanned at 300 ppi appears much sharper than the same image scanned at 72 ppi and artificially increased to 300 ppi in Photoshop.

Optical Resolution versus Enhanced Resolution

In the previous section, you learned that the resolution of an image determines the amount of information saved. Scanning an image involves knowing where the image is to be displayed, and then instructing the scanner to digitize the image.

Scanners typically come packaged with two resolutions: maximum optical and maximum enhanced. The optical resolution is based on the hardware, and the enhanced resolution is based on software. Enhanced resolution is always higher than the optical resolution. For example, if you purchase a scanner with a maximum optical resolution of 1,200 ppi, the enhanced resolution will be somewhere around 9,600 ppi.

In most cases, it is not necessary to exceed the maximum optical resolution of your scanner. When you exceed the optical resolution, you are instructing the scanner to save image details that it cannot see. Say, for example, you have a scanner that scans optically to 1,200, and you instruct the scanner to scan an image at 2,400. The scanner can only see 1,200 pixels in a linear inch, so it has to make up the information it can't see, by adding pixels to the image. Photoshop uses the surrounding pixels to determine what color to apply. The process of adding pixels to the image and then deciding their colors based on surrounding pixels is called *interpolation*, as shown in Figure 1.13.

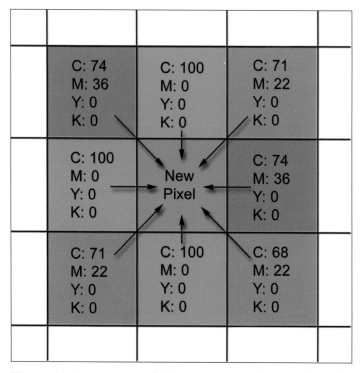

Figure 1.13: *Image interpolation chooses colors for pixels based on the surrounding pixels.*

Photoshop also uses interpolation when you open an image and increase the resolution by selecting Image Size from the Image drop-down menu, as shown in Figure 1.14.

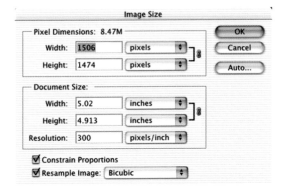

Figure 1.14: *When you exceed the optical resolution of your scanner, you are instructing the scanner to give you information it can't see, or essentially the same as changing the size of the image from the Image Size dialog box in Photoshop.*

COLOR MODES – A ROSE BY ANY OTHER NAME (OR COLOR)

In addition to the resolution of an image, its color mode is very important because it determines the number and type of colors the image is capable of producing. Photoshop's main color modes are Bitmap, Grayscale, RGB (red, green, and blue), and CMYK (cyan, magenta, yellow, and black). When deciding on a color mode, the original image and the final output of the image will always determine the color mode you scan and work in. To change the color mode of an image, open the document in Photoshop and select Mode from the Image pull-down menu. Make a selection on color mode from the available choices.

 Some color modes are not available until you switch the mode of the original image. For example, to convert an RGB image to Bitmap, you must first convert the RGB image into the Grayscale color mode.

The following sections discuss Photoshop's main color modes and their primary uses. Remember, a primary use does not imply its only use. Don't be afraid to experiment with different color spaces. The trick to mastering Photoshop is to not be afraid to explore the possibilities. Sometimes it's the road less traveled that produces the best results.

Bitmap: The Color Mode of Economy

The bitmap color mode is used primarily for scanning and working on fine line art, sketches, and text. For example, scanning a black-and-white line drawing using the bitmap mode lets you increase the resolution of the image, therefore maintaining the smooth shape of the lines while, at the same time, working with a small file. Bitmap accomplishes this by storing color information for only two colors: black and white, as shown in Figure 1.15.

Figure 1.15: *Bitmap images are typically black-and-white line drawings or text.*

For example, an 8 x 10 black-and-white line drawing scanned at 600 ppi using the RGB color mode would produce a file size of 82.4mb. However, scanning the same image at the same resolution using the bitmap color mode produces a file size of only 3.43mb.

The color of each pixel is controlled by a single bit, which has the capability of switching from a 1 or zero. If the bit is equal to 1, the color is black, and if the bit is equal to zero, the color is white. Think of a light switch with two positions, on and off, and you have a good visualization of a bit.

The trade-off to having a small file size combined with high resolution is the inability of Photoshop to do much with the image. Bitmap images cannot have additional layers or channels, none of Photoshop's creative filters will work, and about the only adjustment you can do is invert the colors.

Despite the limitations imposed on a bitmap image, having a high-resolution image with a small file size is intriguing enough to cause a designer to experiment with bitmaps. Besides line drawings and sketches, many Web designers use the bitmap mode to convert black text onto a white background, thus helping to create extremely small files for download onto Web pages (the GIF file format will accomplish the same task). While bitmap images are not as small as a corresponding text file, converting text into a graphic prevents the visitor's Web browser from substituting the font, and help the visitor see the design you intended.

Another reason to use the bitmap color mode is as a transitional step. Say, for example, a company sends its corporate logo to you on your fax machine (yes, that does actually happen in the real world). What you need is a good line drawing of the image, so you can rebuild it.

First, scan the image at a high resolution (600 ppi, or higher) using the bitmap color mode. Then convert the image into a vector, using a program such as Adobe Streamline (Streamline is an awesome program that lets you convert raster images into vector images). The vector file can be reopened in Photoshop, and resized to the proper width and height without hurting the quality of the image (Photoshop lets you choose the width, height, resolution, and color mode for a vector file before rastering the image). Once the image is correctly sized, it can be converted to RGB (or whatever color mode is required by the current project), at a more reasonable resolution, and colorized, as shown in Figure 1.16.

Figure 1.16: *Bitmap images can be converted into vector images and then converted into a workable color image.*

Grayscale: The World Before Color

Grayscale color mode is a step above bitmap. When you scan or work in the grayscale color mode, you can produce a maximum of 256 steps of gray: 1 black, 1 white, and 254 shades of gray.

The shades of gray are controlled by 8 individual bits, each capable of producing a 1 or zero. Imagine 8 light switches in a row, as shown in Figure 1.17.

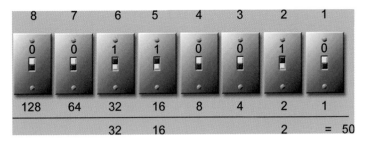

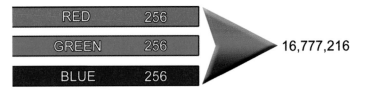

Figure 1.18: *RGB images are capable of producing millions of colors.*

Figure 1.17: *Grayscale images produce shades of gray based on the position of the bits.*

One of the original purposes for the grayscale color mode was the scanning and restoration of old black-and-white photographs; however, most designers quickly became dissatisfied with the limitations of the 8-bit pixel and moved into the RGB color space.

The grayscale color mode is sometimes used as a transitional color mode. For example, to create a duotone color wash from an RGB or CMYK image, it must first be converted into the grayscale mode. In addition, converting an image to bitmap requires first passing the image through the grayscale color mode.

Other than that, the grayscale color mode is used for saving images destined for printing on low-quality papers such as those used by newspapers, and inexpensive brochures, and even for saving certain image types for use on the Internet.

RGB: The Color Mode of Computer Monitors

The RGB (red, green, and blue) color mode can store 16,777,216 separate colors. It accomplishes this by storing the color information of the image in three channels: red, green, and blue. Each channel is capable of producing 256 separate shades of color: 256 x 256 x 256 equals 16,777,216, as shown in Figure 1.18.

RGB is the color mode of all computer monitors as well as television screens. It uses a process defined as additive color. The mixing of 100 percent of all three colors produces pure white, and removing all three colors (zero percent) produces black.

Viewing colors on a computer monitor does not require an external light source. In fact, turning off all the lights produces more intense color. Hence the term *additive* colors.

Because the RGB color mode represents the color mode used by all computer monitors and television screens, it is used for images destined for the Internet, documents displayed on computer monitors, as well as images used on television and computer slide presentations.

CMYK: The Color Mode of Paper

The CMYK (cyan, magenta, yellow, and black) color mode is the color mode of the print world. Images saved in CMYK are destined for reproduction in high-end magazines, books, and even laser and ink-jet printers that are set up to handle the CMYK color mode. CMYK-saved images are not designed for display on a computer monitor, so the output device (press or printer) and the type of inks used will determine the number of reproducible colors.

As CMYK is designed for output to paper, it requires an external light source to view the final image, a process called *subtractive color*. In subtractive color, removing all four-color inks produces white, and adding 100 percent of all four-color inks produces pure black (the opposite of additive color).

In theory, adding 100 percent of cyan, magenta, and yellow produces pure black; however, in the real world, inks contain impurities that cause 100 percent of cyan, magenta, and yellow to turn a muddy brown. To solve this problem, press operators use black ink to produce shadows and blacks in the printed document. Four-color presses use plates that hold the cyan, magenta, yellow, and black inks. As a piece of paper passes through the press, the four colors are applied to the paper, as shown in Figure 1.19.

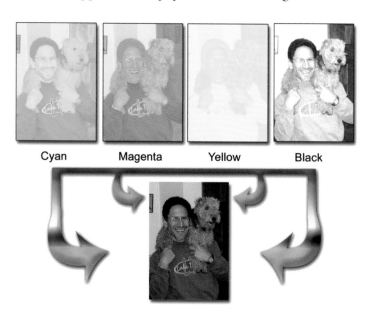

Cyan Magenta Yellow Black

Figure 1.19: *Four-color presses apply ink to the paper, one color at a time.*

WORKING WITH COLOR IN PHOTOSHOP

The final colors within an image do not necessarily determine the color mode used while you're working in Photoshop. Say, for example, your final image is going to be used in a high-quality magazine using CMYK. There are several arguments as to why you should work in the RGB color mode and convert the document into CMYK at the end of the project:

❉ **Ease of Use** – For overall color correction and ease of use, there are definite advantages to using the RGB color mode. The red, green, and blue additive color space represents the colors that occur in nature. In addition, the RGB color space, while representing more than 16 million possible colors, is 25 percent smaller than a corresponding CMYK image. Smaller file sizes process faster in Photoshop.

❉ **Visual Quality** – As stated earlier, the RGB color mode is the color mode of computer monitors. Although you can get close, it is theoretically impossible to view a CMYK subtractive color on an RGB additive monitor. The phrase What You See Is What You Get (WYSIWYG) is incorrect when it comes to viewing a CMYK image on a computer monitor.

❉ **Control of the Image** – When you work in the RGB color mode, you have all the power of Photoshop's filters and adjustments available to you. However, when you work in the CMYK color mode, you lose the ability to use many of Photoshop's filters and adjustments.

This is not to say you would never use the CMYK color space. For example, if the image comes from another designer, and was saved in CMYK, it would be best to stay and work in the CMYK color mode. However, for speed, quality, and control, RGB has distinct advantages over CMYK.

Converting an RGB Image to CMYK

Okay, you've done the right thing and performed all your adjustments and color corrections in the RGB color mode. Now it's time to convert the image into CMYK. The hardest part is managing the relationship between the black ink (K) and the other three colors (cyan, magenta, and yellow).

Incidentally, the letter K was chosen to represent the color black so designers would not confuse it with the color blue.

The relationship between the black ink and the other colors is another good reason to perform color correction in the RGB color space. When you color correct in RGB and convert the image into CMYK, the relationship between the K and CMY is maintained. This can save you, or your printer, a lot of time and trouble.

If you have a CMYK image, and you're not sure about output to print, call the printer and ask his or her advice. All press operators handle their presses differently, so there is no way you would know exactly how to set up the image.

Lab: The Forgotten Color Mode

The previous sections dealt with the main color modes used in Photoshop: Bitmap, Grayscale, RGB, and CMYK; however, another color mode that holds a lot of promise is Lab. The Lab color mode is Photoshop's native color mode, and it is used to convert images between the RGB and CMYK color modes, or vice versa.

Lab color is considered a device-independent color space and can be used to maintain the color integrity of a Photoshop image file, when it is moved to another image-editing program. Two other uses for the Lab color mode, which will be discussed in this book, are sharpening an image, and converting an RGB image into the Grayscale color mode.

FILE FORMATS – THE END JUSTIFIES THE MEANS

When you work with Photoshop documents, they will each have a specific color mode (RGB, CMYK, Grayscale, etc.), a specific resolution (the number of pixels per linear inch), and a specific file format.

File formats are the transportation containers for the document. When you save a file, Photoshop stores the image information with a name and extension. The name is defined by the user, and the extension is determined by the format chosen for the document. The document is then saved on your hard drive or other storage device. When you want to reopen the image, you select File from the pull-down menu and choose Open. In addition, if the file was saved in a program-friendly format, the image can then be opened in other programs such as InDesign or QuarkXpress.

For example, when saving a file with the name image.tif, the name image is defined by the user, and the extension, tif, indicates that the file is saved using the Tagged Image File format (a program-friendly format).

To save a newly created file in Photoshop, select File, choose Save As from the pull-down menu, and make your selection as to file name and format from the available options in the Save As dialog box, as shown in Figure 1.20.

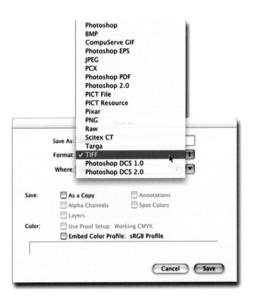

Figure 1.20: *The Save As File dialog box gives you options to save a file, including file name and format.*

The Save As dialog box gives you the option of saving a Photoshop document using one of 18 different formats. The format you choose is based solely on the destination of the image. For example, the formats used for the Internet (JPEG, GIF, PNG) are different than the formats used for sending an image to a 4-color press (EPS, DCS, TIFF). The following list describes the available formats and their various uses.

* **Photoshop** – The Photoshop format (.psd) is used to save a file that will be reopened in Photoshop. If there are multiple layers and alpha channels, they will be saved with the image.

* **Photoshop 2.0** – The Photoshop 2.0 format (.psd) is used to save documents that will be opened in Photoshop 2.0. Because Photoshop 2.0 did not support multiple layers, the image will be flattened when the file is saved.

* **BMP** – The Bitmap format (.bmp) is the native bitmap format of the Windows operating system. It can store mapped or unmapped RGB images up to 24 bits. The BMP format does not support multiple layers or alpha channels.

* **CompuServe GIF** – The Graphics Interchange File format (.gif) is a datastream-oriented file format, primarily designed to compress clipart and text for use on the Internet. It incorporates Run Length Encoding (RLE) to compress the image data.

* **Photoshop EPS** – The Photoshop Encapsulated PostScript format (.eps) is used to save documents that contain vector information, such as a clipping path. Many 4-color presses require images to be saved in the EPS format. Multiple layers and alpha channels are not supported in this format.

* **JPEG** – The Joint Photographers Expert Group format (.jpg) is used primarily for saving files that require compression, such as images destined for the Internet. The JPEG format does not support multiple layers or alpha channels.

* **PCX** – The ZSoft PCX format (.pcx) is an old Windows format used by programs such as MS Paint. In today's world, it is considered better to use the BMP format. The PCX format does not support multiple layers or alpha channels.

* **Photoshop PDF** – The Portable Document File format (.pdf) creates a file that can be viewed using the popular PDF reader program (available free from Adobe). Multiple layers and alpha channels are supported by this format.

* **PICT File** – The Picture file format (.pct) is a Macintosh support file format used primarily to save images for use with the Macintosh operating system. The PICT file format does not support multiple layers or alpha channels.

* **PICT Resource** – The PICT Resource format (.rsr) is used primarily to create Macintosh startup screens. The PICT Resource file format does not support multiple layers or alpha channels.

* **Pixar** – The Pixar file format (.pxr) is a file format made popular by the Pixar animation company (Toy Story, A Bug's Life). The animation is performed on Pixar workstations, which require files saved in the Pixar format. The Pixar file format does not support multiple layers or alpha channels.

* **PNG** – The Portable Network Graphic format (.png), along with the .gif and .jpg formats, is used extensively on the Internet. The PNG format is very popular for saving files used in programs such as Adobe LiveMotion and Macromedia Flash. The PNG file format does not support multiple layers or alpha channels.

* **Raw** – The Raw format (.raw) is a Photoshop PSD file without the header. The header information must be entered when the file is opened in Photoshop. It is used primarily to import and export bitmap data using a very simple, uncompressed binary format. The Raw format does not support multiple layers.

* **Scitex CT** – The Scitex CT format (.sct) (the CT in Scitex CT stands for continuous tone) is used to store 1 to 16 8-bit color separations (color plates). The Scitex CT format does not support multiple layers or additional alpha channels. It is used primarily by the pre-press industry and, in most cases, contains a CMYK or grayscale image. It is probably not a format that you will use very often.

* **Targa** – The Truevision file format (.tga) is a widely used format for saving 24- and 32-bit truecolor images. The PICT file format does not support multiple layers, but it does have limited support of alpha channels. Again, it is probably not a format that you will use very often.

* **TIFF** – The Tagged Image File format (.tif) is one of the most universally used formats for saving a file. The new version of TIFF now supports multiple layers as well as additional alpha channels. The TIFF format is maintained by Adobe, so it works seamlessly with all Adobe products.

✴ **Photoshop DCS 1.0** – The Desktop Color Separation file format, version 1.0 (.eps), is used to create a pre-separated image for use on printing presses. The DCS 1.0 file contains five files: a main file and four files that contain the ink information for the cyan, magenta, yellow, and black plates. The DCS 1.0 file format does not support multiple layers or alpha channels.

✴ **Photoshop DCS 2.0** – The Desktop Color Separation file format, version 2.0 (.eps), is used to create a pre-separated image for use on printing presses. The DCS 2.0 file contains five files: a main file and four additional files that contain the ink information for one or more of the cyan, magenta, yellow, and black plates. The DCS 2.0 file format does not support multiple layers or alpha channels; however, it does support the use of spot colors.

In addition to layers and alpha channels, file formats allow for several other options (refer to Figure 1.20). The following table lists the available Photoshop formats, and what they will and will not support.

	As a Copy	Alpha Channels	Layers	Use Proof Setup	Embed Color Profile	Annotations	Spot Colors
Photoshop	X	X	X		X	X	X
Photoshop 2.0	X	X					
BMP	X						
CompuServe GIF	X						
Photoshop EPS	X			X	X		
JPEG	X				X		
PCX	X						
Photoshop PDF	X	X	X	X	X	X	X
PICT File	X				X		
PICT Resource	X				X		
Pixar	X	X					
PNG	X						
Raw	X	X					X
Scitex CT	X						
Targa	X						
TIFF	X	X	X		X	X	X
Photoshop DCS 1.0	X				X		
Photoshop DCS 2.0	X				X		X

PLANNING A PHOTOSHOP PROJECT – BEGIN WITH THE END IN MIND

This chapter discussed the individual elements of a Photoshop image. Working in Photoshop is a bit like building a home; you need a plan to make the whole thing work. Imagine building a home, but forgetting to put in a front door. As ridiculous as that might sound, working in Photoshop without a plan might just leave you in a similar situation.

Always Work Toward the Output

The output of a Photoshop document determines everything, so know the final destination of your Photoshop images. Before you begin work on a Photoshop project, ask the who, what, and where questions:

✴ **Who** – Who is the audience for this project? The audience determines the subject matter. For example, young people like vivid colors and whimsical designs. As your audience matures, they prefer more muted colors; and if you're dealing with older adults, the ability to perceive subtle shifts of color, especially in the blues and purples, becomes harder. Every Photoshop image will have an audience… know your audience.

✴ **What** – What is the goal of this project? Is it to entertain or inform? Images designed to entertain can have a more relaxed, nontraditional style, whereas images intended to inform require more thought to structure and form. For example, viewers have a tendency to look in the upper-left corner of an image and move down and across the image. In a structured, informational document, you would put the most important information toward the upper left and the least important in the bottom toward the right. In an unstructured, entertaining image, you might place something toward the upper left to catch the viewer's attention.

✴ **Where** – Where is the document to be displayed or viewed? This question is the most crucial, as it deals with the elements of the Photoshop document. For example, a color image displayed on a Web page would be saved using the RGB color mode, at a resolution of 72 ppi. The same image placed into a high-end magazine would use the CMYK color mode, with a much higher resolution, such as 244 ppi.

Here are some common output devices and suggestions as to the Photoshop document format that would be most compatible.

Brochures output to inkjet or laser printers using medium quality paper.

- File Format – TIFF
- Color Mode – RGB
- Resolution – 150 to 200 ppi

Brochures output to inkjet or laser printers using photo-quality paper.

- File Format – TIFF
- Color Mode – RGB
- Resolution – 250 ppi and higher

4-Color Printing Presses

- File Format – TIFF or EPS (DCS 1.0, DCS 2.0)
- Color Mode – CMYK
- Resolution – Depends on press, typically around 244 ppi

The Internet

- File Format – JPEG, GIF, and PNG
- Color Mode – RGB, Grayscale, Bitmap
- Resolution – 72 ppi

Documents viewable on any computer monitor (Mac or Windows)

- File Format – PDF
- Color Mode – RGB
- Resolution – 72 ppi

The previous information is supplied to give you some of the most common uses for various formats based on output. However, as with life, things can change. For example, you might use the TIFF format for saving files for output to inkjet and laser printers, but if your image includes a clipping path, you would save the image using the EPS format. In addition, many inkjet printers today use the CMYK color mode, not RGB.

A word to the wise: If you are sending your documents to a printing press, call and ask the press operator what works best with the presses, and if you are outputting to an inkjet or laser, read the user manual that came with the printer. The more you know about the output before you begin working on a Photoshop document, the faster the job will go, and the better the image will look.

One other point: Experiment with different output settings to see what happens. For example, try different output resolutions and color modes with your inkjet printer to see which combination produces the best results. A users' manual can only give you generic recommendations as to what is best, based on the average user.

If one thing is certain in this universe, it's that creative Photoshop designers are anything but average. So, work through these workshops, then experiment and add your own style and flair. There is a cyclic relationship at work here. The more you learn what you can do with Photoshop, the more easily you can express your creativity. As your creative abilities take off, you'll learn to test the limits of the software.

WHAT'S NEW IN PHOTOSHOP 7

WHENEVER A NEW VERSION OF PHOTOSHOP (OR ANY SOFTWARE) HITS THE MARKET, USERS ALWAYS ASK THE SAME QUESTION: WHAT'S CHANGED FROM THE PREVIOUS VERSION, AND ARE THOSE CHANGES GREAT ENOUGH TO JUSTIFY A PURCHASE OF THE NEW VERSION? TO BE SURE, A STRONG MOTIVATOR FOR RELEASING VERSION 7 WAS COMPATIBILITY WITH WINDOWS XP AND MACINTOSH OS-X, AND HERE PHOTOSHOP DELIVERS BIG TIME. NOT ONLY IS PHOTOSHOP COMPATIBLE WITH THE NEW OPERATING SYSTEMS, BUT IT ALSO TAKES ADVANTAGE OF SOME OF THE NEW SPEED FEATURES, SUCH AS THE UNIX KERNEL IN OS-X, AND ITS ABILITY TO PERFORM TRUE MULTI-PROCESSING.

YET ADOBE DID NOT SKIMP ON THE EXTRAS. PHOTOSHOP'S NEW FILE MANAGEMENT SYSTEM, ITS DYNAMIC BRUSHES PALETTES, AS WELL AS THE NEW HEALING BRUSH AND PATCH TOOL ARE THE STARS OF THE SHOW, AND PROVE THAT THE SAYING "THERE IS NOTHING NEW UNDER THE SUN," IS NOT TRUE WHEN IT COMES TO THE FOLKS AT ADOBE.

Let's take a test drive, and you'll see that Photoshop didn't just get a new version number; it's about to make your life a whole lot easier.

FILE MANAGEMENT: THE PHOTOSHOP WAY

Photoshop's new file browser option is so feature-filled that you might stop opening files by using File - Open. In addition, the image preview goes far beyond the preview available in the File - Open command. If you think that's impressive, you will just love the ability to move, rename, or delete an individual file or groups of files. To access the File Browser, open Photoshop and click the File Browser tab, located in the Options Bar palette well, as shown in Figure 2.1.

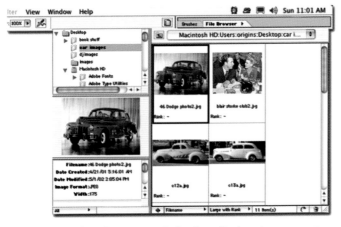

Figure 2.1: *The File Browser dialog box displays image previews and information.*

Controlling the File Browser View

The default setting for image information includes an image preview and details that include the file name, type, rank, date modified, date created, copyright notice, color mode, file size, and pixel dimensions. To change the current view, click the black triangle located on the File Browser tab and choose from the available options, as shown in Figure 2.2.

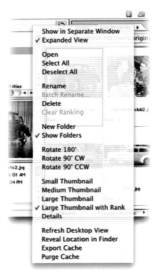

Figure 2.2: *The options controlling the File Browser dialog box are available in a pop-up menu.*

You can choose from small, medium, or large thumbnails, large thumbnails with rank, or all the details (the default setting). The good news about thumbnails is that the images do not have to be previously saved in Photoshop. If you have ever been frustrated by seeing "no preview available" in the Open dialog box, you will see it less often in the File Browser. If the image has an embedded preview image (and most images do), the File Browser will use the embedded preview as the displayable thumbnail.

If you don't want all the details, the large thumbnail option provides an easy-to-see reference to the original image, along with the image's file name, as shown in Figure 2.3.

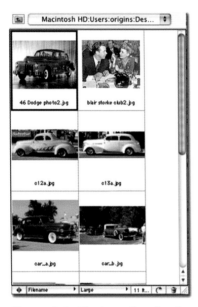

Figure 2.3: *The large thumbnail option displays the image and file name.*

To open an image, double-click an available thumbnail in the File Browser dialog box, or if the thumbnail is already selected, simply press the Enter key.

Selecting and Creating Image Folders

The left section of the File Browser contains a hierarchical structure of your hard drive. When a specific image folder is selected, the available images are displayed in the right-hand window including thumbnails of subfolders, and text and data files, as shown in Figure 2.4.

Figure 2.4: *The hierarchical structure window displays information on the available files and folders.*

To display a different file folder, click the name of the folder in the hierarchical structure window, or use the arrow keys on your keyboard. The up and down arrow keys move you vertically through the file structure, and the right and left arrow keys open folders that contain subfolders (as demonstrated in Figure 2.5). The thumbnails displayed in the File Browser relate to the selected folder in the hierarchical structure window.

To create a new folder, click the black triangle located on the File Browser tab, and choose New Folder from the available options. To view the folder in the File Browser, make sure you select Show Folders. Rename the new folder by double-clicking on the folder's current name (Untitled Folder), and typing the new name, as shown in Figure 2.6.

Figure 2.5: *The keyboard arrow keys help you navigate through the hierarchical structure list.*

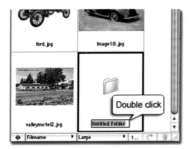

Figure 2.6: *Rename a folder by double-clicking on the folder's current name.*

Moving, Renaming, and Deleting Files

To move an image file into a folder displayed within the File Browser, simply click and drag the file over the thumbnail of the folder, as shown in Figure 2.7.

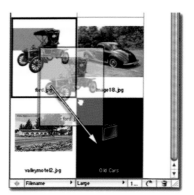

Figure 2.7: *Move files to folders within the Browser Files window by clicking and dragging the file over the thumbnail of the folder.*

To move an image into a folder visible in the hierarchical structure window, click and drag the image thumbnail and drop it on the appropriate folder icon, as shown in Figure 2.8.

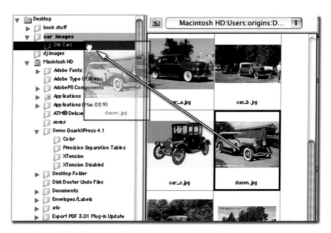

Figure 2.8: *Move files to other folders by clicking and dragging the file to the icon of the folder.*

To rename a file, simply double-click the image's current name, or right-click and choose Rename from the context-sensitive menu, and type the desired name. To rename or move a group of files (or do both at the same time), hold the shift key while selecting two or more files, and click the black triangle, located on the File Browser tab. Select Batch Rename from the available options, as shown in Figure 2.9.

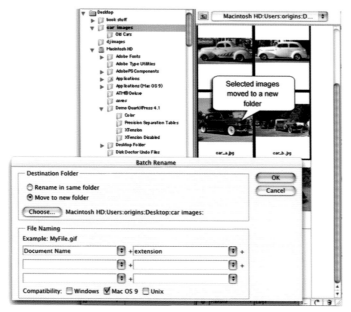

Figure 2.9: *The Select Batch Rename dialog box lets you move and rename groups of files.*

You can choose to rename the files and leave them in the same folder, or choose to move them into another folder. Remember, you are not renaming and copying the files; you're renaming and *moving* them into the other folder. You can also get to the Batch Rename option through the File menu (choose File – Automate – Batch). You can choose to leave the names the same and simply move them to another folder, or you can choose from the available renaming options for the file name and extension, as shown in Figure 2.10.

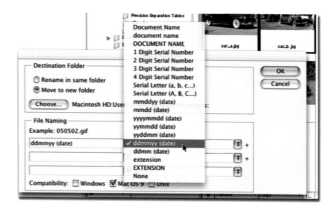

Figure 2.10: *The renaming options let you modify the name of groups of image files.*

In addition to renaming the image files, you can select compatibility options for Windows, Mac OS 9, or Unix.

If you want to delete a file, select the thumbnail and press the Backspace key (Delete key: Macintosh), but be fore-warned, deleting a file doesn't just remove it from the file list, it drops it into the trashcan. If you've set up your trashcan to delete files instead of storing them, you might be in trouble.

Viewing Image Information

In addition to viewing a thumbnail with details (refer back to Figure 2.1), the File Browser gives you the ability to view specific information about the equipment that produced the image. To view different information, click the pop-up button located in the lower-left corner of the File Brower palette, and select All or EXIF. All displays everything about the file, and EXIF (information produced by digital cameras) gives you information on the setting used to take the image, as shown in Figure 2.11.

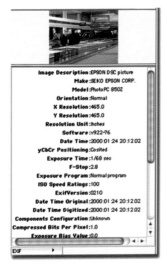

Figure 2.11: *The EXIF option gives you detailed information on the type of camera and the settings used to take the picture.*

Controlling the File Browser

By default, the File Browser is located in the docking station of the Options Bar. To remove it from the Options Bar and make it a free-floating palette, click the File Browser tab and drag it onto the desktop. When the palette is detached from the docking station, you have more control over its relative size and position in the monitor window, as shown in Figure 2.12.

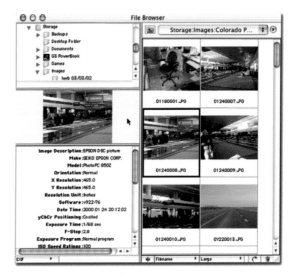

Figure 2.12: *The File Browser can be detached from the palette well and become a free-floating palette.*

Returning the File Brower to the palette well is trickier than returning a normal palette. To move a palette (such as the Layers palette) into the palette well, simply click the palettes tab and drag it into the well. However, you might have noticed that when you drag the File Browser out of the palette well, it loses its tab. To return the File Browser to the well, click the black triangle located in the upper-right corner of the File Brower and select Dock to Palette Well from the available options.

USING TOOL PRESETS

Another new feature in Photoshop 7 that has the potential of saving time is the new Tool Presets. Tool Presets give you the ability to create a one-click option for a tool containing a specific set of options. Say, for example, you use the Clone Stamp tool for image restoration. When you use the tool, you prefer to start with a soft, 25-pixel brush using a Flow of 80 percent. In addition, you want the Aligned and Use All Layers Options selected.

Rather than make these changes to the Clone Stamp tool every time you use it, you can create a preset and you're only a click away from your favorite tool. To create a preset, first select the tool (in our example, the Clone Stamp tool) and adjust the options, as shown in Figure 2.13.

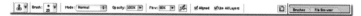

Figure 2.13: *The modified Clone Stamp tool.*

To create the new preset, click the Create new tool preset icon located at the bottom of the palette to access the New Tool Preset dialog box, as shown in Figure 2.14.

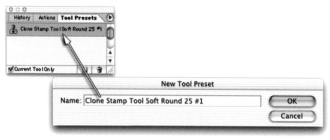

Figure 2.14: *The New Tool Preset dialog box lets you rename the current tool.*

Name the preset and click the OK button to add it to the list. The next time you require the Clone Stamp tool with those specific options, open the Tool Presets palette and you're only one click from accessing the tool. When you work with user-defined tools, the Tool Presets palette is a tremendous time saver. Watch carefully how you work in Photoshop. If you see that you're using a specific tool and constantly changing its options, stop and make a preset for that tool.

To control the number of displayable tools, select Current Tool Only from the bottom of the Tool Presets palette. This option limits the displayable presets to the available tool. For example, if you select the History Brush tool, the Tool Presets palette will display presets for the History Brush. If you deselect this option, the Tool Presets palette will display all the available presets regardless of the selected tool.

 Note: To save space in the Tool Presets palette, and to control your presets, click the black triangle in the upper-right corner of the palette and choose Save Tool Presets from the available options. Saving presets gives you the option of loading them when you need them and removes the clutter of unneeded presets.

WORKING WITH THE NEW PATTERN MAKER FILTER

The Pattern Maker filter is a great tool for creating dynamic tile patterns for use in backgrounds or Web pages. To use the Pattern Maker filter, open an image you want to create a pattern from, then select Filter and choose Pattern Maker from the pull-down menu, as shown in Figure 2.15.

Select an area of the image that you want to use as a pattern sample and click the Generate button. The Pattern Maker filter generates a pattern based on the selected area of the image, as shown in Figure 2.16.

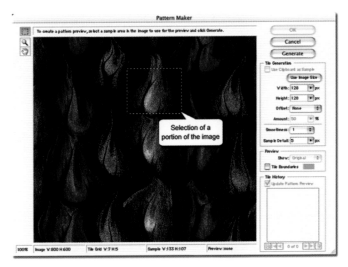

Figure 2.15: *The Pattern Maker filter lets you create a pattern based on a selected portion of the image.*

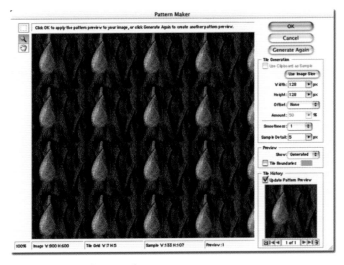

Figure 2.16: *The complete pattern.*

To edit the current pattern, select from the Tile Generations options (see Figure 2.17). You can choose to use an image saved to the clipboard, control the width and height of the tiles, or choose to offset the original tile image. In addition, you can control the visual blending of the tiles with the Smoothness and Sample Detail options.

To generate a second pattern, click the Generate Again button. The Pattern Maker creates a new pattern, and saves it in the Tile History (which can hold as many as 20 patterns). To transfer a pattern to the document window, select a pattern from the available Tile History options and click the OK button.

The Pattern Maker filter helps you create unique patterns, but that's not all it is capable of doing. As you will see in Chapter 6, "Photographic Restoration," the Pattern Maker filter can be used in conjunction with the Pattern Stamp tool to restore damaged areas of an image.

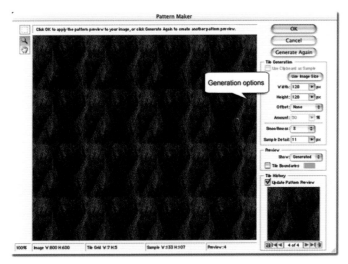

Figure 2.17: *Tile Generation options let you create different patterns.*

IMAGE RESTORATION THE PHOTOSHOP 7 WAY

If you use Photoshop to do photo restoration, and you do a lot of photo restoration, the new Healing Brush and Patch tool alone are almost worth the cost of upgrading to Photoshop 7.

The Healing Brush

The Healing Brush tool is similar to the Clone Stamp tool, but with an important difference. It doesn't simply cover damaged areas with image information cloned from another area of the image. It replaces information while preserving the base color and texture of the original image.

To use the Healing Brush tool, open an image in Photoshop and select the Healing Brush tool from the toolbox, as shown in Figure 2.18.

Note: Unlike the Clone Stamp tool, the Healing Brush tool must work within the original image layer. In addition, you are limited to a standard brush. The Dynamic Brushes palette is not available when you use the Healing Brush tool.

Figure 2.18: *The Healing Brush tool makes quick work of damaged areas of an image.*

1. When you select the Healing Brush tool (or any of Photoshop's brush tools), you can select the size of the brush by using the left ([) and right (]) bracket keys on your keyboard to decrease or increase the brush's diameter. Brush feathering is not necessary; the Healing Brush performs feathering as you work.
2. Select the sample area by holding the Alt key while clicking on the area (Option + clicking: Macintosh). In this example, the area on the right cheek was selected, as shown in Figure 2.19.

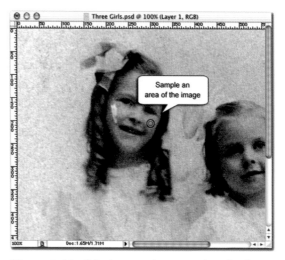

Figure 2.19: *Select a sample area within the document window.*

3. Move to the area to heal, then click and drag. Use short strokes to stay close to the original sampled area. Continue to drag over the damaged area until the scratch or blemish is removed, as shown in Figure 2.20.

To learn more about the Healing Brush tool, refer to Chapter 6, "Photographic Restoration."

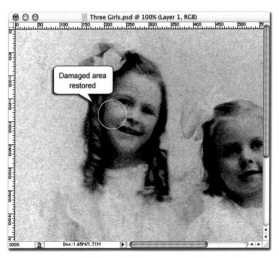

Figure 2.20: *Click and drag, using short strokes over the damaged area.*

THE PATCH TOOL

The Patch tool works to apply texture and color to damaged areas of an image. For example, images that contain large areas of missing detail are perfect candidates for the Patch tool, as shown in Figure 2.21.

To correct the damaged areas of the image, select the Patch tool from the toolbox and perform these steps:

1. Choose Destination from the available Patch tool options.
2. Use the Patch tool to select an area of the image. This area should contain detail similar to the image detail missing in the damaged area. Selecting an area with the Patch tool is similar to using the Lasso tool. Simply click and drag to define the area, as shown in Figure 2.22.
3. Click and drag the selected area over the damaged area, and release your mouse to apply the patch to the image, as shown in Figure 2.23.
4. Continue selecting and moving areas of the image until all of the damaged areas of the image are repaired, as shown in Figure 2.24.

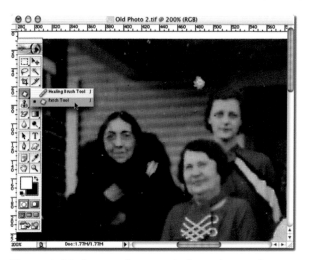

Figure 2.21: *Images that contain large damaged areas are ideal for the Patch tool.*

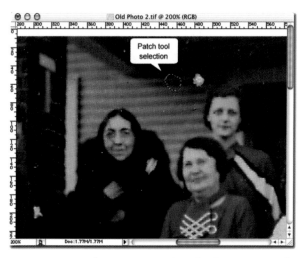

Figure 2.22: *Select an area within the document window by clicking and dragging.*

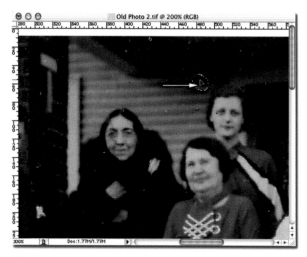

Figure 2.23: *Drag the selected area over the damaged area.*

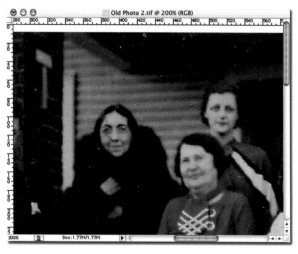

Figure 2.24: *The damaged areas of the image fully restored using the Patch tool.*

To learn more about the Patch tool, refer to Chapter 6, "Photographic Restoration."

LAYER BLENDING MODES

In Photoshop 7, Adobe added 5 new blending modes and they reorganized the blending modes palette, as shown in Figure 2.25.

Figure 2.25: *Photoshop blending modes work by mixing the image information of two or more layers.*

The new blending modes are

❋ **Linear Burn:** Darkens the image similar to the Color Burn tool, but with a greater contrast value.

❋ **Linear Dodge:** Lightens the image similar to the Color Burn tool, but with a greater contrast value.

❋ **Vivid Light:** A combination of the Color Dodge and Color Burn tools. Use this blending mode to equally affect underlying colors and brightness.

✳ **Linear Light:** A combination of the Linear Dodge and Linear Burn tools. Use Linear Light to generate a higher contrast value compared to the Hard or Soft Light blending modes.

✳ **Pin Light:** A combination of the Lighten and Darken blending modes. Use Pin Light to generate higher contrast values while preserving more edge detail.

PHOTOSHOP'S NEW BRUSH ENGINE

Every version of Photoshop has included a brushes palette. However, if you haven't worked with Photoshop's new brushes, hold on to your hat—things have changed. To access the new Brushes palette, first select a brush tool, then select the Brushes tab from the Palette Well, as shown in Figure 2.26.

Note: To access the brush palette options, you must select a tool that uses a brush.

Figure 2.26: *The new and improved Brushes palette.*

The right side of the Brushes palette contains the Brush Presets. You can create your own presets by creating a brush, using Brush Dynamics, and then clicking the Create new brush icon, located at the bottom-right of the Brushes palette.

The left side of the Brushes palette contains the dynamic options. This is where you control the size, shape, and dynamics of the individual brushes. Click an option to gain access to Brush Tip Shape controls.

✳ **Brush Tip Shape:** Select this option to control the standard parts of a brush such as its size, angle, roundness, and spacing.

✳ **Shape Dynamics:** Controls many of the Jitter options for the brush. Changing brush jitter typically affects the edges of the brush.

✳ **Scattering:** Breaks the elements of a brush apart.

✳ **Texture:** Controls the physical texture of the brush, based on predefined patterns. The Texture option can create a brush stroke on canvas or emulate an oil brush.

✳ **Dual Brush:** Combines the current brush with a second brush.

✳ **Color Dynamics:** Uses the current foreground and background color swatches to modify the brush colors.

✳ **Other Dynamics:** Controls the Opacity and Flow Jitter of the current brush.

Additional options include Noise, Wet Edges, Airbrush, Smoothing, and Protect Texture. Unlike the previous options, these are toggle switches without additional control, as shown in Figure 2.27.

To choose from the Brushes options, click the black triangle located on the Brushes palette tab and choose from the available options. The Brushes options give you the ability to save sets and load sets of brushes as well as change the view of what you see in the Brushes palette (thumbnails, text, list).

To get an idea of just what is now possible with Photoshop's brushes, create a new document and select the Paintbrush tool. Spend some time working with brush dynamics and see what's possible in Photoshop 7.

WHAT'S NEW IN PHOTOSHOP 7 ㉛

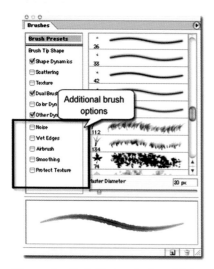

Figure 2.27: *Additional selectable brush options.*

ADDITIONAL FEATURES

Although the previous pages dealt with the more evident changes to Photoshop 7, there are a few hidden changes that are nice to know about.

Customized Workspaces

Say, for example, you like to work with the Layers and History palette open and the rest of the palettes closed. Then, ten minutes later, you want access to the Tool Presets and the Actions palette. It's been a long time coming, but Photoshop now lets you create customized workspaces.

To create a customized workspace, set the palettes and toolbox where you want them, and close out anything you don't want to see. Now select Window - Workspace, and choose Save Workspace from the available options on the fly-out menu, as shown in Figure 2.28.

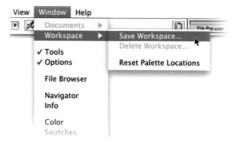

Figure 2.28: *Save workspaces to give you greater control over the layout of Photoshop.*

Name the new workspace (in this example normal) and click the OK button. The next time you require that particular configuration, select Window - Workspace, and choose the desired workspace. Create specific workspaces for image retouching and image colorization...whatever you need, as shown in Figure 2.29.

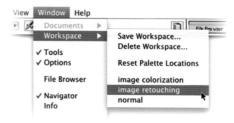

Figure 2.29: *Create workspaces for all your Photoshop needs.*

Floating Brushes Palette

When Adobe released Photoshop 6, users missed the floating brushes palette. Well don't despair; the floating brushes palette is back. To create a floating brushes palette, first drag the Brushes palette out of the Palette Well. Then click the black triangle button located in the upper-right portion of the Brushes palette and choose Small Thumbnail from the view options. To get rid of the controls on the right deselect the Expanded View option, as shown in Figure 2.30.

Figure 2.30: *The floating brushes palette returns in Photoshop 7.*

To return the Brushes palette to the Palette Well, click and drag it back into the Well, or select Dock to Palette Well from the Brushes options.

Spell Checking

That's right, Photoshop now contains a powerful spell-checking engine. To access the spell checker, use the type tool to enter text into your Photoshop document. Then select Edit and choose Check Spelling from the pull-down menu, as shown in Figure 2.31.

Figure 2.31: *Photoshop's new spell-check engine.*

Auto Color Correction

Photoshop added an easy way to restore an image's color called Auto Color. To experiment with Auto Color, open a color image in Photoshop, select Image - Adjustments, and choose Auto Color from the available options. Auto Color analyzes an image by examining the highlight, midtones, and shadows in the image and making corrections to color values based on that information, as shown in Figure 2.32.

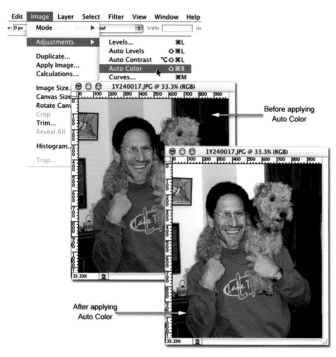

Figure 2.32: *Auto Color works to restore an image's original colors.*

Picture Package and Contact Sheet Improvements

The Picture Package option now lets you select more than one image for the package. To create a picture package from multiple images, select File - Automate and choose Picture Package from the fly-out menu, as shown in Figure 2.33.

Figure 2.33: *The Picture Package dialog box.*

Changing an individual image is easy; simply click the image you want to change, and Photoshop displays the Select an Image File dialog box. Choose the image and click the OK button to change the image. You may change as many images as you want, as shown in Figure 2.34.

As you can see, Photoshop 7 isn't just Photoshop 6 with a new paint job; it's a totally reworked, feature-packed version. So kick the tires and run it around the block a few times to get the feel. Remember, the more you know about what Photoshop can do, the more you can control what you do. Have fun.

Figure 2.34: *Picture Package now lets you choose more than one image for the package.*

CHAPTER 3

CREATING WOOD AND METAL TEXTURES

TEXTURES ARE LIKE COPPER PENNIES; EVERYONE HAS A FEW, BUT NO ONE SEEMS TO KNOW EXACTLY WHAT TO DO WITH THEM. TEXTURES SERVE ALL KINDS OF PURPOSES; THEY CAN BE USED TO FILL IN AN OTHERWISE BORING BACKGROUND, OR THEY CAN BE INCORPORATED INTO AN OVERALL DESIGN SCHEME, SUCH AS A COMPANY'S LOGO. USING VARIATIONS OF A TEXTURED BACKGROUND ON A WEB SITE HELPS TO REINFORCE THE OVERALL DESIGN THEME OF THE SITE. IN ADDITION TO BACKGROUNDS, TEXTURES CAN BE USED TO CREATE STUNNING TEXT AND SHAPES. TEXTURES PROVIDE A LOT OF POTENTIAL.

This chapter covers some of the more creative ways to design textures, and it sheds some light on how they might be incorporated into a Photoshop image. As you move through the workshops, the dimensions, resolution, and color mode chosen for each project are averages. As in all Photoshop projects, the parameters of the image file are solely based on the intended output of the image. For example, in most of the workshops, I've used a resolution of 72 ppi: While this may be fine for incorporation into a Web page, it would be considered unsatisfactory for use in the printing world.

WORKSHOP 1 – CREATING A SIMPLE WOOD SURFACE

Creating wood in the real world takes time. You plant a seed, patiently care for it and water it, and then sit back and watch it grow into a tree. About thirty years later or so, when it's big, you cut it down and, presto, instant wood. Okay, the part about it being instant might have been a bit exaggerated, but when you create wood textures in Photoshop, the process is as close to instant as you can get.

Let's start with a simple wood texture, and then progress to something with a bit more character.

To create a simple wood texture, open Photoshop and perform these steps:

1. Select File and choose New from the pull-down menu, and create a document in the New dialog box using the parameters shown in Figure 3.1.
2. Create a new layer by going to the Layers palette and clicking the New Layer icon located at the bottom of the palette. Name the new layer wood-grain. Keep the wood-grain layer selected throughout this workshop.
3. Click and hold your mouse on the Marquee tool and select the Single Column Marquee tool.
4. Click once in the middle of the document window to select a single column of pixels, as shown in Figure 3.2.

Figure 3.1: *The New dialog box defines the parameters for this workshop.*

Figure 3.2: *The Single Column Marquee tool creates a vertical selection 1-pixel wide.*

5. Press the letter D on your keyboard to reset the foreground and background colors to their defaults of black and white, respectively.
6. Press CTRL + Backspace (CMD + Delete: Macintosh). This is the shortcut to fill the selected area (our 1-pixel column) with the background color.
7. Select Filter – Noise, and choose Add Noise from the fly-out menu.
8. Choose an amount of 400 percent, Distribution: Gaussian, and if selected, uncheck the Monochromatic option, as shown in Figure 3.3.

Figure 3.4: *The bounding box defines the limits of the selected area.*

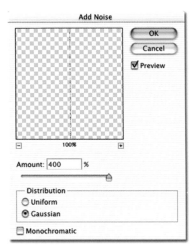

Figure 3.3: *The Add Noise Filter dialog box controls the amount of noise applied to the image.*

9. Select Edit and choose Free Transform from the pull-down menu. Photoshop will place a bounding box with handles around the column of noised pixels, as shown in Figure 3.4.
10. Move your cursor over the middle handle (the cursor will resemble a horizontal double arrow), and drag to the right, until you reach the edge of the document window.

11. Return to the middle handle and drag to the left until you reach the edge of the document window. The noised column of pixels should now be stretched to fit the boundaries of the document window, as shown in Figure 3.5.
12. Press the Enter key to confirm the Free Transform operation. If you wish to redo the transform, press the Esc key to cancel the Free Transform operation.
13. Soften the lines by selecting Filter – Blur, and choosing Gaussian Blur from the fly-out menu.
Choose a Radius of 1 pixel, and click the OK button to apply the Gaussian blur to the image, as shown in Figure 3.6.

Figure 3.5: *The Free Transform command lets you stretch the single column of pixels the length of the document window.*

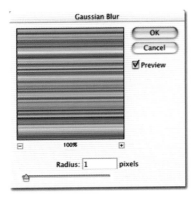

Figure 3.6: *The Gaussian Blur filter softens the image layer.*

14. Open the Swatches palette and select a shade of brown (wood textures look best using a shade of brown or sepia). The default Swatches palette has several shades of sepia and brown located at the bottom of the list, as shown in Figure 3.7. In this example, the swatch named Pale Warm Brown was selected.

Figure 3.7: *The Swatches palette contains a row of sepias and browns.*

15. Select Image – Adjustments, and choose Hue/Saturation from the fly-out menu.
16. Click the Colorize option and change the Saturation value to 45 percent, as shown in Figure 3.8. The higher the Saturation value, the more brown is introduced into the image.

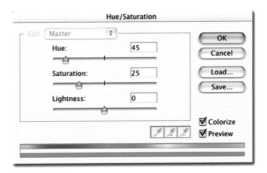

Figure 3.8: *The Hue/Saturation adjustment colorizes the image based on the selected foreground color.*

17. Click the OK button to apply the Hue/Saturation to the image.
18. Select Edit and choose Free Transform from the pull-down menu. Grab the top-middle handle and drag about halfway down. This compresses the image, creating a more realistic wood grain, as shown in Figure 3.9.

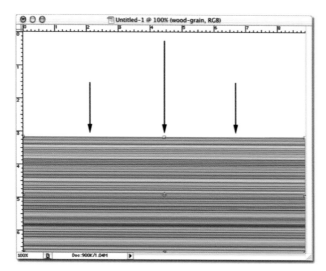

Figure 3.9: *Horizontally compress the digital image using Free Transform.*

19. Press Enter to apply the Free Transformation to the wood-grain layer.
20. Use the Crop tool to crop the document window to fit the size of the wood-grain image.

What you have created at this stage of the workshop is a generic wood grain. Save the project with the name wood-grain.psd before continuing.

WORKSHOP 2 – CHANGING THE GRAIN IN THE WOOD

In the previous workshop, you created a generic wood grain. However, in the real world, wood grains are not simply straight lines, they bend and curve. In this workshop, you will add a bit of realism to the wood by bending the grain.

1. Open the file named woodgrain.psd (saved from the previous workshop), or open the file from the Chapter 3 folder on the companion Website.
2. Create a copy of the wood-grain layer by dragging it over the New icon located at the bottom of the Layers palette.
3. Select the layer named wood-grain copy.
4. Click the Blending mode button and select Multiply from the available blending options. This will darken the wood grain, as shown in Figure 3.10.

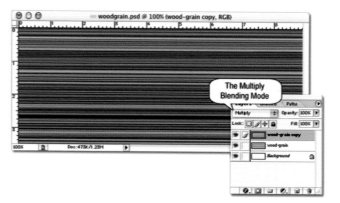

Figure 3.10: *The blending mode option, Multiply, darkens the visible image.*

5. Press CTRL + E (CMD + E: Macintosh). This is the shortcut for merging the selected layer with the layer directly underneath. You now have two layers in the Layers palette: wood-grain and Background. Keep the layer named wood-grain selected.

6. Select the Rectangular Marquee tool and draw a selection marquee enclosing the horizontal width of the wood-grain document and approximately 25 percent vertically.

7. Choose Select and choose Feather from the pull-down menu.

8. Enter a Feather Radius of 5 pixels and click the OK button to apply the feather to the rectangular selection, as shown in Figure 3.11.

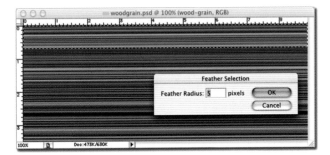

Figure 3.11: *The Feather command softens the visible edge of the selection marquee.*

9. Select Filter – Distort, and choose Twirl from the fly-out menu.

10. Choose an Angle of 100 and click OK to apply the twirl effect to the selected area of the wood grain, as shown in Figure 3.12.

11. Create another rectangular selection marquee with a 5-pixel feather. This time select about half the width of the document window with the same vertical height, as shown in Figure 3.13.

12. Press CTRL + F (CMD + F: Macintosh) to reapply the Twirl Filter to the selected area.

13. Move the selection to the far left, and then reapply the Twirl filter. Continue down the image until the Twirl filter is applied to the entire image. Figure 3.14 illustrates one pattern for selecting and applying the Twirl filter. Use your imagination to create different selection patterns.

14. Press CTRL + D (CMD + D: Macintosh) to deselect the rectangular marquee.

15. Save the file with the name woodgrain2.psd.

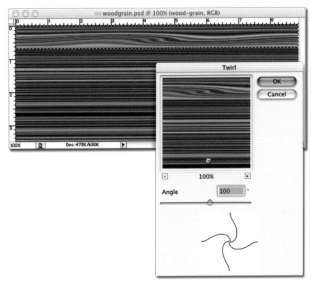

Figure 3.12: *Use the Twirl filter to add variety to the wood layer.*

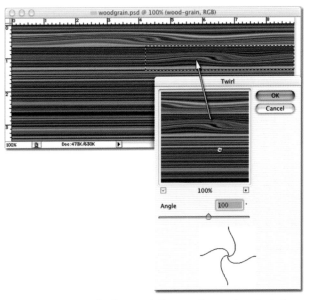

Figure 3.13: *Apply the Twirl filter to the newly selected area.*

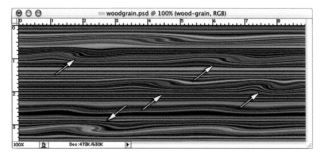

Figure 3.14: *The Twirl filter applied to random areas of the wood layer.*

WORKSHOP 3 – ADDING A FEW KNOTHOLES

If you followed workshops 1 and 2, you created a wood grain pattern and added a few twists and twirls to the grain. In this workshop, you'll further increase the realism by adding a few imperfections, in the form of knotholes.

1. Open the file named woodgrain2.psd (saved from the previous workshop), or open the file from the Chapter 3 folder on the companion Website.
2. Select the Elliptical Marquee tool and draw an elongated oval in the upper-left area of the image, as shown in Figure 3.15.

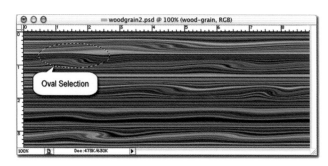

Figure 3.15: *The Elliptical Marquee defines a small oval selection.*

3. Choose Select and choose Feather from the pull-down menu.
4. Enter a Feather Radius of 3 pixels and click the OK button to apply the feather to the elliptical selection.
5. Select Filter – Distort, and choose Twirl from the fly-out menu.
6. Choose an angle of 150 and click the OK button to apply the Twirl to the selected area, as shown in Figure 3.16.

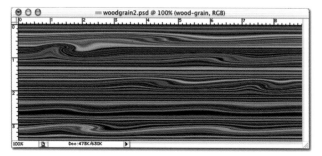

Figure 3.16: *The Twirl filter is used to create a knothole.*

7. Add two or three more knotholes to the document by using the Elliptical Marquee tool to select various size ovals, and use different angles for the Twirl filter, as shown in Figure 3.17.

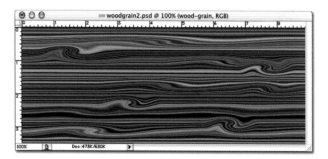

Figure 3.17: *Various knotholes added to the image, using the Twirl filter.*

8. Select Filter – Render, and choose Lighting Effects from the fly-out menu. In this example, choose a Texture Channel of Red and change the Height value to 20 percent, as shown in Figure 3.18. The Lighting Effects filter helps to add a dimensional aspect.

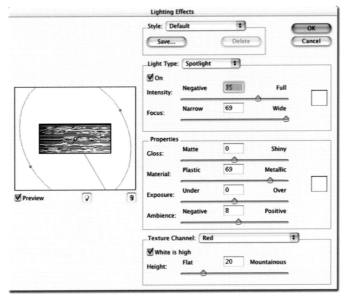

Figure 3.18: *Use the Lighting Effects filter to add depth to the image.*

9. Click the OK button to apply the lighting filter to the image, as shown in Figure 3.19.
10. Save the file using the name woodgrain3.psd.

Figure 3.19: *The Lighting Effects filter applied to the image.*

WORKSHOP 4 – CREATING ANOTHER WOOD TEXTURE

Here's a quick method for generating a rich wood texture. Open Photoshop and follow these steps:

1. Select File, choose New from the pull-down menu, and create a document using the parameters shown in Figure 3.20.

Figure 3.20: *The New dialog box defines the parameters for this workshop.*

2. Create a new layer by going to the Layers palette and clicking the New Layer icon located at the bottom of the palette. Name the new layer wood and keep the layer selected.

3. Press the letter D on your keyboard to reset the foreground and background colors to their defaults of black and white, respectively.

4. Press CTRL + Backspace (CMD + Delete: Macintosh). This is the shortcut to fill the wood layer with the background color (white).

5. Select Filter – Texture, and choose Craquelure from the fly-out menu. Choose a Crack Spacing of 15, a Crack Depth of 6, and a Crack Brightness of 8. Click the OK button to apply the Craquelure filter to the wood layer, as shown in Figure 3.21.

Figure 3.21: *The Craquelure filter adjusts the white pixels in the wood layer.*

6. Select Image – Adjustments, and choose Levels from the fly-out menu. Move the black input slider to the right to darken the gray areas of the image, as shown in Figure 3.22. Click the OK button to apply the Levels adjustment to the wood layer.

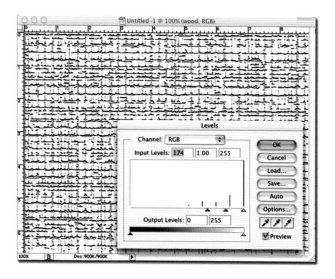

Figure 3.22: *The Levels adjustment darkens the gray pixels in the image.*

7. Select Filter – Blur, and choose Motion Blur from the fly-out menu. Choose an Angle of 0 and a distance of 25. Click the OK button to apply the Motion Blur filter to the wood layer, as shown in Figure 3.23.

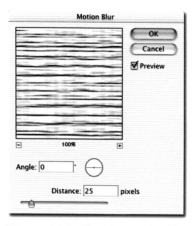

Figure 3.23: *The Motion Blur filter creates a soft effect on the wood layer.*

8. Go to the Channels palette and make a copy of the Blue channel by clicking and dragging the Blue channel over the New Channel icon, as shown in Figure 3.24.

Figure 3.24: *By dragging the Blue channel over the New Channel icon, you can create a copy of the channel named Blue copy.*

9. Return to the layers palette and fill the wood layer with a brown color selected form the bottom row of the default layers palette. You will be filling the layer you just created with brown, but the whole purpose of that layer was to make a channel, so you won't need it anymore.

10. Select Filter – Render, and choose Lighting Effects from the fly-out menu. Use the parameters displayed in Figure 3.25, or experiment until you see something you like.

11. Save the file as a Photoshop document using the name wood.psd.

In this example, the wood layer resembles wicker. By experimenting with the Craquelure, and Motion Blur filters, you can create different wood textures. You're not limited to wood textures; with a little practice, and the right filters and adjustments, you can create metals such as brushed aluminum and polished chrome, you can even emulate rocks, gravel, and stucco wall paneling. The limits on what you create are only bounded by your knowledge of Photoshop and what it is capable of doing.

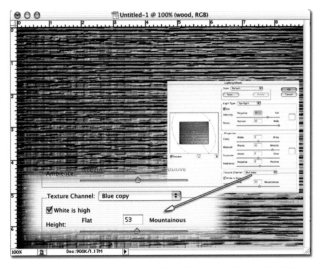

Figure 3.25: *The Lighting Effect filter completes the illusion of wood grain.*

WORKSHOP 5 – CREATING WOODEN TEXT

Wood textures can be used for many applications. In this example, the wood texture created in the previous workshop is used to create some wooden text.

1. Open the file named woodgrain3.psd (saved from the previous workshop), or open the file from the Chapter 3 folder on the companion Website.

2. Create a copy of the wood-grain layer by dragging over the New layer icon. Make sure the wood-grain copy layer is selected.

3. Select the Horizontal Type Mask tool, and create a type mask. In this example, the word "WOOD" was typed using the Papyrus font at 200 points, as shown in Figure 3.26.

Figure 3.26: *The Horizontal Type Mask tool creates a selection based on the size and shape of the selected font.*

4. Choose Select – Modify, and choose Expand from the fly-out menu. Expand by 6 pixels, and click the OK button to apply the changes to the type mask.
5. Create a layer mask to the wood-grain copy layer by clicking the Add Layer Mask icon at the bottom of the Layers palette. To view the wood type, turn off the original wood-grain layer, as shown in Figure 3.27.

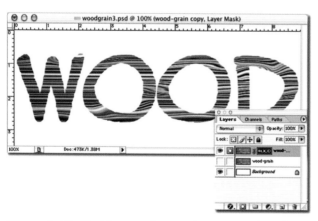

Figure 3.27: *The Type mask created text using the information in the wood layer.*

6. Add a layer style to the wood-grain copy layer by clicking the Add Layer Style button at the bottom of the Layers palette. In this example, a Chisel Soft, Inner Bevel, and Drop Shadow were added to the type, as shown in Figure 3.28.

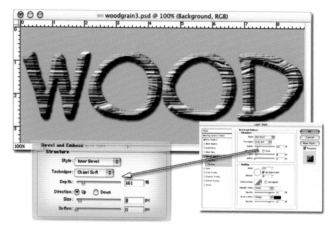

Figure 3.28: *The Chisel Soft, Inner Bevel, and Drop Shadow complete the effect of wood text.*

Once you get the basic wood-grain image the way you want it, you can save it and use it for anything from background tiles to text. You could even apply the image to a drawn shape. A layer mask was used to help control the creative process in this workshop. Remember, layer masks do not change the layer; they only change what you see. In the previous example, the text is shaped by the layer mask. To return the layer to its original form, simply click and drag the layer mask to the trash.

Control is what it's all about...the more you know, the more you control.

WORKSHOP 6 – CREATING A BRUSHED METAL PLATE

Metallic surfaces, like wood grains, are created using a combination of filters and adjustments. Once created, they can be used to generate a metallic plate, complete with bolts, or the illusion of words stamped directly into the metal. In addition, the resolutions and dimensions used in this workshop are only a starting point for the creative process; so feel free to experiment with different filters, colors, and adjustments. Experimentation combined with knowledge are the keys to success in Photoshop. So, with that in mind, let's get started.

To create a basic metallic surface, open Photoshop and perform the following steps:

1. Select File, choose New from the pull-down menu, and create a document, using the parameters shown in Figure 3.29.

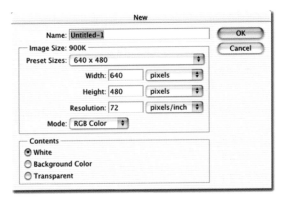

Figure 3.29: *The New dialog box defines the parameters for this workshop.*

2. Create a new layer by going to the Layers palette and clicking the New Layer icon located at the bottom of the palette. Name the new layer metal, and keep the metal layer selected.
3. Press the letter D on your keyboard to change the foreground and background colors to black and white, respectively.
4. Press CTRL + Backspace (CMD + Delete: Macintosh) to fill the metal layer with the background color (white).
5. Select Filter – Render, and choose Lighting Effects from the fly-out menu. The object is to set up three or four lights at different locations, to give the effect of reflections on the surface of the metal. The process of placing the spotlights on the image is purely subjective; different light placement produces different results. In this example, three spotlights were randomly arranged, as shown in Figure 3.30.

Figure 3.30: *Set up three or four spotlights using the Lighting Effects filter.*

6. Click the OK button to apply the Lighting Effects filter to the image.
7. Click the Add New Layer icon to add a new layer directly above the layer you applied the Lighting Effects filter to, and rename the layer noise, as shown in Figure 3.31.

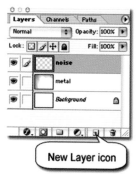

New Layer icon

Figure 3.31: *The New Layer icon creates a new layer directly above the selected layer.*

8. Press CTRL + Backspace (CMD + Delete: Macintosh) to fill the noise layer with the background color (white).
9. Select Filter – Noise, and choose Add Noise from the fly-out menu.
10. Choose an Amount of 120, Uniform Distribution, and select the Monochromatic option, as shown in Figure 3.32.
11. Click the OK button to apply the Noise filter to the noise layer.
12. Select Filter – Blur, and choose Motion Blur from the fly-out menu.
13. Choose an Angle of 0 and a distance of 50 pixels, as shown in Figure 3.33.
14. Click the Blending Mode button, and change the blending mode of the noise layer to Overlay, as shown in Figure 3.34.
15. Select Image – Adjustments, and choose Levels from the fly-out menu.
16. Move the black and white input sliders toward the middle to change the brightness and contrast of the image. Stop adjusting when you like what you see, as shown in Figure 3.35.

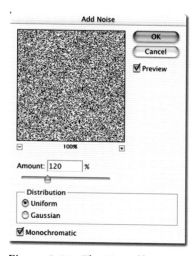

Figure 3.32: *The Noise filter generates random noise in the noise layer.*

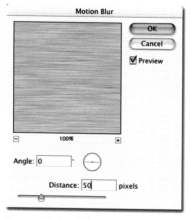

Figure 3.33: *The Motion Blur filter softens the effects generated by the Noise filter.*

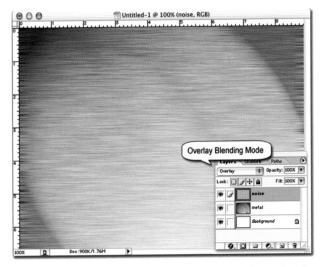

Figure 3.34: *The Overlay blending mode combines the elements of the noise layer with the metal layer.*

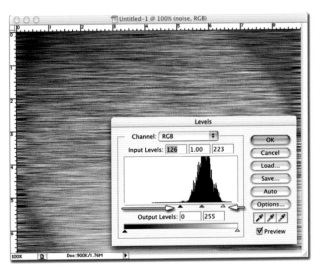

Figure 3.35: *The Levels adjustment bumps the brightness and contrast of the noise layer.*

17. Click the OK button to apply the Levels adjustment to the noise layer.
18. Select the Crop tool and crop the far left and right areas of the image, where the Motion Blur filter did not take full effect.
19. Select the noise layer, and press CTRL + E (CMD + E: Macintosh) to merge the noise layer with the metal layer.
 Save the image as a Photoshop document with the name metal.psd.

WORKSHOP 7 – CREATING AND SAVING A DIAMOND METAL PATTERN

In this example, you will create a diamond metal plate from scratch. This metal surface is great for creating an industrial look and feel to a graphic image. To create a diamond effect, open Photoshop and perform these steps:

1. Select File, choose New from the pull-down menu, and create a document using the parameters shown in Figure 3.36.

Figure 3.36: *The New dialog box defines the parameters for this workshop.*

2. Create a new layer by going to the Layers palette and clicking the New Layer icon located at the bottom of the palette. Name the new layer diamond, and keep the diamond layer selected.

3. Select the Rectangular Marquee tool and draw a small square about 72 pixels (Hint: Hold the Shift key down when you're drawing the square; this constrains the tool to draw a perfect square).

4. Make sure your foreground color is black, and then fill the selected area with black by pressing ALT + Backspace (Option + Delete: Macintosh).

5. Select Edit and choose Free Transform from the pull-down menu. Photoshop will place a bounding box with handles around the black square.

6. Move your cursor outside the bounding box (it should resemble a curved arrow), and drag down while holding the Shift key. The Shift key constrains the rotation to certain angles. Stop when the box is at a 45-degree angle. Press the Enter key to set the transformation, as shown in Figure 3.37.

Figure 3.37: *The Free Transform command lets you rotate the selected pixels.*

7. Select Edit – Transform, and choose Scale from the fly-out menu. Photoshop will place a bounding box with handles around the black square.

8. Select the middle-right handle (your cursor will resemble a horizontal double arrow), and drag to the left until you have a compressed diamond shape. Press the Enter key to apply the Scale transformation to the square, as shown in Figure 3.38.

Figure 3.38: *The Scale command lets you adjust the horizontal width of the selected pixels.*

9. Press CTRL + D (CMD + D: Macintosh) to deselect the diamond shape.

10. Select the Move tool and drag the black diamond shape to the right while holding down the Alt key (Option key: Macintosh). Holding down the Alt key instructs Photoshop to make a copy of the diamond layer. Keep the diamond copy layer selected.

11. Select Edit, and choose Free Transform from the pull-down menu. Rotate the diamond copy 90 degrees. Press the Enter key to set the Scale Transformation.

12. Use the Move tool to place the diamond copy to the right of the original diamond layer, as shown in Figure 3.39.

Figure 3.39: *Move the diamond copy up and to the right of the original diamond layer.*

13. Select the diamond copy layer and press CTRL + E (CMD + E: Macintosh) to merge the two layers into one layer named diamond.
14. Select Edit, and choose Free Transform from the pull-down menu.
15. Rotate the two diamond shapes 45 degrees counterclockwise. Press the Enter key to apply the rotation to the image, as shown in Figure 3.40.

Figure 3.40: *Use the Free Transform tool to rotate the diamond shapes 45 degrees.*

16. Select Edit, and choose Free Transform one more time from the pull-down menu.
17. Select any corner handle, and drag inward while holding down the Shift key. Stop when the diamond shapes are approximately half their original size. Press the Enter key to apply the size change to the image.
18. Select the Rectangular Marquee tool and draw a perfect square (remember to hold the Shift key), enclosing the two diamond shapes.
19. Select Edit, and choose Define Pattern from the pull-down menu. Name the pattern diamond, and click the OK button to save the pattern, as shown in Figure 3.41.
20. Save the file as a Photoshop document with the name diamond.psd (although you already saved the pattern, you might want to come back and modify the original).

Figure 3.41: *The Define Pattern dialog box, to name and save the diamond pattern.*

WORKSHOP 8 – APPLYING THE DIAMOND METAL PATTERN

In the previous session, you created and saved a pattern named diamond. Now that you have the pattern, it can be applied to almost any document. For this example, you will create a diamond pattern in a new document. To create a diamond pattern metal surface, open Photoshop and perform these steps:

1. Select File, choose New from the pull-down menu, and create a document using the parameters shown in Figure 3.42.

Figure 3.42: *The New dialog box defines the parameters for this workshop.*

2. Select Edit, and choose Fill from the pull-down menu. Select Pattern from the Use pop-up menu, and choose the diamond pattern from the available Custom Patterns.
3. Select Normal from the Blending Mode options, with an Opacity of 100 percent. Click the OK button to apply the fill to the new document, as shown in Figure 3.43.
4. Select Filter – Stylize, and choose Emboss from the fly-out menu. Choose an angle of 90 degrees, 2 pixels in height, and an amount of 100 percent. Click the OK button to apply the Emboss filter to the image, as shown in Figure 3.44.
5. Rename the Background layer diamonds (double-click the layer name).

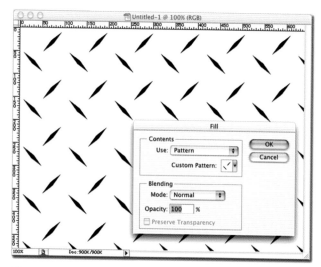

Figure 3.43: *Use the Fill command to fill the layer with the diamond pattern.*

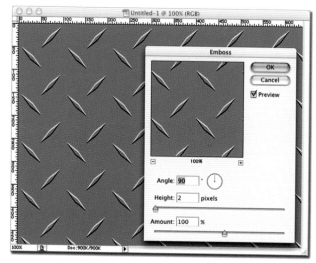

Figure 3.44: *The Emboss filter creates the illusion of embossing, using the black and white in the original layer.*

6. Select the Magic Wand tool, and click once in the solid gray area of the image (use the default settings for the Magic Wand).
7. Press CTRL + J (CMD + J: Macintosh). This creates a second layer containing the selected areas of the diamond layer. Rename this copied layer metal-plate.
8. Select the Lock Transparent Pixels option for the metal-plate layer, as shown in Figure 3.45.

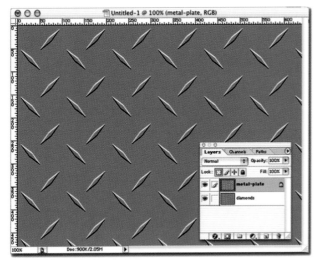

Figure 3.45: *The Lock Transparent Pixels option prevents the transparent areas of the selected layer from being modified.*

9. Select Filter – Noise, and choose Add Noise from the fly-out menu. Choose an Amount of 25 percent, Gaussian Distribution, and select the Monochromatic option. Click OK to apply the Add Noise filter to the metal-plate layer, as shown in Figure 3.46.
10. Click the Blending Mode option for the metal-plate layer, and choose Multiply from the available options.
11. Select Filter – Noise, and choose Motion Blur from the fly-out menu. Choose an angle of 90 degrees and 5 pixels for Distance. Click the OK button to apply the Motion Blur to the metal-plate layer, as shown in Figure 3.47.
12. Save the image as a Photoshop document, using the name metalplate.psd.

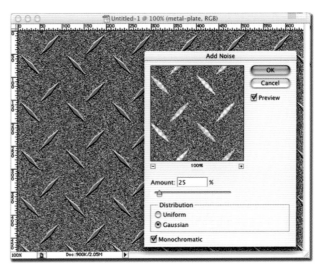

Figure 3.46: *The Add Noise filter applied to the metal layer.*

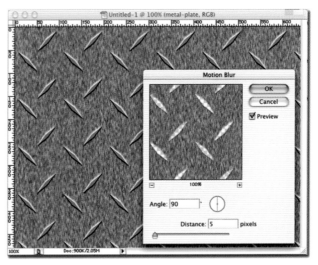

Figure 3.47: *The Motion Blur filter softens the effects of the Add Noise filter.*

WORKSHOP 9 – CREATING METAL SCREWS

Next, let's create some metal screws that can be used to secure our metal plates. To create metal screws, open Photoshop and perform these steps:

1. Select File, choose New from the pull-down menu, and create a document using the parameters shown in Figure 3.48.

Figure 3.48: *The New dialog box defines the parameters for this workshop.*

2. Create a new layer by going to the Layers palette and clicking the New Layer icon located at the bottom of the palette. Name the new layer screw and keep the screw layer selected.
3. Select the Elliptical Marquee tool, and draw a perfect circle by holding down the Shift key as you drag the mouse. In this example, draw a circle approximately half an inch (36 pixels) in diameter.
4. Choose a medium gray from the Swatches palette and fill the circle, as shown in Figure 3.49.

Figure 3.49: *Select Alt + Backspace (Option + Delete: Macintosh) to fill the selected circle with the medium-gray color.*

5. Select Filter – Noise, and choose Add Noise from the fly-out menu. Choose an Amount of 20 percent, Distribution of Uniform, and select the Monochromatic option. Click OK to apply the Noise filter to the selected area of the screw layer.
6. Select Filter – Blur, and choose Motion Blur from the fly-out menu. Choose an Angle of 45 degrees with a Distance of 5 pixels. Click the OK button to apply the Motion Blur filter.
7. Press CTRL + D (CMD + D: Macintosh) to deselect the circle (remove the marching ants marquee).
8. Select the Add a layer style icon, located at the bottom of the Layers palette, and add a Bevel and Emboss style using the options indicated in Figure 3.50.
9. Select the Rectangular Marquee tool and draw a small rectangle on the surface of the screw-head. This will be the slot for the screwdriver, as shown in Figure 3.51.
10. Press CTRL + J (CMD + J: Macintosh) to make a copy of the selected portion of the screw-head layer. Change the name of the layer to slot.

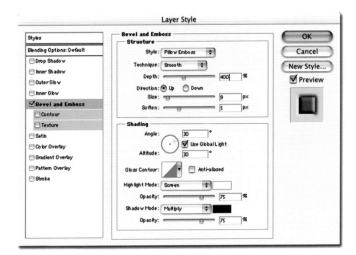

Figure 3.50: *The Bevel and Emboss options control the visual application of the filter to the image.*

Figure 3.51: *The Rectangular selection tool defines the width of the screw slot.*

11. Select the Add a layer style icon, located at the bottom of the Layers palette, and add a Bevel and Emboss style using the options indicated in Figure 3.52.

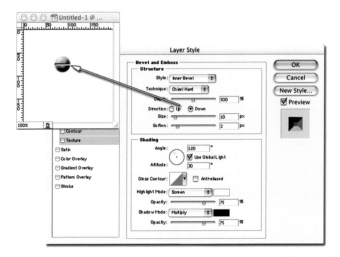

Figure 3.52: *The Bevel and Emboss options control the visual application of the filter to the image.*

12. Click the Linking icon to link the screw and slot layers.
13. Now create a new Layer Set by clicking the options button, located in the upper-right corner of the Layers palette (Layer Sets let you organize one or more layers into a single group). Select New Set from Linked options, name the new Layer Set screwhead, and click the OK button.

Note: Placing the two separate parts of the screw in a set makes it easier to move the screw head into a new file, and you still have the added benefit of being able to control the position of the slot.

14. Save the file as a Photoshop document named screwhead.psd.

WORKSHOP 10 – CREATING A METALLIC PLAQUE

Let's start putting some of our creations together and produce a metallic plaque. To create a metallic plaque, open Photoshop and perform these steps:

1. Select File, choose New from the pull-down menu, and create a document using the parameters shown in Figure 3.53. The dimensions of the document represent the size and shape of the plaque.

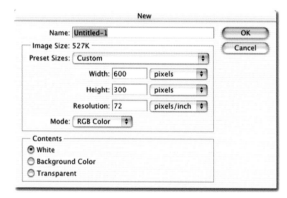

Figure 3.53: *The New dialog box defines the parameters of the project.*

2. Select File – Open, and open the metal.psd file created in Workshop 5.
3. Position the document files so you can see both of them at the same time. Now, select the metal.psd document, move into the Layers palette, and click and drag the metal layer into the new document, as shown in Figure 3.54.
4. Close the metal.psd file.
5. Use the Move tool to fill the document window with the metal layer. If the metal layer is too small, select Edit – Free Transform and use the bounding box handles to drag the layer to the proper size. Press the Enter key to apply the transformation to the metal layer.
6. Select the Rectangular Marquee tool and draw a box around the border, leaving a half-inch of space on all four sides, as shown in Figure 3.55.

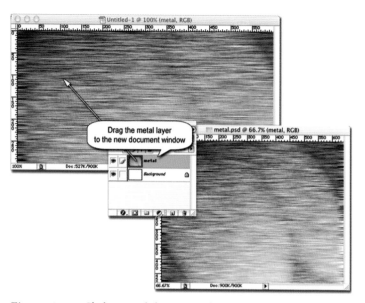

Figure 3.54: *Clicking and dragging a layer from one open document into another creates a copy of the layer in the moved document.*

Figure 3.55: *Use the Rectangular Marquee tool to create a selection marquee around the image.*

7. Press CTRL + J (CMD + J) to make a copy of the selected area of the metal layer in its own separate layer. Name the new layer plaque.

8. Select the Add a layer style icon located at the bottom of the Layers palette, and add a Bevel and Emboss style using the parameters in Figure 3.56.

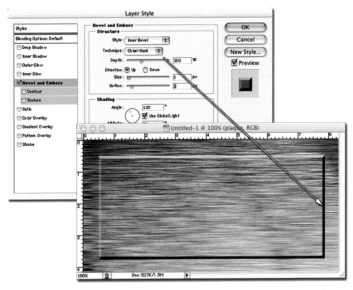

Figure 3.56: *The Bevel and Emboss options control the visual application of the filter to the image.*

9. Select the Rectangular Marquee tool and create a selection as in step 6. This time, leave only a quarter inch of space from the edge of the document window.

10. Choose Select, and choose Inverse to reverse the selected area.

11. Select the original metal layer, and press CTRL + J (CMD + J) to make a copy of the selected area of the metal layer in its own separate layer. Name the new layer border.

12. Copy the Bevel and Emboss effect to the border layer by clicking and dragging the Bevel and Emboss style from the plaque layer to the border layer, as shown in Figure 3.57.

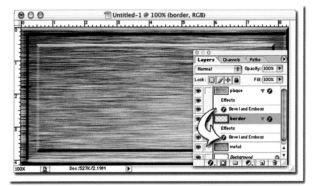

Figure 3.57: *Clicking and dragging a layer style from one layer to another creates an exact copy of the layer style.*

Note: If you find your Layers palette being clogged up with layers and their associated styles, just click the small gray triangle to collapse the styles into the associated layer. Click the triangle again to reopen the styles.

13. Select File – Open, and open the screwhead.psd file.

14. Select the topmost layer (plaque) in the new document, and then select the screwhead file. Click and drag the layer set (screwhead) containing the screw into the new document.

15. Use the Move tool to position the screwhead in the upper-left portion of the plaque.

Note: If the screwhead is too large, make sure the screwhead set is selected, and then use the Free Transform tool to resize the image.

16. Select the Move tool, and click and drag the screwhead while holding down the Alt key (Option key: Macintosh) to create a copy of the screw. Move the copy to the upper-right corner of the plaque. Repeat this process two more times, until you have a screw in all four corners of the plaque, as shown in Figure 3.58.

Figure 3.58: *Place copies of the screwhead set in all four corners of the plaque layer.*

17. Make the plaque layer the active layer.
18. Select the Horizontal Type Mask tool and create some text for our plaque. Almost any font will do; however, large sans serif fonts work best. In this example, I used the Impact font.

 Note: If the text needs to be modified, open the Characters palette (Window – Show Character), and use the Horizontal and Vertical scale options.

19. Press CTRL + J (CMD + J), and make a copy of the selected area of the plaque layer. Name the new layer text.
20. The text layer now contains the same layer style as the plaque layer. Double-click the Bevel and Emboss layer style associated with the text layer, and experiment with the options. In particular, try selecting the Up and Down buttons, and observe what it does to the visual perception of the text, as shown in Figure 3.59.
21. Save the document as a Photoshop file with the name plaque.psd.

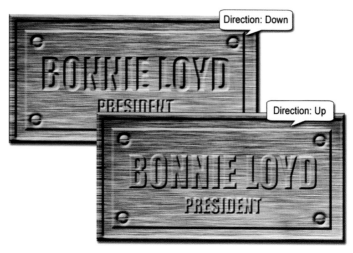

Figure 3.59: *The Bevel and Emboss options create the illusion of beveled text on a metal surface.*

WORKSHOP 11 – PAYING ATTENTION TO THE DETAILS

In the previous workshop, we created a metallic plaque. The three-dimensional aspects were created using the Layer style options. Layer styles have been available in Photoshop since version 5.0; however, as fantastic as layer styles are, they won't do everything.

For example, open the project created in Workshop 9 (plaque.psd); notice how the bevel effect seems to blend into the surrounding metal layer, as shown in Figure 3.60.

What is needed is a more definable edge for the separate layers. To correct this problem, open the plaque.psd image in Photoshop and perform these steps (if you followed the steps in Workshop 9, and named the layers accordingly, the following steps will be easier to follow).

Figure 3.60: *The edges of the bevels are difficult to see.*

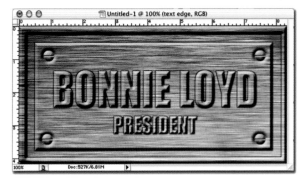

Figure 3.61: *The Blur More filter softens the hard line separating the layers and creates a definable edge for the bevel effect.*

1. Create a new layer directly under the layer named border. Name the layer border-edge.
2. Hold down the CTRL key (CMD key: Macintosh), and click the layer named border. This nifty shortcut creates a selection based on the information in the border layer.
3. Choose Select – Modify, and choose Expand from the fly-out menu. Expand the image by 1 pixel, and click the OK button to apply the change to the selection marquee.
4. Press the letter D on your keyboard to switch the foreground and background swatches to their defaults of black and white.
5. Select the newly created border-edge layer.
6. Press Alt + Backspace (Option + Delete: Macintosh) to fill the selected area with black.
7. Press CTRL + D (CMD + D: Macintosh) to remove the marching ants marquee.
8. Choose Filter – Blur, and select Blur More from the fly-out menu. Press CTRL + F (CMD + F: Macintosh) to reapply the Blur More filter, as shown in Figure 3.61.

Notice how the underlying layer (border-edge) creates a visual line between the layers that helps to define the bevel. Using this same technique create a new layer underneath the plaque and even the text layer, then perform steps 2 thru 8, to create edge layers. The edge layers give definition to the layer effects.

It's the difference between clicking buttons and moving to the next step, and spending the time to make your image the best it can be.

CHAPTER 4

CREATING BRICK AND ROCK TILE PATTERNS

PATTERNS, UNLIKE TEXTURES, ARE REPEATING ELEMENTS OF A SINGLE DESIGN. CREATING A SINGLE CERAMIC TILE OR BRICK AND THEN COPYING THE ELEMENT REPEATEDLY TO FILL A FLOOR OR WALL ARE BOTH EXAMPLES OF PATTERNS. IN ADDITION TO BRICKS AND TILES, PATTERNS CAN BE IMAGES (SUCH AS A COMPANY LOGO) OR JUST SIMPLY A REPEATED PATTERN OF WORDS IN THE BACKGROUND.

PATTERNS ARE TYPICALLY USED AS A FOUNDATION FOR SOMETHING ELSE, SUCH AS THE BACKGROUND OF A WEB PAGE THAT HOLDS IMAGES AND TEXT. REMEMBER, HOWEVER, THAT A BACKGROUND TILE PATTERN IS JUST THAT... A BACKGROUND. IT IS NOT THE MAIN DESIGN ELEMENT OF THE DOCUMENT. IF YOUR BACKGROUNDS ARE SO DRAMATIC THAT THEY DISTRACT FROM THE REST OF THE DOCUMENT, THEY ARE HURTING YOUR DESIGN, NOT HELPING IT.

IN ADDITION, IF YOU PLACE TEXT OVER A BUSY BACKGROUND, IT MAKES IT DIFFICULT FOR YOUR VIEWERS TO ACTUALLY READ THE TEXT. DO NOT CREATE DESIGN ELEMENTS, SUCH AS PATTERNS, UNLESS THEY SUPPORT THE OVERALL MESSAGE OF THE DOCUMENT.

WORKSHOP 1 – CREATING A DIAMOND TILE PATTERN

Let's begin by creating a diamond-tile pattern from scratch. To create this pattern, open Photoshop and perform these steps:

1. Create a new document based on the parameters in Figure 4.1.

Figure 4.1: *The New File dialog box defines the parameters for the workshop.*

2. Create a new layer in the Layers palette by clicking the Create a new layer icon. Name the new layer tile. Leave the tile layer selected.
3. Choose a color for your tile by clicking on a color swatch in the Swatches palette and pressing Alt + Backspace (Option + Delete: Macintosh) to fill the tile layer with the color. In this example, I chose a light cyan color, as shown in Figure 4.2.
4. Select Filter – Noise, and choose Add noise from the fly-out menu. The amount of noise depends on the color of the tile, the resolution of the image, and personal preference. In this example, I chose an Amount of 8 along with a Distribution of Gaussian. In addition, I deselected the Monochromatic option, as shown in Figure 4.3.
5. Create a new layer in the Layers palette directly above the tile layer. Name the new layer grout. Leave the grout layer selected.
6. Choose a color for the grout by clicking on a color swatch in the Swatches palette. Tile grout is not pure white, so choose a light gray. In this example, I selected the 10 percent gray color swatch.

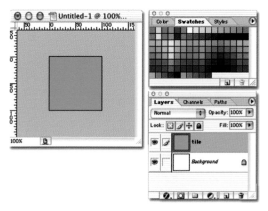

Figure 4.2: *Select a tile color from the Swatches palette.*

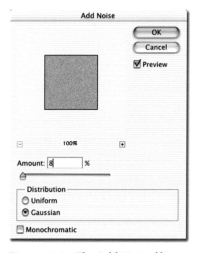

Figure 4.3: *The Add Noise filter generates random noise in the tile layer.*

7. Select a solid, round brush from the Brushes palette, and select a brush size for the grout. The brush size is determined by the resolution of the image. In my example, the image has a resolution of 72 ppi, so a 5-pixel brush creates a nice, clean grout. For more information on creating a brush in Photoshop 7, refer to Chapter 2, "What's New in Photoshop 7."

8. Place the brush cursor in the upper-left corner of the grout, then click and release your mouse (make sure the brush is snug in the corner when you click). Move down to the lower-right corner (remember you're not dragging the mouse), then hold the Shift key, and click and release your mouse. Holding down the Shift key is a neat trick for drawing a straight line between two points.

9. Repeat the previous step by going to the upper-right corner, clicking once, and shift-clicking in the lower-left corner, as shown in Figure 4.4.

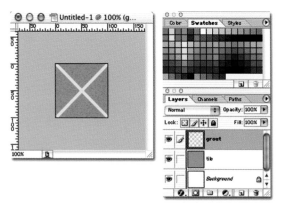

Figure 4.4: *Holding down the Shift key lets you create a straight brush stroke between two points.*

10. Click the Add a layer style icon at the bottom of the Layers palette. Select Inner Shadow. The Inner Shadow layer style will create the visual illusion of the grout being lower than the tile. Because the tiles are at a 45-degree angle, chose an angle other than 45, -45, 135, or -135. In this example, I chose an angle of 110 degrees along with a distance of 3, as shown in Figure 4.5.

Figure 4.5: *The Inner Shadow layer style creates an illusion of depth.*

11. Move into the Layers palette and click once on the tile layer. This makes the tile layer the active layer.

12. Hold the CTRL key (CMD key: Macintosh) and click once on the grout layer. This creates a selection based on the gray pixels defining the grout. The tile layer is still selected.

13. Press the Backspace key (Delete key: Macintosh) to remove those portions of the tile image covered by the grout. Press CTRL + D (CMD + D: Macintosh) to deselect the marching-ant marquee.

14. Click the Add a layer style icon, and select Bevel and Emboss from the available style options. Apply a Smooth, Inner Bevel to the tile layer, as shown in Figure 4.6.

Figure 4.6: *The Bevel and Emboss filter creates a three-dimensional tile effect.*

15. Click the Layers palette options button (the black triangle in the upper-right corner of the Layers palette), and select Flatten image from the available options. You might wish to save the layered document before flattening, just in case you want to tweak some of the layer effect.

16. Select Image, and choose Canvas Size from the pull-down menu. Change the Width and Height options to 90 pixels. This will crop off the unwanted Bevel and Emboss effect that was applied to the edges of the image. Click the OK button. When Photoshop warns you that the canvas size is smaller than the current canvas, click the Proceed button. The Canvas size option successfully removes the outer beveled edge, as shown in Figure 4.7.

Figure 4.7: *Reducing the Canvas size eliminates the bevel from the edges of the tile.*

17. Select Filter – Other, and select Offset from the fly-out menu. Use 45 pixels in the Horizontal and Vertical input fields (45 pixels is half the size of our tile document). Notice how the center of the tile displays a seam, as shown in Figure 4.8.

18. Click the OK button to apply the offset to the image.

19. Select the Blur tool and, using a small brush, gently blur the seam until it disappears into the tile, as shown in Figure 4.9 (this will take a bit of practice).

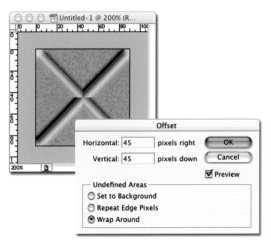

Figure 4.8: *The Offset filter helps identify possible problems in the tile.*

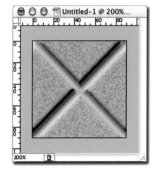

Figure 4.9: *Use the Blur tool to visually blend the pieces of the tile.*

20. Save the tile in the TIFF using the name d_tile.tif (the d is short for diamond).

21. Select Edit, and choose Define Pattern from the pull-down menu. Name the pattern d-tile and click the OK button to save the pattern.

22. To check the pattern, create a new document, select Edit, and choose Fill to fill the document area with the d_tile pattern, as shown in Figure 4.10.

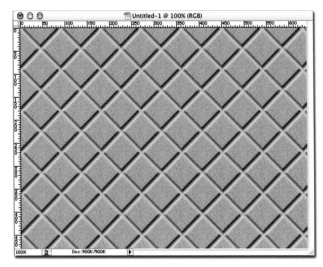

Figure 4.10: *Check the pattern by opening a new document and filling it with the newly created pattern.*

If you see any problems with the tile effect, reopen the d_tile.tif file and correct the problems. Don't forget to use the Offset filter to check the pattern. With a bit of practice, you'll wind up with a perfect diamond tile pattern.

WORKSHOP 2 – DESIGNING A STRAIGHT CERAMIC TILE

In the previous workshop, you created a diamond-tile pattern within a square area and then used that pattern to fill a document window. In this workshop, you will draw on what you learned in the first workshop and create a straight (as opposed to diagonal) ceramic tile. To spice up the tile, you'll add a gloss with the Plastic Wrap filter and you'll add a design. To create the tile, open Photoshop and perform these steps:

1. Create a new document based on the parameters in Figure 4.11.

Figure 4.11: *The New File dialog box defines the parameters for the workshop.*

2. Create a new layer in the Layers palette by clicking the Create a new layer icon. Name the new layer tile. Leave the tile layer selected.

3. Choose a color for your tile by clicking on a color swatch in the Swatches palette, and pressing Alt + Backspace (Option + Delete: Macintosh) to fill the tile layer with the color. In this example, I chose a light pastel yellow color, as shown in Figure 4.12.

Figure 4.12: *Select a color swatch from the Swatches palette.*

4. Select Filter – Noise, and choose Add noise from the fly-out menu. The amount of noise depends on the color of the tile, the resolution of the image, and your own personal preference. In this example, I chose an Amount of 10 and a Distribution of Gaussian. In addition, I selected the Monochromatic option, as shown in Figure 4.13.

Figure 4.13: *The Add Noise filter adds random noise to the image.*

5. Create a copy of the tile layer by clicking and dragging the tile layer over the Add new layer icon, as shown in Figure 4.14. Leave the tile copy layer selected.

Figure 4.14: *Dragging a layer over the Add new layer icon creates a copy of the original layer.*

6. Select Filter – Artistic, and choose Plastic Wrap from the fly-out menu. In this example, the Highlight Strength, Detail, and Smoothness were set to 12, 11, and 6 respectively; however, the object is to make the surface appear reflective, so experiment until you see something similar to Figure 4.15.

7. Click the Blending Mode button for the tile copy layer, and choose the multiply option, as shown in Figure 4.16. (If you chose a darker color for the tile, you might try the Overlay or Screen blending modes.)

8. Press CTRL + E (CMD + E: Macintosh) to merge the tile copy layer with the tile layer. You now have two layers named Background and tile; leave the tile layer selected.

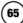

Figure 4.15: *The Plastic Wrap tool creates a reflective surface on the tile.*

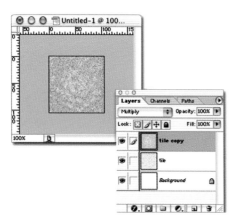

Figure 4.16: *The Multiply blending mode option mixes elements of the tile layer with the tile copy layer.*

9. Select the Move tool, and use the arrow keys to nudge the tile 5 pixels to the left and 5 pixels up (click the left and up arrow keys 5 times each), as shown in Figure 4.17.

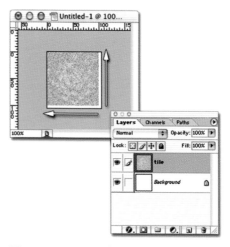

Figure 4.17: *Use the Arrow keys to nudge the tile up and to the left.*

10. Select the Magic Wand and, using the default wand settings, click once in the white area created by offsetting the tile. The entire white area (like a reverse letter L) is now selected.
11. Create a new layer directly below the tile layer, and name the layer grout. Leave the grout layer selected.
12. Press the letter D on your keyboard to change the default foreground and background color swatches to black and white; then press CTRL + Backspace (CMD + Delete: Macintosh) to fill the selected area with white. (In this workshop the grout is white.)
13. Press CTRL + D (CMD + D: Macintosh) to deselect the marching ant marquee.
14. Click the Add a layer style icon at the bottom of the Layers palette. Select Inner Shadow. The Inner Shadow layer style will create the visual illusion of the grout being lower than the tile. In this example, I used the default values for Inner Shadow, as shown in Figure 4.18.

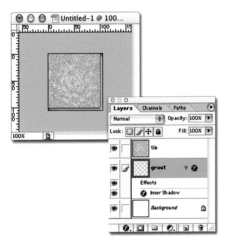

Figure 4.18: *The Inner Shadow creates the visual illusion of depth.*

15. Press CTRL + A (CMD + A: Macintosh) to select the entire image.

16. Select Image and choose Crop from the pull-down menu. Because you nudged the image up and to the left, that part of the tile is still present; you just can't see it because it's outside the viewable area of the document window. Applying the Crop command lets you delete the unneeded portions of the tile.

17. Press CTRL + D (CMD + D: Macintosh) to deselect the marching ant marquee.

18. Click the Add a layer style icon, and select Bevel and Emboss from the available style options. Apply a Smooth, Inner Bevel to the tile layer, as shown in Figure 4.19.

19. Click the Layers palette options button (the black triangle in the upper-right corner of the Layers palette), and select Flatten Image from the available options. You might wish to save the layered document before flattening, just in case you want to tweak some of the layer effects.

20. To check how the tiles blend, select Filter – Other, and choose Offset from the fly-out menu. Use 53 pixels in the Horizontal and Vertical input fields (53 pixels is half the size of our tile document). Notice how the center of the tile displays a seam, as shown in Figure 4.20.

Figure 4.19: *The Bevel and Emboss layer style applied to the tile layer.*

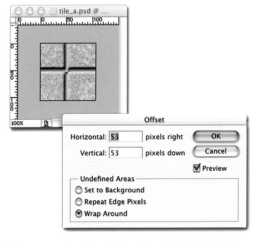

Figure 4.20: *The Offset filter help detects flaws in the tile pattern.*

21. Click the OK button to apply the Offset filter to the tile, and then use the Blur tool to soften the edge effect. When you have successfully softened the edge of the tile, press CTRL + F (CMD + F: Macintosh) to reapply the Offset filter and restore the tile.
22. Select Edit, and choose Define Pattern from the pull-down menu. Name the pattern s_tile (straight tile), and click the OK button to save the pattern.
23. Click the Add new layer icon, and create a new layer. Name the layer design.
24. Create a design for your tile. In this example, I used the symbol font named Adobe Wood Type to create the design, and I enhanced the effect with a Pillow Emboss layer style, as shown in Figure 4.21.

Figure 4.21: *The design applied to the tile.*

25. Click the Layers palette options button (the black triangle in the upper-right corner of the Layers palette), and select Flatten Image from the available options. You might wish to save the layered document before flattening, in case you want to tweak some of the layer effects.
26. Select Edit, and choose Define Pattern from the pull-down menu. Name the pattern s_tile2 and click the OK button to save the pattern.

Test the patterns out by opening a new document, selecting Edit, and choosing Fill from the pull-down menu. You now have two straight tile patterns: one plain and one with a distinctive pattern, as shown in Figure 4.22.

Figure 4.22: *The two completed patterns.*

WORKSHOP 3 – CREATING A BRICK WALL PATTERN

In the previous workshops you created two tile patterns and used those patterns to fill an area. Consistency is the key to a great pattern—The one thing that makes a tile pattern look like a pattern is that each tile looks the same.

In some instances that might be acceptable; but there are exceptions. For example, in the real world, bricks do not always look the same. To create a more realistic brick wall, you will create another pattern and then use that pattern to overlay the brick wall. Using patterns to overlay patterns will give you more control and flexibility, as you will soon see. To create the pattern you will use in the brick wall workshop, open Photoshop and perform these steps:

1. Select File – New, and create a new document based on the parameters in Figure 4.23.
2. Select Filter – Noise, and choose Add noise from the fly-out menu. In this example, I chose an Amount of 100 and a Distribution of Gaussian. In addition, I selected the Monochromatic option.

Figure 4.23: *The New File dialog box defines the parameters for the workshop.*

3. Select Filter – Artistic, and choose Poster Edges from the fly-out menu. Choose an Edge Thickness, Edge Intensity, and Posterization of 6, 6, 3, respectively, to get the overall effect shown in Figure 4.24.
4. Select Edit, and choose Define Pattern from the pull-down menu. Name the pattern pattern_a, and click the OK button to save the pattern.

Figure 4.24: *The Poster Edges filter applied to the image.*

The fun thing about patterns is that they can be virtually any combination of filters and effects. The trick to making patterns that will be used to overlay an image (in our case, a wall of bricks) is to use a filter or combination of filters that doesn't create a definable edge when the pattern is painted over the image (the edge of the pattern is a dead giveaway, even for an untrained eye).

If you're concerned that the pattern might generate a definable edge, select Filter – Other, and choose Offset from the fly-out menu. In the Horizontal and Vertical input fields, type in half the width and height of the image and view the results. If you see an edge (assuming you don't want to see the edge), cancel the Offset filter and work to eliminate the edge. Some techniques to use are Gaussian Blur, Motion Blur, and Noise.

WORKSHOP 4 – CREATING BRICKS

In this workshop, you will create a brick; however, bricks are not usually arranged like ceramic tiles (they're offset), so you will create one brick, and then use that brick to create a small, offset pattern. Then, you will use the pattern created in Workshop 3 to create bricks with a different appearance. To create the first brick in the wall, open Photoshop and perform these steps:

1. Select File – New, and create a new document based on the parameters in Figure 4.25.

Figure 4.25: *The New File dialog box defines the parameters for the workshop.*

2. Create a new layer, and name the layer bricks. Leave the bricks layer selected.
3. If Photoshop's ruler bars are not visible, select View and choose Rulers from the pull-down menu.
4. To define the shape and placement of the bricks, click in the ruler bar and drag vertical and horizontal guidelines into the document window. In our example, the bricks are 130 pixels wide by 30 pixels tall. In addition, there will be 10 pixels of space (the mortar for the bricks) between each brick. Create guidelines for three bricks, horizontally, as shown in Figure 4.26.

Figure 4.26: *Use guidelines to define the area of the bricks and the mortar.*

5. Select the Rectangular Marquee tool and, using the guides, create a rectangle the size and shape of the first brick.
6. Choose a red color swatch from the Swatches palette (bricks are usually red).
7. Press Alt + Backspace (Option + Delete) to fill the selected area with the red color. Press CTRL + D (CMD + D: Macintosh) to remove the selection marquee.
8. Select the Move tool, hold down the Alt key (Option key: Macintosh), and click and drag the brick you just created over and to the right. Holding the Alt/Option key instructs Photoshop to create a copy of the brick in a separate layer. Place the brick within the guidelines for the second brick (if you created accurate guidelines, it should fit perfectly).
9. Repeat the previous step and place a copy of the brick in the third space. You should now have three horizontal bricks, as shown in Figure 4.27.

Figure 4.27: *Three bricks aligned according to the guidelines.*

10. Go back to the ruler bar and create another set of guides directly below the first set. The bricks need to be offset, so start the guidelines from the center of the middle brick, as shown in Figure 4.28.

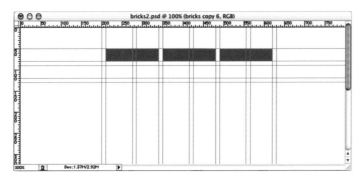

Figure 4.28: *Create a second set of brick guidelines underneath the first set.*

11. Select the Move tool, and repeat step 8 until the lower areas are filled with copies of the bricks, as shown in Figure 4.29.

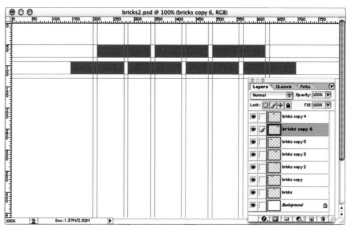

Figure 4.29: *Copy the bricks into the new areas defined by the guidelines.*

12. Move to the Layers palette and deselect the Background layer (you will see the tablecloth pattern appear in the document window).

13. Click the Layers options button, and select Merge Visible from the available options, as shown in Figure 4.30. Make sure you do not have the Background layer selected, or this command will not work.

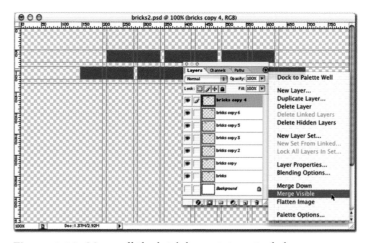

Figure 4.30: *Merge all the brick layers into a single layer.*

14. Select the Rectangular Marquee tool, and select the bricks, starting with the upper-left portion of the brick, down to the lower-right corner. Include the area reserved for the mortar on the bottom and right side of the brick pattern. Use the guidelines to assist you in the selection, as shown in Figure 4.31.

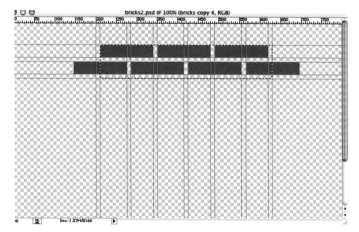

Figure 4.31: *Use the Rectangular Marquee tool to select the brick pattern.*

15. Select Edit, and choose Define Pattern from the pull-down menu. Name the new pattern bricks, and click the OK button to save the pattern.

Note: It is important that the Background layer is turned off before defining the pattern. If you leave the Background layer on, the areas defining the mortar will be filled with white.

16. Save the Photoshop file you just created as redbricks.psd.

WORKSHOP 5 – CREATING A BRICK WALL

In the two previous workshops, you created bricks and a pattern to overlay the bricks. In this workshop, you will use both defined patterns (plus a little help from layer styles) to create a brick wall.

1. Select File – New, and create a new document based on the parameters in Figure 4.32.

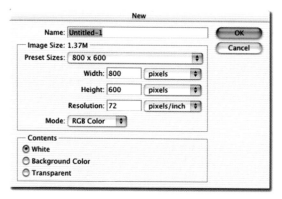

Figure 4.32: *The New File dialog box defines the parameters for the workshop.*

2. Create a new layer, and name the layer brick-wall. Leave the brick-wall layer selected.
3. Select Edit, and choose Fill from the pull-down menu.
4. Select Pattern for the Fill Contents, and choose the bricks pattern from the available options. Leave the other values at their default settings, as shown in Figure 4.33.
5. Click the OK button to apply the Fill command to the brick-wall layer, as shown in Figure 4.34.

Note: If you do not want the entire document window filled with the brick pattern, choose any of Photoshop's selection tools to define the fill area before using the Fill command.

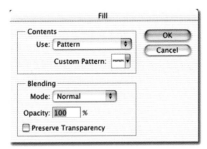

Figure 4.33: *Choose the bricks pattern from the Fill dialog box.*

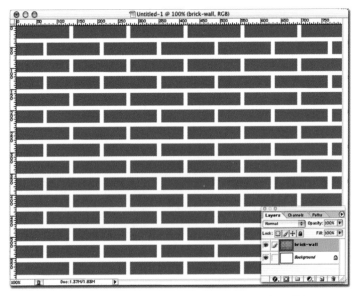

Figure 4.34: *The Fill command applied to the brick-wall layer.*

6. Move to the Layers palette, and click the Add layer style button. Select Pattern Overlay from the available layer style options. Choose the pattern created in Workshop 3, pattern_a.
7. Click the Blend Mode button, choose Darken from the available options, and change the Scale of the pattern to 75 percent, as shown in Figure 4.35.

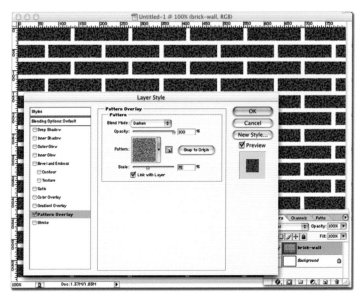

Figure 4.35: *Choose the Darken blending mode from the available Blending Mode options.*

8. Select the Bevel and Emboss option from the Styles list, and choose a Chisel Hard Bevel. Increase the Depth to 400, the Size to 2, and the Angle to 120 degrees, as shown in Figure 4.36.

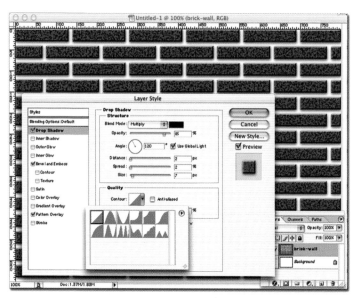

Figure 4.36: *The Chisel Hard bevel creates a visual sense of depth.*

Figure 4.37: *The Drop shadow layer style applied to the image.*

9. Select the Drop Shadow option from the Styles list and choose an Opacity of 85 percent, an angle of 120 degrees, a Distance of 2, a Spread of 2, and a Size of 7, as shown in Figure 4.37.
10. Click the OK button to apply the layer styles to the brick-wall layer.
11. Move to the Layers palette, and double-click the Background layer. Name the layer mortar, and click the OK button to apply the change to the layer. Leave the mortar layer selected.
12. Move to the Layers palette, and click the Add layer style button. Select Pattern Overlay from the available layer style options. Choose the pre-packaged pattern created by Adobe called Weave2.
13. Click the OK button to apply the layer style to the mortar layer, as shown in Figure 4.38.

Figure 4.38: *The completed brick wall pattern.*

WORKSHOP 6: CREATING A LAYERED SANDSTONE PATTERN

Sandstone is a great overall background pattern, and as long as you don't use radical color changes for the layers of sandstone, it can be used as a background for text or images. To create a layered sandstone pattern, open Photoshop and perform these steps:

1. Select File – New, and create a new document based on the parameters in Figure 4.39.

Figure 4.39: *The New File dialog box defines the parameters for the workshop.*

2. Double-click the Background layer, and change the name of the layer in the New Layer dialog box to sandstone. Click the OK button to record your change to the background layer.
3. Select Filter – Noise, and choose Add Noise from the fly-out menu. Choose an Amount of 300 percent, Gaussian Distribution, and uncheck the Monochromatic option, as shown in Figure 4.40. Click the OK button to apply the Add Noise filter to the image.

Figure 4.40: *The Add Noise filter applied to the image.*

4. Select Filter – Blur, and choose Motion Blur from the fly-out menu. Choose an angle of 0 degrees, and a Distance of 55 pixels. Click the OK button to apply the Motion Blur filter to the image.
5. Select the Rectangular Marquee tool and create a selection from top to bottom, leaving out the left and right edges where the Motion Blur did not take full effect, as shown in Figure 4.41.
6. Select Edit, and choose Free Transform from the pull-down menu. A bounding box with handles appears around the selected area of the image. Click and drag the left and right middle handles outward toward the edges of the document window. Dragging stretches the image horizontally and eliminates the drop-off created by the Motion Blur filter, as shown in Figure 4.42.

Figure 4.41: *Use the Rectangular Marquee tool to select the areas of the image where the Motion Blur filter was fully applied.*

Figure 4.42: *The Free Transform applied to the image.*

7. Press the Enter key to apply the Free Transform command to the image.
8. Move to the Layers palette, and create a new layer by clicking on the Add new layer icon (the new layer icon resembles a dog-eared piece of paper). Name the new layer texture, and leave it selected.
9. Fill the new layer with white. (Press CTRL + Backspace, or CMD + Delete on the Macintosh.)
10. Select Filter – Noise, and choose Add Noise from the fly-out menu. Use the same values as Step 3, except make sure the Monochromatic option is selected. Click the OK button to apply the Add Noise filter to the texture layer.
11. Select Filter – Blur, and choose Gaussian Blur from the fly-out menu. Choose a Radius of 2 pixels. Click the OK button to apply the Gaussian Blur filter to the texture layer.
12. Select Filter – Stylize, and choose Diffuse from the fly-out menu. Choose a Mode of Normal, and click the OK button to make the change to the texture layer.
13. Press CTRL + F (CMD + F: Macintosh) to reapply the last filter (Diffuse). Repeat this action 3 more times—you will have applied the Diffuse filter a total of 5 times to the texture layer.
14. Select Image – Adjust, and choose Brightness/Contrast from the fly-out menu. Change the Contrast to 80 percent, as shown in Figure 4.43.

Figure 4.43: *The Brightness/Contrast Adjustment increases the contrast of the image.*

15. Click the OK button to apply the changes to the texture layer.

16. Select Filter – Stylize, and choose Emboss from the fly-out menu. Select an Angle of 130, a Height of 1 pixel, and an Amount of 100 percent. Click the OK button to apply the Emboss filter to the texture layer.

17. Change the Blending Mode of the texture layer to Multiply, and reduce the Opacity to 80 percent, as shown in Figure 4.44

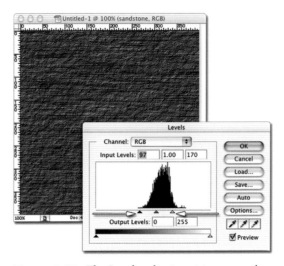

Figure 4.45: *The Levels adjustment increases the contrast of the image.*

Figure 4.44: *Select the Multiply blending mode from the available options.*

18. To enhance the effect of the sandstone, make the sandstone layer the active layer, select Image – Adjustments, and choose Levels from the fly-out menu. Move the black and white input slider toward the center, to increase the overall contrast of the sandstone layer, as shown in Figure 4.45.

19. To introduce a bend or wave to the layers of sandstone, make the sandstone layer active, choose Filter – Distort, and select Twirl from the fly-out menu. Choose an angle of 20 percent, and click the OK button to apply the changes to the sandstone layer, as shown in Figure 4.46.

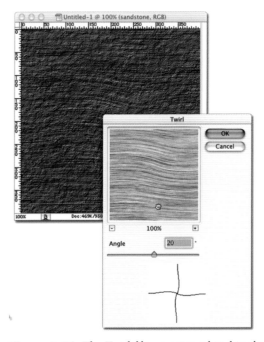

Figure 4.46: *The Twirl filter creates a bend in the sandstone layer.*

20. To convert the colors of the sandstone to muted shades of brown (or any color you choose), select a brown color swatch from the Swatches palette. Then select Image – Adjustments, and choose Hue/Saturation from the fly-out menu. Choose the Colorize option, and adjust the Saturation and Lightness options until you're happy with the results, as shown in Figure 4.47.

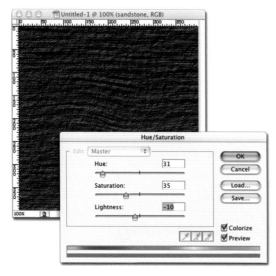

Figure 4.47: *Use the Hue/Saturation adjustment to add color to the sandstone layer.*

21. Select Edit, and choose Define Pattern from the fly-out menu. Name the New pattern sandstone, and click the OK button to save the pattern.
22. Select File, and choose Save from the pull-down menu. Save the file as a Photoshop document using the name sandstone.psd.

WORKSHOP 7 – CREATING A ROCKY TEXTURE

Probably one of the simplest patterns to create is a rocky texture. The next two workshops explain two easy ways to create a generic rocky pattern. To create a rocky pattern, open Photoshop and perform these steps:

1. Select File – New, and create a new document based on the parameters in Figure 4.48.

Figure 4.48: *The New File dialog box defines the parameters for the workshop.*

2. Double-click the Background layer, and change the name of the layer in the New Layer dialog box to granite. Click the OK button to apply your change to the background layer.
3. Select Filter – Noise, and choose Add Noise from the fly-out menu. Choose an Amount of 350 percent, Gaussian Distribution, and uncheck the Monochromatic option, as shown in Figure 4.49. Click the OK button to apply the Add Noise filter to the granite layer.

Figure 4.49: *The Add Noise filter applied to the image.*

Figure 4.50: *The Diffuse filter applied to the image.*

4. Select Filter – Blur, and choose Gaussian Blur from the fly-out menu. Select a Radius of 1.5 pixels. Click the OK button to apply the changes to the granite layer.

5. Select Filter – Stylize, and choose Diffuse from the fly-out menu. Select a Mode of Normal. Click the OK button to make the change to the image, as shown in Figure 4.50.

6. Press CTRL + F (CMD + F: Macintosh) to reapply the last filter (Diffuse). Repeat this action 4 more times. When you have finished, you will have applied the Diffuse filter a total of 5 times to the texture layer.

7. Select Image Adjustments, and choose Desaturate from the fly-out menu.

8. Select Image – Adjustments, and choose Brightness/Contrast from the fly-out menu. Select a contrast of 80 percent, and click the OK button.

9. Select Filter – Stylize, and choose Emboss from the fly-out menu. Choose an Angle of 120 degrees, a Height of 2 pixels, and an Amount of 100 percent. Click the OK button to apply the change to the granite layer, as shown in Figure 4.51.

Figure 4.51: *The final version of the granite pattern.*

10. Select Edit, and choose Define Pattern from the fly-out menu; name the pattern rocky. Click the OK button to save the pattern.

You can vary the look and feel of the granite by changing the Noise and Gaussian Blur options. In addition, try some of the Artistic and Brush Stroke filters before applying the Emboss filter.

WORKSHOP 8 – CREATING A SLATE TEXTURE

Another easy technique is creating a slate texture, as you will learn in this workshop.

1. Select File – New, and create a new document based on the parameters in Figure 4.52.

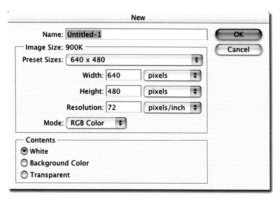

Figure 4.52: *The New File dialog box defines the parameters for the workshop.*

2. Double-click the Background layer, and change the name of the layer in the New Layer dialog box to slate. Click the OK button.

3. Press the letter D on your keyboard to default the foreground and background color swatches to black and white.

4. Select Filter – Render, and choose Clouds from the fly-out menu. Click the OK button to apply the change to the slate layer.

5. Select Filter – Artistic, and choose Dry Brush from the fly-out menu. Select a Brush Size of 2, Brush Detail of 8, and Texture of 2 (see Figure 4.53). Click the OK button.

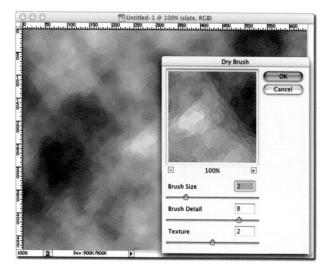

Figure 4.53: *The Dry Brush artistic filter applied to the image.*

6. Select Filter – Stylize, and choose Emboss from the fly-out menu. Choose an Angle of 120 degrees, a Height of 3 pixels, and an Amount of 200 percent. Click the OK button to apply the change to the slate layer, as shown in Figure 4.54.

Vary the Amount in the Emboss filter to generate more (or less) detail in the slate layer. Slate is better used as a whole background as opposed to a pattern, and it's easy to create a separate slate layer for each individual project. In fact, you could record the steps in the slate workshop as an Action and create a slate background with the click of a button.

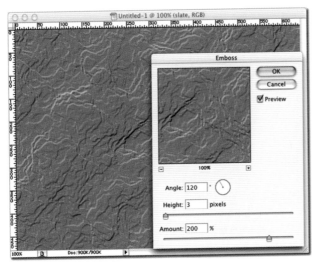

Figure 4.54: *The Emboss effect completes the slate effect.*

WORKSHOP 9 – CREATING CONCRETE BLOCKS

Okay, one more brick workshop. This time you will create some concrete blocks using some of the same techniques used in Workshops 4 and 5; however, you won't use an overlay pattern for the concrete bricks, and you'll use a new technique to create a realistic sense of depth for the mortar between the bricks. To create the concrete blocks, open Photoshop and perform these steps:

1. Select File – New, and create a new document based on the parameters in Figure 4.55.
2. Create a new layer, and name the layer block. Leave the block layer selected.
3. If Photoshop's ruler bars are not visible, select View, and choose Rulers from the pull-down menu.

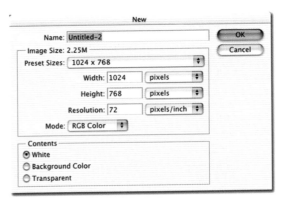

Figure 4.55: *The New File dialog box defines the parameters for the workshop.*

4. To define the shape and placement of the bricks, click in the ruler bar and drag vertical and horizontal guidelines into the document window. In our example, the blocks are 180 pixels wide by 80 pixels tall. In addition, there will be 10 pixels of space (the mortar for the blocks) between each block. Create guidelines for three bricks, horizontally, as shown in Figure 4.56.

Figure 4.56: *The guidelines define the shape and size of the concrete blocks.*

5. Select the Rectangular Marquee tool and, using the guides, create a rectangle the size and shape of the first block.

6. Choose a medium gray color swatch from the Swatches palette.

7. Press Alt + Backspace (Option + Delete) to fill the selected area with the gray color and then press CTRL + D (CMD + D: Macintosh) to remove the selection marquee, as shown in Figure 4.57.

Figure 4.58: *The three defined areas filled with copies of the original gray block.*

Figure 4.57: *The first concrete block filled with a medium gray color.*

8. Select the Move tool, hold down the Alt key (Option key: Macintosh), and click and drag the block you just created over and to the right. Holding the Alt/Option key instructs Photoshop to create a copy of the block in a separate layer. Place the block within the guidelines for the second brick (if you created accurate guidelines, it should fit perfectly).

9. Repeat the previous step and place a copy of the block in the third space. You should now have three horizontal bricks, as shown in Figure 4.58.

10. Go back to the ruler bar and create another set of guides directly below the first set. The bricks need to be offset, so start the guidelines from the center of the middle brick, as shown in Figure 4.59.

Figure 4.59: *Create a second set of guidelines below the original set.*

11. Select the Move tool, and repeat Step 8 until the lower areas are filled with copies of the bricks, as shown in Figure 4.60.

Figure 4.60: *The concrete block areas filled with copies of the original layer.*

12. Move to the Layers palette and deselect the Background layer (you will see the tablecloth pattern appear in the document window).

13. Click the Layers options button, and select Merge Visible from the available options, as shown in Figure 4.61. Make sure you do not have the Background layer selected, or this command will not work. Rename the merged layer blocks.

Figure 4.61: *Merge all the block layers into a single layer.*

14. Select Filter – Noise, and choose Add Noise from the fly-out menu. Choose an Amount of 10 percent, Uniform Distribution, and select the Monochromatic option. Click OK to apply the changes to the blocks layer.

15. Select Filter – Stylize, and choose Emboss from the fly-out menu. Choose an angle of 120 degrees, a Height of 2, and an Amount of 100 percent. Click the OK button to apply the change to the blocks layer, as shown in Figure 4.62.

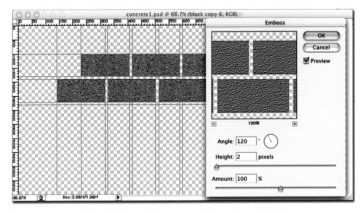

Figure 4.62: *The Emboss filter applied to the blocks layer.*

16. Move to the Layers palette, and click the Add layer style button. Select Bevel and Emboss from the available layer style options. Select a Smooth, Inner Bevel with a Depth of 125 percent and a Size of 3 pixels. Click the OK button to apply the changes to the blocks layer, as shown in Figure 4.63.

17. Select the Rectangular Marquee tool, and select the blocks, starting with the upper-left portion of the first block, down to the lower-right corner. Include the area reserved for the mortar on the bottom and right side of the block pattern. Use the guidelines to assist you in the selection, as shown in Figure 4.64.

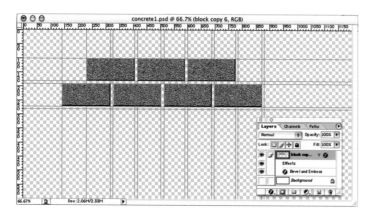

Figure 4.63: *The Bevel and Emboss filter applied to the blocks layer.*

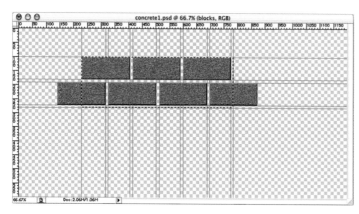

Figure 4.64: *Use the Rectangular Marquee tool to select the area of the block pattern.*

18. Select Edit, and choose Define Pattern from the pull-down menu. Name the new pattern blocks, and click the OK button to save the pattern.

 Note: It is important that the Background layer is turned off before defining the pattern. If you leave the Background layer on, the areas defining the mortar will be filled with white.

19. Save the Photoshop file you just created as blocks.psd.

As you can see, creating the concrete blocks was very similar to creating the red bricks in Workshop 4. However, we added the surface texture to the pattern, as opposed to using a pattern overlay.

WORKSHOP 10 – CREATING A UNIQUE MORTAR EFFECT

In this workshop, you will use the pattern created in Workshop 9, and add the mortar between the blocks using a special technique. To create the unique mortar, open Photoshop and perform these steps:

1. Select File – New, and create a new document based on the parameters in Figure 4.65.

Figure 4.65: *The New File dialog box defines the parameters for the workshop.*

2. Create a new layer, and name the layer blocks. Leave the block layer selected.

3. Select Edit, and choose Fill from the pull-down menu. Choose the blocks pattern created in Workshop 9, and click the OK button to fill the blocks layer with the pattern.

4. Create a new layer directly underneath the blocks layer, and name it mortar. Leave the mortar layer selected.

5. Move into the Layers palette and click the blocks layer, while holding down the CTRL key (CMD key: Macintosh). This creates a selection marquee based on the information in the blocks layer (the blocks), as shown in Figure 4.66.

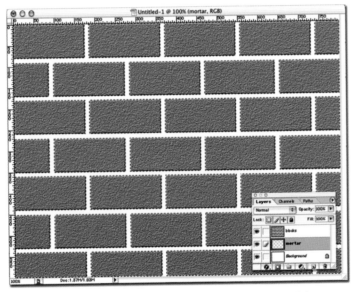

Figure 4.66: *The selection defines the visible elements of the blocks layer.*

6. Choose Select, and choose Inverse from the pull-down menu. This reverses the selection. The areas between the concrete blocks are now selected.

7. Select a light gray color swatch from the Swatches palette, and press Alt + Backspace (Option + Delete: Macintosh) to fill the spaces between the blocks with the selected color (make sure the mortar layer is still selected), as shown in Figure 4.67.

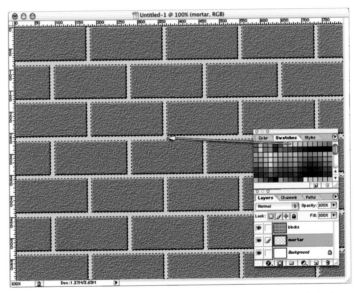

Figure 4.67: *Fill the selected areas of the mortar layer with light gray.*

8. Select CTRL + D (CMD + D: Macintosh) to deselect the marching ant marquee.

9. Click the Add layer style button. Select Inner Shadow from the available layer style options. Select an Angle of 110 degrees, a Distance of 6, a Size of 6, and a Noise value of 20 percent. Click the OK button to apply the layer style to the mortar layer, as shown in Figure 4.68.

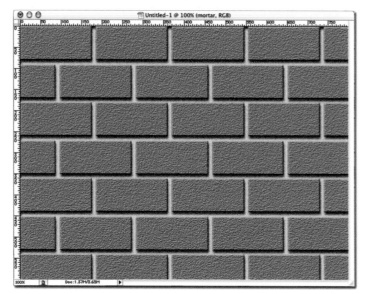

Figure 4.68: *The Inner Shadow layer style creates a visual sense of depth.*

As you can see, creating a separate layer for the mortar, and applying the Inner Shadow layer style, creates a realistic effect of mortar between the concrete blocks. The technique of creating a separate layer for the mortar can be applied to any pattern, including the bricks created in Workshop 5.

WORKSHOP 11 – SAVING YOUR NEW PATTERNS

In this chapter, you've created several patterns and saved them using Edit – Define Pattern. Understand that although these patterns are available in Photoshop, they are not, technically, saved.

If you were to go into the Patterns palette and select the option Reset Patterns, you would lose all the patterns. If you want to keep your new patterns, it's important that you save them. To save a group of patterns, open Photoshop and perform these steps:

1. Select Edit, and choose Preset Manager from the pull-down menu.
2. Select Patterns from the Preset Type option, as shown in Figure 4.69.
3. Shift-click the pattern swatches that you want to include in the pattern set, as shown in Figure 4.70.
4. Select the Save Set button, and name your patterns.

Figure 4.69: *The Preset Manager displays the patterns currently available to Photoshop.*

Figure 4.70: *Shift-click to save multiple patterns.*

Once a pattern set is saved it can be retrieved any time it is needed by selecting the Load button. This chapter, like the previous one, gave you insight into the creation of shapes and patterns. Once you know how to create a pattern, it is a simple matter to include that image with other Photoshop elements (text, photographs, etc.), and create your own customized images. The key to success is experimentation. Use these workshops as a foundation for new images. You just might be surprised what you come up with.

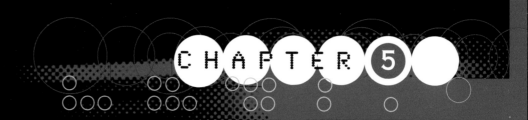

CHANGING ENVIRONMENTS

OKAY, SO YOU TAKE THIS PICTURE, AND IT LOOKS GREAT; HOWEVER, SOMETHING IS MISSING...IT'S THE MOOD OF THE IMAGE. IMAGE MOOD CAN BE CREATED USING MANY METHODS. FOR EXAMPLE, COLOR CREATES MOODS: BRIGHT COLORS FOR UPBEAT IMAGES AND MUTED COLORS FOR SUBDUED PHOTOS. A SOFTLY FOCUSED IMAGE CREATES A DIFFERENT MOOD THAN AN IMAGE IN SHARP FOCUS. EVEN TEXT CAN BE USED TO GENERATE A MOOD. (WE'LL TALK ABOUT TEXT IN CHAPTER 11, "WORKING WITH TEXT.")

WHILE WE'RE ON THE SUBJECT OF MOOD, HOW ABOUT CHANGING THE MOOD OF AN IMAGE BY CHANGING THE WEATHER? I'M NOT SUGGESTING YOU WAIT FOR THE WEATHER TO CHANGE (IMAGINE TELLING YOUR MODEL TO HOLD THAT POSE UNTIL IT STARTS RAINING); I'M SAYING YOU CAN CHANGE THE WEATHER BY USING PHOTOSHOP.SOMETIMES YOU WANT IT TO RAIN OR SNOW (I KNOW I DO).

This chapter discusses the methods you can employ to change the environment of an image: sunny to rainy, warm to snowy, and day to night. So sit back, put your tray tables and seat backs in their upright positions, and have some fun.

WORKSHOP 1 – TURNING DAY INTO NIGHT

Simulating nighttime conditions from a picture taken during the day is more involved than opening the Levels dialog box, and lowering the mid-gamma point. Many times, there are visual clues that let the viewer know the time of day.

For example, are there hard shadows, such as those that would be visible on a sunny day? If so, they will need to be removed or toned down. Does the image contain buildings with windows or streets containing streetlights? Then you might want to turn some of the lights on in the building's windows and, of course, turn on the streetlights. Finally, as the sun goes does, so does the saturation of the color. The human eye requires light to see colors, so the less light, the less color.

All of these factors, and more, must be carefully examined when changing the visual state of an image, and each image, in subtle ways, will be different from any other image. Understanding what needs to be accomplished, and knowing what tools in Photoshop will help you reach that goal, makes the difference.

Changing an image to simulate nighttime conditions creates a composite image. Composite images contain a series of steps that, when complete, produce the final result. For example, the steps used to darken the sky, illuminate the street lamps, and make it rain or snow, are repeatable steps. The good news is about composite images is that the steps can be repeated in other images. In many cases, the steps can be recorded in the Actions palette, and applied to another image with the click of a button.

To turn day into night, open an image in Photoshop, or use the pws_day.psd image provided in the Chap5 folder on the companion CD. Before beginning, examine the image and look for possible problems; for example, the area on the right of the image is too bright (remember this image is supposed to be taken at night). This is due to direct exposure to the sun. Let's start by toning down the sunlit areas of the image.

Removing the Clouds

1. Create a selection around the clouds in the image. In this example, the Polygon Lasso tool was used to create the selection, as shown in Figure 5.1.

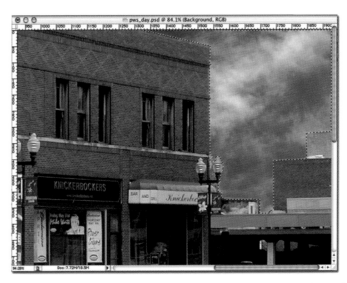

Figure 5.1: *The selected areas of the image represent the cloud/sky portions of the image.*

2. Choose Select, and choose Feather from the pull-down menu. Choose a Feather Radius of 1, and click the OK button to apply the feather to the image.

3. Select the Color palette and create a color for the sky. In this example, the values Red: 245, Green: 248, and Blue: 255, were used to create a blue/gray color.

4. Create a new layer above the Background, and rename the layer sky. Press CTRL + Backspace (CMD + Delete: Macintosh) to fill the selected sky area with the blue/gray color, as shown in Figure 5.2.

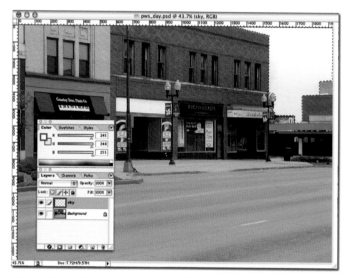

Figure 5.2: *The selected areas of the sky are filled with the blue/gray color.*

Overall Darkening of the Image

Now that the sunlit areas are subdued, the next step is to reduce the overall brightness of the image.

5. Click the Create new adjustment layer icon (the half-moon icon) located at the bottom of the Layers palette, and create a new Hue/Saturation adjustment layer. Double-click the name of the adjustment layer, and rename it darken.

6. Move the Lightness input value to −50, as shown in Figure 5.3.

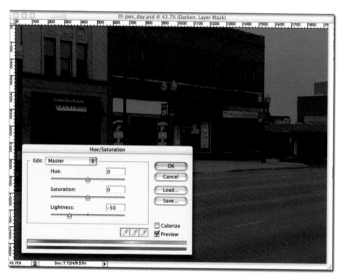

Figure 5.3: *The Hue/Saturation dialog box darkens the image.*

Note: Normally, linear adjustments such as Hue/Saturation are not used on Photographs; however, the overall darkening of the image using Hue/Saturation produces an across-the-board darkening of the image that simulates nighttime. Remember, you are attempting to alter this image (change from day to night), not enhance it.

Turning on the Street Lamps

To further enhance the effect of nighttime, turn on the street lamps.

7. Create a new layer and name the layer streetlights. Move the streetlights layer to the top of the Layers palette.

8. Select the globes on the streetlights. In this example, I made the streetlight selections with a combination of the Lasso tools, as shown in Figure 5.4.

9. Choose a bright yellow color from the swatches palette, and press Alt + Backspace (Option + Delete: Macintosh) to fill the selected areas of the streetlights layer with yellow.

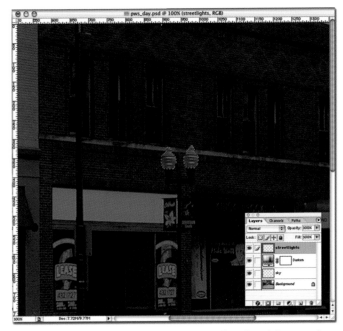

Figure 5.4: *The selected areas correspond to the globes on the streetlamps.*

10. Press CTRL + D (CMD + D: Macintosh) to deselect the streetlights.
11. Select Filter - Blur, and choose Gaussian Blur from the fly out menu.
12. Choose a Radius of 1 pixel, and click the OK button to apply the Gaussian Blur filter to the streetlights layer.
13. Press CTRL + J (CMD + J: Macintosh) to make a copy of the streetlights layer.
14. Select Filter - Blur, and choose Gaussian Blur from the fly-out menu.
15. Choose a Radius of 15 pixels, and click the OK button to apply the Gaussian Blur filter to the streetlights copy layer.
16. To turn on the lights in one or two windows, create a new layer and rename the layer windows. Move the layer to the top of the Layers palette.
17. Repeat Step 8, but this time select the glass in the windowpanes (for the windows you want to light up).
18. Repeat Step 9; however, substitute white or a 10 percent gray for the bright yellow.

 Note: Lights differ between images and light sources. Some street lamps give off a distinct blue-white color, while others are more orange than yellow.

19. Repeat Steps 10 through 15 to finish turning on the lights in the building, as shown in Figure 5.5.

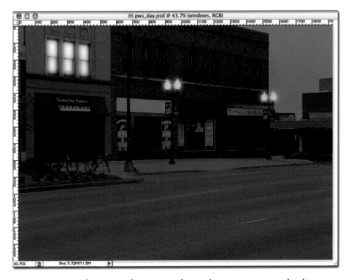

Figure 5.5: *The street lamps and windows appear to be lit.*

Accenting the Streetlights

One thing is missing from this image. The streetlights would reflect off some of the surrounding surfaces. In Step 5, you created a Hue/Saturation adjustment layer and named it darken. You will now use that layer to help accent the streetlights.

20. Select the Hue/Saturation adjustment layer named darken.
21. Press the letter D on your keyboard to default the foreground and background color swatches to black and white.
22. Select a 40 percent gray from the Swatches palette. Your foreground and background colors are now gray and white.
23. Select the Gradient tool and choose the radial gradient from the Options Bar, as shown in Figure 5.6.

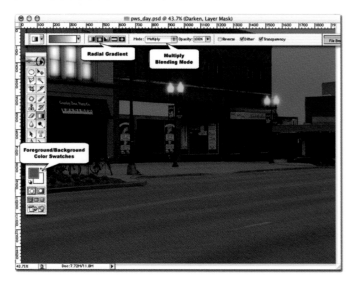

Figure 5.6: *The Radial Gradient tool creates circular and oval gradients based (in the example) on the foreground and background color.*

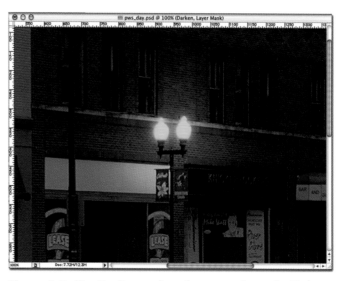

Figure 5.7: *The Gradient tool used to create the oval of light surrounding the street lamp.*

Note: You are about to draw a radial gradient on the Hue/Saturation adjustment layer mask. When you paint on a mask (in this example, you will use a gradient), the level of black directly relates to the application of the adjustment to the image. For example, areas of an adjustment mask painted black will receive zero percent adjustment, and areas painted 40 percent black will receive 60 percent of the adjustment. The gray/white radial gradient will brighten up the area surrounding the streetlight.

24. Move the Radial Gradient tool to the center of the streetlight, hold down the Alt key (Option key: Macintosh), and drag outward. The Alt/Option key allows you to draw the radial gradient from the center of the light. Create a small oval around the streetlight, as shown in Figure 5.7.

25. The gray in the adjustment mask brightens the areas of the image surrounding the streetlights. If you don't like what you see, redraw the gradient until you're happy with the results, as shown in Figure 5.8.

26. Save the completed image on your hard drive using the name night.psd.

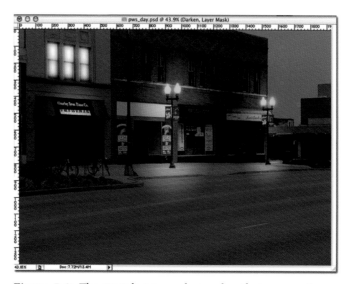

Figure 5.8: *The street lamp now has a glow that appears to illuminate other parts of the image.*

WORKSHOP 2 – MAKING IT RAIN: THE FORECAST CALLS FOR GLOOM

Open an image in Photoshop, or use the image created in the previous workshop. If you are using a new image, you will need to use some, or all, of the techniques discussed in Workshop 1 to darken the image. If you are using the Workshop 1 image, simplify the process by flattening the image. (You will be using this image in Workshop 3, so you might want to flatten a copy and preserve the original layered image.)

Creating the Rain

1. Open the Layers palette and create a new layer by clicking on the Create a new layer icon. Rename the layer rain_a, as shown in Figure 5.9.

Figure 5.9: *Rename the new layer rain_a.*

2. Press the letter D on your keyboard to default the background and foreground color swatches to black and white, and press Alt + Backspace (Delete + Backspace: Macintosh) to fill the rain_a layer with the foreground color (black).
3. Select Filter - Noise, and choose Add Noise from the fly-out menu.
4. Choose an Amount of 300 percent, Gaussian, and Monochromatic. Click the OK button to apply the Noise filter to the rain_a layer, as shown in Figure 5.10.
5. Select Filter - Blur, and choose Motion Blur from the fly-out menu.

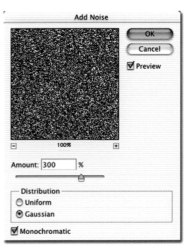

Figure 5.10: *The Gaussian Blur filter applied to the rain_a layer.*

6. Choose an almost vertical angle for the rain. Remember, unless there is a hurricane brewing, rain typically falls straight down. In this example, I chose an Angle of 70 degrees with a Distance of 40 pixels. Click the OK button to apply the Motion Blur to the rain_a layer, as shown in Figure 5.11.
7. Change the blending mode of the rain_a layer to Screen to remove the black from the rain_a layer.
8. Select Image - Adjustments, and choose Levels from the fly-out menu. Move the black and white input sliders in toward the center. The closer the black and white input sliders are to each other, the fewer raindrops. In this example, I moved the black and white sliders to 113 and 183, as shown in Figure 5.12.
9. Create a copy of the rain_a layer by selecting the layer in the Layers palette and pressing CTRL + J (CMD + J: Macintosh). Rename the layer rain_b.
10. Select Edit, and choose Free Transform from the pull-down menu.
11. Move to the Options Bar and change the width and height values to 200 percent. Click the Check Mark icon to the right of the Options Bar to apply the transformation to the rain_b layer, as shown in Figure 5.13.
12. Select Image - Adjustments, and choose Levels from the fly-out menu. Drag the black and white sliders toward the center. This reduces the number of large raindrops in the layer. Click the OK button to apply the adjustment to the rain_b layer, as shown in Figure 5.14.

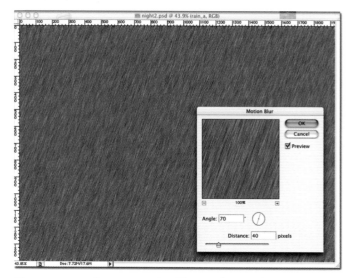

Figure 5.11: *The Motion Blur filter applied to the rain_a layer.*

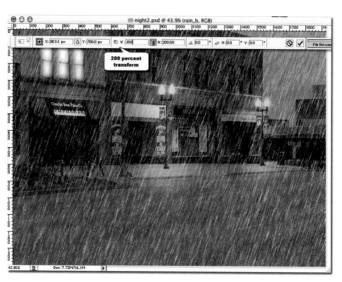

Figure 5.13: *The rain_b layer, with its 200 percent increase in size, represents the rain closer to the viewer.*

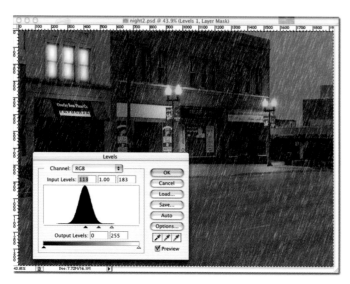

Figure 5.12: *The Levels input sliders control the intensity of the rain in the image.*

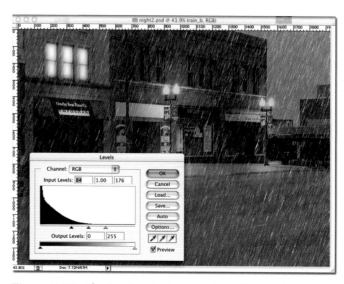

Figure 5.14: *The Levels adjustment reduces the number of large raindrops.*

13. If applying the transformation to the rain_b layer makes the rain appear pixilated, select Filter - Blur and choose Gaussian Blur from the fly-out menu. Apply a 1- or 2-pixel blur to soften the rain_b layer.

14. Select File, and choose New from the fly-out menu. Create a New Photoshop document twice the size of the current document.

15. Repeat Steps 2 through 7, to create another rain layer. Rename this layer rain_c.

16. Click and drag the rain_c layer from the new document into the original document. If you hold down the Shift key, the new layer is centered in the document window.

17. Select Edit, and choose Free Transform from the pull-down menu.

18. Move to the Options Bar and change the width and height values to 50 percent. Click the Check Mark icon to the right of the Options Bar to apply the transformation to the rain_c layer.

19. This layer represents smaller (more distant) raindrops, so you will need to mask out the foreground elements in the image. Select the Lasso tool (or whatever selection tool you feel will best make the selection), and carefully select the entire image, with the exception of the foreground elements, as shown in Figure 5.15.

20. Select the rain_c layer, and click the Add layer mask icon located at the bottom of the Layers palette. The mask defines the visible areas of the image based on the selection made in Step 18.

21. Touch up the mask (if necessary) by selecting the Brush tool (make sure you have the mask, not the image, selected) and painting the mask black to remove the rain, or white to expose the rain, as shown in Figure 5.16.

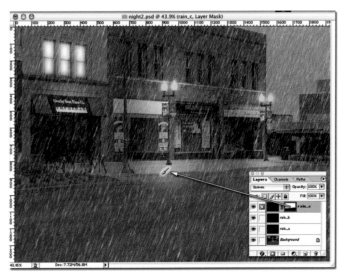

Figure 5.16: *Use black and white with a small, soft brush to touch up the mask attached to the rain_c layer.*

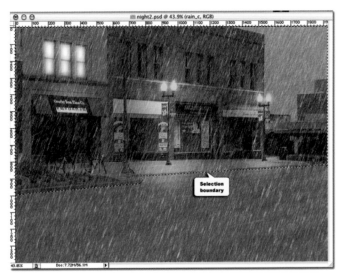

Figure 5.15: *Use the Lasso tool to select distant image elements.*

Depending on your image, you might need to create an additional layer mask on the rain_b layer to mask out portions of the rain interacting with the foreground elements.

Creating Reflections

When it rains, flat surfaces, especially streets, generate reflections of nearby objects (buildings, cars, streetlights). To make the scene more realistic, you will create a reflection of the buildings on the surface of the street. To simplify the creation of the reflections, turn off the three rain layers (rain_a, rain_b, and rain_c).

22. Select the layer containing the buildings (Background).
23. Press CTRL + J (CMD + J: Macintosh) to make a copy of the layer. Name the new layer reflections.
24. Select the area of the image that will hold the reflection (the street), as shown in Figure 5.17.

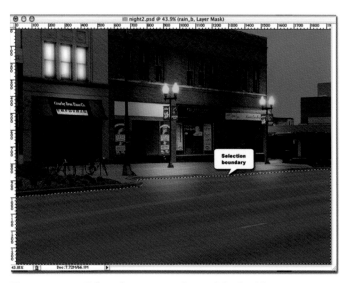

Figure 5.17: *Select the street in front of the buildings using standard selection methods.*

25. Click the Create Add layer mask icon to create a layer mask on the reflections layer (the new mask is based on the selection made in Step 24).
26. Move into the Layers palette and click once on the chain icon, located between the mask and image thumbnails (this separates the mask from the image).
27. Click once on the image thumbnail (this selects the image, not the mask).
28. Select Edit - Transform, and choose Flip Vertical to flip the reflections image, as shown in Figure 5.18.
29. Select the Move tool, and drag the reflections layer down, until the image of the flipped buildings is positioned in the street.
30. Select Edit, Transform, and choose Rotate from the fly-out menu. Select a rotation value of –2 degrees, and press Enter to set the rotation of the reflections layer, as shown in Figure 5.19.

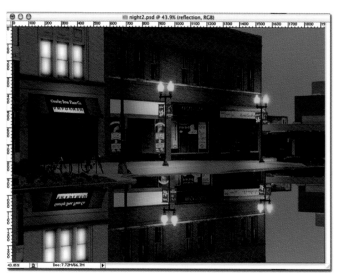

Figure 5.18: *The reflections layer, flipped vertical.*

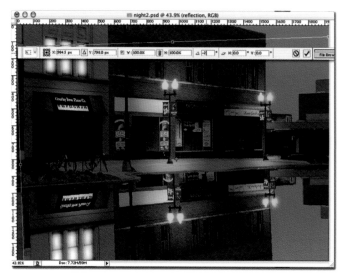

Figure 5.19: *Rotate the reflections image to visually align the reflection with the original image.*

31. Use the Move tool to line the reflection with the original buildings, and change the blending mode of the reflections layer to Screen, as shown in Figure 5.20.

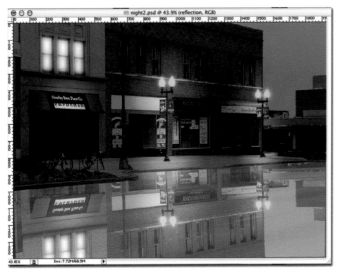

Figure 5.20: *Use the Move tool to align the reflections layer with the original image layer.*

32. To complete the effect, select Filter - Blur, and choose Gaussian Blur from the fly-out menu. Choose a Radius of 3, and press the OK button to apply the effect to the reflections layer.

33. Reactivate the rain layers to view the final image, as shown in Figure 5.21.

Blurring the Background

The final step will be to apply a slight blur to the buildings. This will create the effect of viewing the buildings through the rain.

34. Move into the Layers palette and select the layer containing the buildings (Background).

35. Select the buildings in the image, being careful to avoid any foreground objects. In this example, I used the Lasso tool to create the selection, as shown in Figure 5.22.

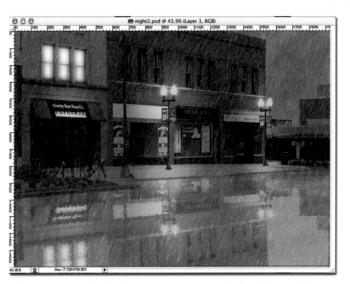

Figure 5.21: *The final image containing the buildings, lights, reflections, and rain.*

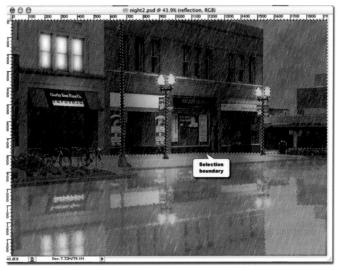

Figure 5.22: *Select the buildings in the image.*

36. Select Filter - Blur, and choose Gaussian Blur from the fly-out menu. Choose a Radius value of 2, and press the OK button to apply the effect to the selected buildings in the Background, as shown in Figure 5.23.

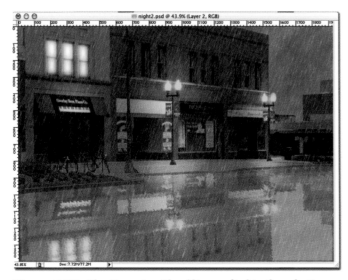

Figure 5.23: *The Gaussian Blur filter applied to the selection.*

WORKSHOP 3 – MAKING IT SNOW

To make snow, open a new image, or start with the image created in Workshop 2. If you are using the image created in Workshop 2, make a copy of the multilayered image, and delete the rain and reflection layers.

1. Create a new layer at the top of the Layers palette, and rename the layer snow_a.

2. Press the letter D on your keyboard to default the foreground and background color swatches to black and white.

3. Press CTRL + Backspace (CMD + Delete: Macintosh) to fill the snow_a layer with the background color (white).

4. Select Filter - Noise, and choose Add Noise from the fly-out menu. Choose an Amount of 200 percent, Gaussian, and Monochromatic, and click the OK button to apply the effect to the snow_a layer.

5. Reduce the opacity of the snow_a layer to 15 percent and choose the Hard Light blending mode, as shown in Figure 5.24. (Don't be afraid to experiment with the opacity to create a more or less intense snowfall.)

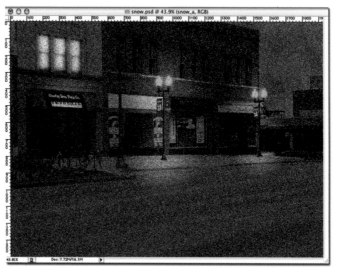

Figure 5.24: *The snow layer creates the illusion of gently falling snow.*

6. Press CTRL + J (CMD + J: Macintosh) to create a copy of the snow_a layer. Rename the copied layer snow_b.

7. Select Edit - Transform, and choose Scale from the fly-out menu. Choose a width and height value of 300 percent. Click the checkmark icon, located to the right of the Options Bar, to apply the transformation to the snow_b layer, as shown in Figure 5.25.

 Note: The snow_a layer represents the distant snow, and the snow_b layer represents the snow closer to the viewer's perspective.

8. Create a layer mask on the snow_a layer, by clicking the Add layer mask icon located at the bottom of the Layers palette.

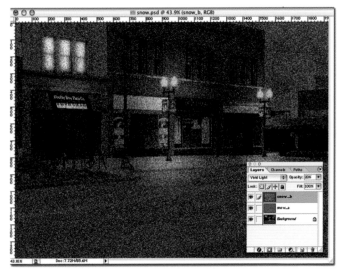

Figure 5.25: *The Scale Transform option creates the snow visually closer to the viewer.*

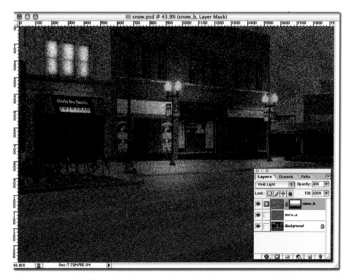

Figure 5.26: *The Gradient tool applied to the mask filters out the distant snow.*

9. Select the Gradient tool, and choose the linear gradient option, using the foreground and background colors.
10. Drag the Gradient tool from the bottom of the image to approximately two-thirds the height of the document. This will mask out the effect of the distant snow in the foreground of the image, as shown in Figure 5.26.
11. Create a layer mask on the snow_b layer, and use the Gradient tool, this time reversing the direction of the gradient (top down). This will partially mask out the larger snow particles in the background, as shown in Figure 5.27.

Adding Accumulated Snow

As an added effect, let's add some accumulated snow to the street and sidewalks.

12. Carefully select the areas of the image that will contain the snow (streets and sidewalk), as shown in Figure 5.28.
13. Select the layer containing the original image (Background).

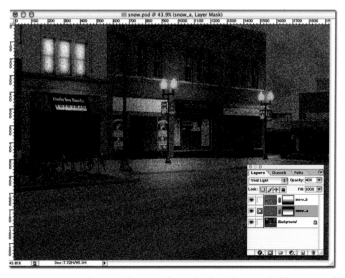

Figure 5.27: *The Gradient tool applied to the mask filters out the larger snow.*

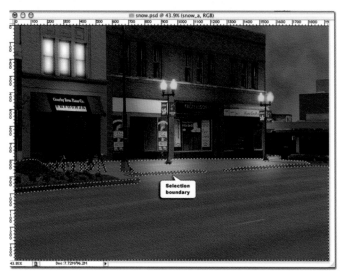

Figure 5.28: *Select the street and sidewalks in the image.*

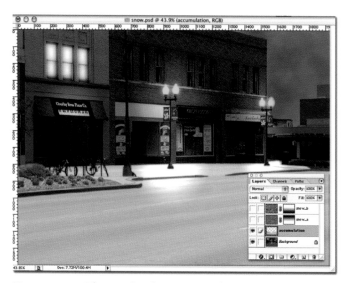

Figure 5.29: *The Levels adjustment applied to the accumulation layer.*

14. Choose Select, and choose Feather from the pull-down menu. Enter a Feather Radius of 3, and click OK to apply the feather to the selection. Press CTRL + J (CMD + J: Macintosh) to create a copy of the selected area of the Background layer. Rename the layer accumulation.

15. Select Image - Adjustments, and choose Desaturate from the fly-out menu. This shifts the accumulation layer from color into shades of gray.

16. Select Image - Adjustments, and choose Levels from the fly-out menu. Move the white input slider to the left to whiten the image. The further the white input slider is moved to the left, the thicker the appearance of the snow. In this example, I chose an the input value of 193.

17. Select the middle gray input slider and move it to the right to further lighten the image. In this example, I selected an the input value of .30.

18. Click the OK button to apply the adjustment to the accumulation layer, as shown in Figure 5.29.

19. To create a more pronounced snow, select Filter - Artistic, and choose Poster Edges from the fly-out menu. Choose an Edge Thickness of 2, Edge Intensity of 1, and a Posterization of 2. Click the OK button to apply the effect to the accumulation layer.

20. Press CTRL + F (CMD + F: Macintosh) twice to apply the Poster Edges filter two more times to achieve the final image, as shown in Figure 5.30.

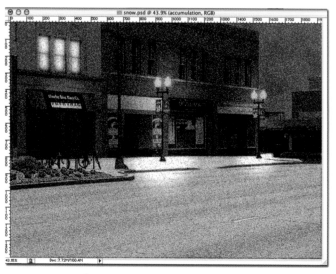

Figure 5.30: *The final falling snow image.*

PHOTOGRAPHIC RESTORATION

SIMPLY STATED, PHOTO RESTORATION IS THE PROCESS OF TAKING A BAD IMAGE AND MAKING IT BETTER. THERE IS NOTHING MORE SATISFYING THAN TAKING AN OLD PHOTO (FADED, SCRATCHED, AND GENERALLY IN A POOR STATE OF REPAIR), AND RESTORING THAT IMAGE TO ITS FORMER GLORY.

EXCELLENT PHOTO-RESTORATION IS A COMBINATION OF THE SOFTWARE THAT MAKES IT POSSIBLE ANDALL THOSE RIGHT-BRAIN, CREATIVE TALENTS JUST ITCHING TO GET OUT AND SEE WHAT'S POSSIBLE. WHEN IT COMES TO UNLEASHING YOUR BEST PHOTO CLEANUP IDEAS, PHOTOSHOP IS CHOCK FULL OF POSSIBILITIES. THIS CHAPTER TEACHES YOU HOW TO CORRECT COMMON PROBLEMS WITH THE TOOLS THAT PHOTOSHOP USES TO RESTORE OR ENHANCE PHOTOGRAPHIC IMAGES.

PHOTO RESTORATION CAN BE A LOT OF FUN, OR IT CAN BE A FRUSTRATING EXPERIENCE. THE DIFFERENCE BETWEEN FUN AND FRUSTRATION IS KNOWLEDGE OF THE TOOLS PHOTOSHOP USES TO RESTORE THE IMAGE. WITH THAT IN MIND, LET'S EXPLORE THE BEST WAY TO MOVE YOUR IMAGES INTO PHOTOSHOP.

SCANNING AND IMAGE RESOLUTION

When you repair an image using Photoshop (or any computer program, for that matter), you must have a way to access the image. Moving an image from the real world into Photoshop is a process called digitizing, and the hardware that makes that possible is called a scanner, as shown in Figure 6.1.

Scanners come in all sizes and shapes, but they all perform one function: digitizing an image. When you lay an image on your scanner (for example, an old photograph), the scanner divides or cuts the image into pieces (called pixels). Each pixel represents a piece of color information from the original image. Additional information concerning pixels and resolutions can be found in Chapter 1.

Imagine a brick wall with each individual brick painted a different color. When you move away from the wall, the colored bricks visually blend and your eyes see an image. When you move closer to the wall, the individual elements (bricks) become visible. Scanners, like the brick wall, break the image into individual pixels; Photoshop then reassembles all the pixels to produce the image, as shown in Figure 6.2.

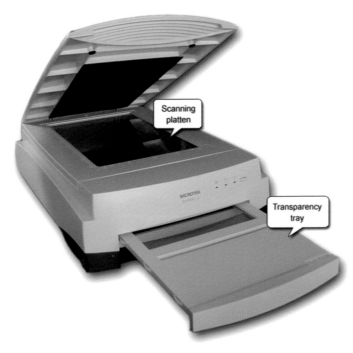

Figure 6.1: *Scanners convert images into a raster, or grouping of pixels.*

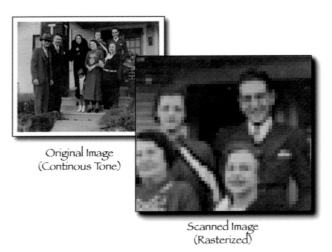

Original Image
(Continous Tone)

Scanned Image
(Rasterized)

Figure 6.2: *Photoshop reassembles the pixels into a visible image.*

When you scan an image, you start by defining a specific resolution for the image. Say, for example, you scan a 5-inch-by-5-inch image at 150 ppi (pixels per inch). The resulting image would have 25 square inches, containing a grand total of 562,500 pixels (150 x 150 x 25). If we return to our analogy of pixels representing bricks, you've just constructed a wall with more than a half-million bricks, and that's a heck of a lot of bricks. If bricks are heavy (and believe me, they are) then the more bricks (pixels) an image is scanned at, the larger the file size.

In truth, scanning a photograph becomes a tradeoff between the quality of the image (more resolution translates into more image information) and the size of the file (more resolution creates a larger file size).

For example, a 5-inch-by-5-inch image scanned at 72 ppi using the RGB color mode would produce an image with a file size of 380kb; that's a reasonable file size, and the resolution is fine if you're intending to display the image on a Web page. However, if your intention is to print the image, the low resolution will create a poor quality print. The obvious solution is to rescan the image at a higher resolution, say around 300 ppi (more acceptable for print). The same photograph scanned at 300 ppi produces an image with a file size of 6.4mb, 16 times larger than the 72 ppi scan. Unfortunately, the larger the file size, the longer it takes Photoshop to perform digital restoration of the image.

 If you have ever waited a long time for Photoshop to perform an adjustment, in fact so long that you wiggle your mouse just to make sure the computer isn't locked up, it's a sure sign that either you need a newer, faster computer or you need to work on smaller images.

Scan and Examine

When you work with photographs, you're looking for a final scan that contains all the details contained within the original image, or what is called good *dynamic range*. Opening the scan in Photoshop and examining its histogram can determine the dynamic range of a scanned image.

To access the histogram, select Image, and choose Histogram from the fly-out menu.

The histogram defaults to a display of the luminosity of the active image. Luminosity displays the distribution of pixels within the image, with the number of pixels in each range represented by the height of the graph. In the world of luminosity, each pixel has the possibility of being black, white, or a shade of gray (or color), and there are 256 possible luminosity settings. The histogram represents darker pixels at the left of the graph (with black being zero), and lighter pixels at the right (with white being 255). Think of the Histogram as a bar chart with 256 bars, the more bars on the left of the Histogram, the darker the image; conversely, the more bars on the right of the Histogram, the lighter the image. As you can see in Figure 6.3, the luminosity histogram indicates an image that lost information in the shadow and highlight areas (no bars on the left or right). This is typical of old images.

Figure 6.3: *This histogram indicates an image that has lost information in the shadows.*

When you scan an image, you want as much information as possible. Scanners create information using pixels (short for picture element), so the more pixels in the image, the more information.

The second element that influences image information is the dynamic range of the scanner; or what the scanner is capable of seeing. Say, for example, you have an old image where the shadow areas have become a dark muddy brown. Your eyes can see details; however, when you scan the image, the information is lost, as shown in Figure 6.4.

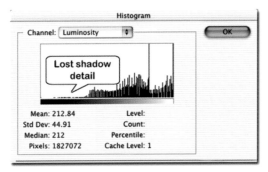

Figure 6.4: *Scanners that lack dynamic range cannot reproduce subtle shifts in image color and brightness.*

Loss of information can be blamed on one of two problems: incorrect settings when the image was scanned or a scanner that lacks dynamic range. The first is a user problem, the second is a hardware problem. Scanners with high dynamic ranges cost more, but they have the ability to preserve subtle shifts of color and brightness.

To determine the best image based on your current scanner, scan the image using the default settings for brightness, contrast, etc., and open the image in Photoshop.

Select Image, and choose Histogram from the pull-down menu. The Histogram displays a graph on the information contained within the image. The area resembling a black mountain is actually a bar chart of the brightness levels of the pixels in the image. The hills and valleys represent shifts in the image's brightness, and the thickness of the Histogram represents the total amount (or dynamic range) captured by the scanner, as shown in Figure 6.5.

Figure 6.5: *The Histogram is a record of the information contained within the image.*

Next, save the image and rescan the original; however, before scanning, adjust the brightness or midpoint gamma (say 5 percent darker), and rescan. Now, open the image and compare the two Histograms. If the second scan produces a more diverse and thicker Histogram, you have more information, as shown in Figure 6.6.

Continue to rescan and examine the Histograms of the images until you have the best Histogram. In doing so, you are fine-tuning your scanner to give you the best possible image. Of course, the best possible image will ultimately be limited by your scanner and its optics, but it will be the best possible image that your particular scanner

Figure 6.6: *The second Histogram indicates an image that contains more information.*

is capable of producing. Now, save those settings, and use them when you need to scan and work on that particular type of image.

Remember: always start with a good scan. Photoshop can only work with the information you give it. The more information, the better the final output. ALWAYS start with a good scan.

WORKSHOP 1 – BASIC IMAGE RESTORATION: WORKING IN A NON-LINEAR WORLD

Uncompressing an image's digital information will, in effect, restore its brightness and contrast. The best tool to restore the brightness and contrast of a digital photograph is the Levels adjustment; you make the image corrections using an adjustment layer.

Adjustment layers have several advantages including they let you view changes to the image without actually remapping the image or applying the changes to the image. In addition, they allow you to re-access the adjustment layer and make further changes. If those reasons weren't enough, adjustment layers contain a mask that allows you to control the areas of the image affected by the adjustment.

Correcting an Image Using Adjustment Layers

1. Create an adjustment layer by clicking the half-moon icon at the bottom of the Layers palette and choosing Levels from the available options. In turn, Photoshop opens the Levels adjustment tool, as shown in Figure 6.7.

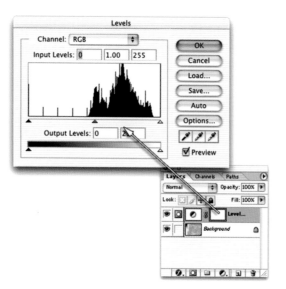

Figure 6.7: *Adjustment layers let you view adjustments to an image in the document window without changing the original image.*

2. Move the black input slider to the right until you reach the data on the left side of the histogram (or the foot of the mountain). In this example, the black input slider was moved to 20, as shown in Figure 6.8.

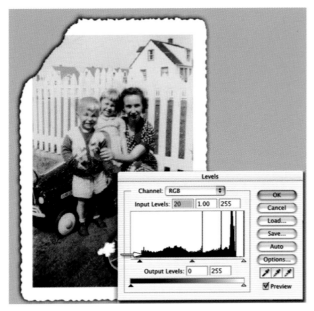

Figure 6.8: *Moving the black input slider redefines the black point within the image.*

3. Move the white input slider to the left and place it directly under the data on the right side of the histogram. In this example, the white input slider was moved to 238, as shown in Figure 6.9.

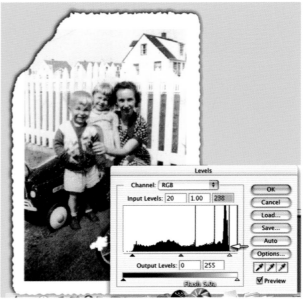

Figure 6.9: *The white slider redefines the white point in the image.*

When you move the Levels input sliders, you are remapping the pixels within the image. The histogram represents where, and how many pixels are contained within the image, so moving the black and white sliders to the base of the histogram data gives Photoshop the information it needs to rebalance the black and white points in the image.

In this example, the brightness value of 20 becomes the new black point (0), and 238 becomes the new white point (255). Any pixels falling outside the range of the black and white sliders become pure black or white, respectively.

4. Let's darken the image in the midtones by clicking and dragging the midtone slider (the gray slider in the middle) to the right. In this example, move the slider until the midtone input field reads .85, as shown in Figure 6.10.

5. Click the OK button to make the changes to the Levels adjustment layer.

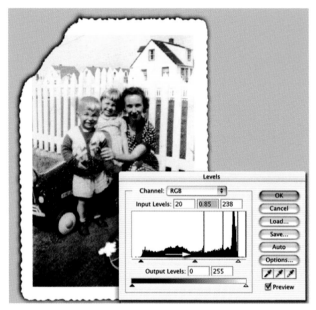

Figure 6.10: *Moving the midtone slider to the right darkens the midtone values of the pixels while preserving the modified black and white points.*

As you can see, the contrast of the image has been restored, as well as image details that were difficult to see in the original compressed photograph. The Levels adjustment layer holds these changes to the image in a separate layer within the Layers palette. To view the image before the changes were applied, click the visibility icon (the eyeball to the left of the layer). When you turn off the Levels adjustment layer, the original image appears in the document window.

Turning the adjustment layer on and off is a great way to see if you like the changes made to the photograph. If you decide more adjustments are called for, simply double-click on the Levels icon (that's the thumbnail that looks like the Levels adjustment tool), and the Levels adjustment tool magically reappears. Make any needed changes and click the OK button to save the changes to the adjustment layer.

That's the power of adjustment layers: they give you control over the final image, and control is what you need to experiment with Photoshop and be creative.

WORKSHOP 2 – REPAIRING RIPS AND TEARS

Once you have reestablished the contrast in the image, the next step is to examine the image for defects. As you can see in Figure 6.11, the image has several problems; there is a tear in the upper-right portion of the image, there is a splotch on the tire of the tricycle, and there are some dust spots on the car.

The ripped corner appears to be one of the more difficult areas to repair, so we'll handle that problem first.

1. This image has three good corners, so we'll start by selecting one of the good corners and using it to replace the damaged corner. Choose the Rectangular marquee tool and select the upper-right corner of the image. Make sure to select enough of the corner to replace the damaged area, as shown in Figure 6.12.

Figure 6.11: *This photograph contains several areas that require help.*

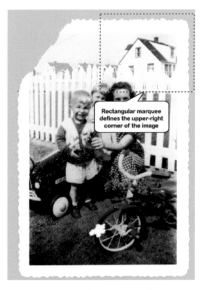

Figure 6.12: *The upper-right corner of this image will be used to replace the damaged corner.*

2. Press CTRL+J (CMD+J: Macintosh). This handy shortcut instructs Photoshop to create a copy of the selected corner and places it in a separate layer, directly above the image layer.
3. Select Edit and choose Transform from the pull-down menu options. Now select Flip Horizontal from the available Transform options. In turn, the corner selection is flipped horizontally, as shown in Figure 6.13.

Figure 6.13: *The Flip Horizontal option flips the corner selection left to right.*

4. Select the Move tool from the toolbox and move the selection over the upper-left portion of the image until the border is lined up to your satisfaction. Don't worry about the duplicate house (we'll take care of that in a minute); concentrate on aligning the copied border with the original border, as shown in Figure 6.14.
5. Select the Rectangular marquee and select the image portion of the copied corner. Make sure to leave the border; select only the image.
6. Press the delete key to remove the image information, as shown in Figure 6.15.

Figure 6.14: *The layer containing the copied borders is aligned with the original image border, thereby successfully covering the damage.*

Figure 6.15: *Deleting the image information in the copied layer restores the border, but leaves a gap where the original photograph was torn.*

7. To restore the missing sky, select the layer containing the original image, and use the Zoom tool to enlarge the upper part of the image. Then use your Rectangular marquee tool to select a portion of the sky in the undamaged area of the image, as shown in Figure 6.16.

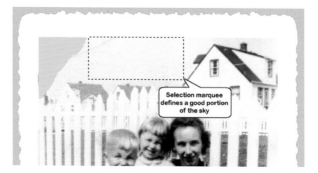

Figure 6.16: *Select a large portion of the sky in the undamaged portion of the image.*

8. Press CTRL+J (CMD+J: Macintosh) to create a copy of the selected sky in a layer directly above the image layer.
9. Use the Move tool to reposition the sky to cover the damaged area. The sky layer is underneath the copied border layer, so it should be easy to blend it into the image, as shown in Figure 6.17.

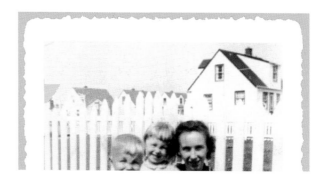

Figure 6.17: *The copied area of the image blends smoothly with the damaged portion of the image.*

! If the copied sky looks perfect, you can press CTRL+E (CMD+E: Macintosh). This instructs Photoshop to merge the selected layer with the layer directly underneath. In this example, it merges the copied sky layer with the original image.

While this is not necessary, it will help control the number of layers in the image. However, merging the sky into the original image prevents you from making further adjustments to the image.

10. The last area to repair is the small triangular rip on the left. Select the Lasso tool and create a selection around the last remaining torn area. You don't have to be perfect. In fact make the selection slightly larger than the rip, as shown in Figure 6.18.

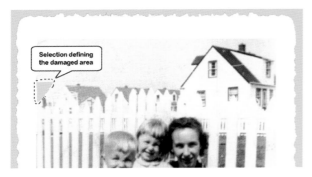

Figure 6.18: *The Lasso tool works to create a selection around the damaged area of the image.*

11. With the Lasso tool still selected, click in the middle of the selection and move it up into the undamaged sky area of the image, as shown in Figure 6.19.
12. Press CTRL+J (CMD+J: Macintosh) to create a copy of the selected sky in a separate layer.
13. Use the Move tool to reposition the sky to cover the damaged area, as shown in Figure 6.20.

! When you press CTRL+J (CMD+J: Macintosh), Photoshop uses the active layer to create the copy. In this example, make sure you have the layer containing the sky selected before making a copy.

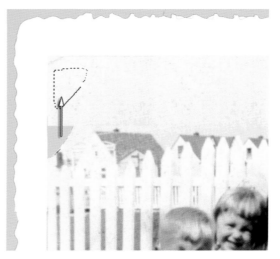

Figure 6.19: *Move the selection up into the sky portion of the image.*

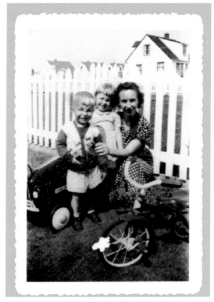

Figure 6.20: *The copied portion of the sky successfully covers the damaged portion of the image.*

WORKSHOP 3 – REMOVING DUST AND SCRATCHES

Another problem area in old photographs is dust and scratches. As you can see in our image (refer to Figure 6.20), the child's car and part of his front sweater have a number of scratches.

Photoshop has a number of ways to remove dust and scratches from an image; however, in this case, we'll use the new Healing Brush tool.

1. Use the Zoom tool to enlarge the portion of the image that contains the dust and scratches.
2. Select the Healing Brush tool from the toolbox.

For more information on the use of the Healing Brush tool, refer to Chapter 11, Exercise 4: Using the Healing Brush Tool to Remove Dust and Scratches.

3. Select a brush size and tip from the Brushes palette. The Healing Brush tool works best when you apply it to small areas at a time, so work with a small, soft brush. In this example, choose a 20-pixel brush.
4. Make sure that the Aligned option is not selected and choose Sampled from the Healing Brush options. By turning off Aligned, you're instructing the Healing Brush tool to return to the original sample point every time you release the mouse.
5. Let's start by healing the upper portion of the car. Move the Healing Brush tool over the car and sample a portion of the color by clicking your mouse while holding down the Alt key (Option key: Macintosh), as shown in Figure 6.21.
6. Move the Healing Brush over a scratch and rub it out using a small circular motion. Then release the mouse (to reestablish the original sample point), move to the next scratch, and remove it using the same technique, as shown in Figure 6.22.

Notice that the area where the scratches were removed has the same color and texture as the sampled area.

7. To remove the scratches in the darker areas of the image, resample the car using a darker portion of the image, as shown in Figure 6.23.
8. Methodically work through the remainder of the car, using small circular motions to heal all the remaining scratches, as shown in Figure 6.24.

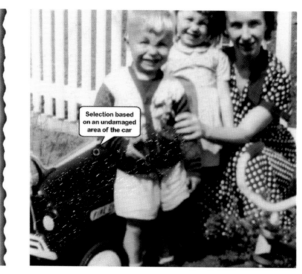

Figure 6.21: *Select the portion of the car you want to use in the healing operation by clicking your mouse while holding down the Alt key (Option key: Macintosh).*

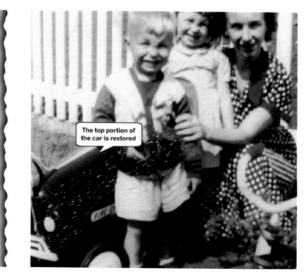

Figure 22: *The Healing Brush tool successfully removes the dust and scratches from the top portion of the car.*

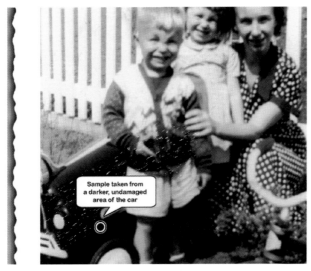

Figure 6.23: *Select a darker portion of the car to heal the scratches occurring in the shaded areas of the image.*

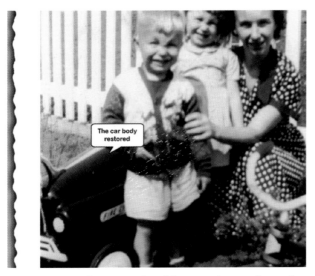

Figure 6.24: *The remainder of the scratches on the car have been repaired.*

9. The three remaining areas will require three more samples: one for the hand, one for the shorts, and one for the sweater. Create the samples one at time, using undamaged pixels that reflect the color and texture of the area you are restoring, and remove the remaining scratches, as shown in Figure 6.25.

Figure 6.25: *The Healing Brush tool successfully removed all of the dust and scratches from the image.*

WORKSHOP 4 – WORKING ON DAMAGED AREAS THAT CONTAIN IMAGE DETAIL

The final area to restore is the damaged portion of the tricycle. In Figure 6.26, you can see that a portion of the image was destroyed (probably eaten by a pesky moth).

The Healing Brush tool cannot repair this level of damage. In this instance, the best tool to use is our tried and trusty Clone Stamp. The Clone Stamp tool lets you select a specific portion of an image and use those pixels to cover the damaged areas of the photograph.

Figure 6.26: *The damaged area of the image is missing a lot of detail information.*

1. Photoshop lets you use the Clone Stamp tool in a separate layer, so start by creating a new layer directly above the image layer. Make sure that the new layer remains the active layer throughout this operation.
2. Select the Clone Stamp tool from the toolbox. Check to ensure the Aligned and Use All Layers options are selected, as shown in Figure 6.27.

Figure 6.27: *The Aligned and Use All Layers options need to be selected for this operation.*

The Use All Layers option lets you perform the Clone Stamp operation in a separate layer (that gives you control). The Aligned option instructs the Clone Stamp tool to maintain the same relative distance and angle to the sampled pixels, even when the mouse is released.

3. Choose a soft brush from the Brushes palette. In this example, I selected a 40-pixel brush.
4. Move the Clone Stamp tool to the top of the tire and click your mouse while holding down the Alt key (Option key: Macintosh). This selects the top of the tire as the starting sample point for the Clone Stamp tool, as shown in Figure 6.28.

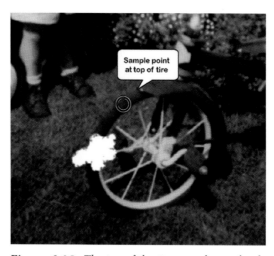

Figure 6.28: *The top of the tire was chosen for the Clone Stamp tool's sample point.*

5. Click somewhere to the left of the damaged area of the tire and drag your mouse to create a copy of the tire. Make sure you copy the tire from the top of the tricycle to the beginning of the damaged area. You should see something like Figure 6.29.

Notice that the curvature of the tire prevents you from doing a simple Clone Stamp replacement of the damaged area. You will need to rotate the tire to fit the damaged area.

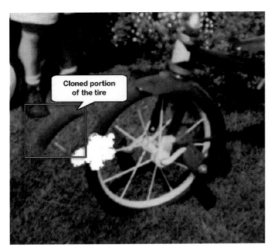

Figure6.29: *The cloned portion of the tire appears to the left of the tire.*

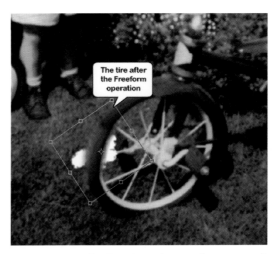

Figure 6.30: *The Free Transform tool gives you the ability to rotate the cloned tire.*

6. Select Edit and choose Free Transform from the pull-down menu options. Photoshop places a bounding box around the cloned tire. That's the reason you're performing this operation in a separate layer, to give you control over the cloned pixels (and you thought I was crazy).

7. Move your cursor outside the bounding box until you see it change into a curved double arrow. Click and drag your cursor to rotate the tire counter-clockwise. Stop when the cloned tire matches the curvature of the damaged portion of the image, as shown in Figure 6.30.

8. Press enter to save the changes to the tire, as shown in Figure 6.31.

9. Select Image - Adjustments, and choose Levels from the menu options. You're going to darken the cloned tire pixels by dragging the midtone slider to the right. In this example, I stopped at an Input level of 0.65, as shown in Figure 6.32. Click the OK button to make the change.

10. Select the Clone Stamp tool and choose a soft 20-pixel brush.

11. Sample the grass to the left of the tire by Alt-clicking (Option-clicking: Macintosh), as shown in Figure 6.33.

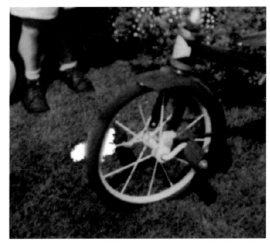

Figure 6.31: *The rotated tire aligned with the original image.*

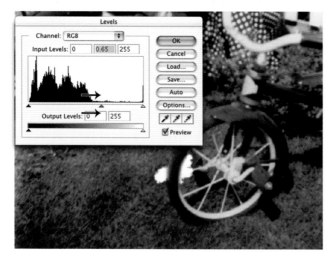

Figure 6.32: *The Levels midtone adjustment helps blend the cloned tire pixels into the damaged area of the image.*

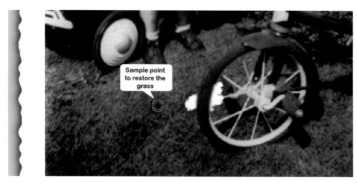

Figure 6.33: *The grass to the left of the tire will be used as a sample to restore the missing grass.*

12. Move over to the damaged area on the left of the tire and click and drag your mouse carefully over the damaged area. Stop when you have replaced all the grass, as shown in Figure 6.34.

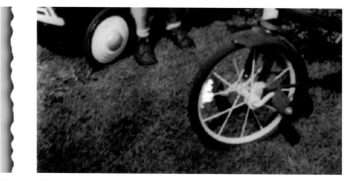

Figure 6.34: *The damaged grass area is restored using the Clone Stamp Tool.*

13. Using the same technique, sample the interior area of the tire, paying careful attention to the spoke in the wheel. Take several samples of the spoke and surrounding grass, until you have restored (to your satisfaction) the interior of the wheel, as shown in Figure 6.35.

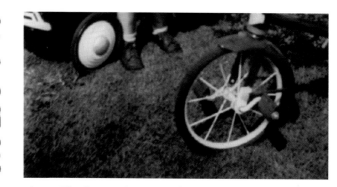

Figure 6.35: *The damaged interior of the wheel, including the missing spoke, has been restored using a careful application of the Clone Stamp tool.*

Reducing Image Tint with Hue/Saturation

The sepia color in our photograph is not a part of the original image. Image tints are commonly caused by traces of photographic chemicals left on the paper, and over the years the chemicals react with the environment causing the image to turn brown, sepia, or even yellow.

Now that the major problems with the image are solved, we'll reduce, but not eliminate the sepia color by using the Hue/Saturation adjustment tool.

1. Flatten the image (or a copy of the layered image) by selecting Flatten Image from the Layers palette options.
2. Select Image - Adjustments, and choose Hue/Saturation from the available options, as shown in Figure 6.36.

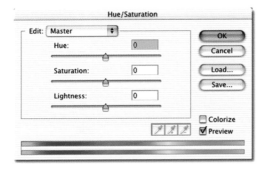

Figure 6.36: *The Hue/Saturation adjustment tool gives you the ability to reduce the color cast caused by the aging of an image.*

3. To reduce the sepia tone of the image without affecting other image components, select the Saturation slider and drag to the left until you see a –50 in the Saturation input field, or type "-50" in the input field (sometimes it's faster to enter the number, especially when you're tired).
4. Click OK to change the image, as shown in Figure 6.37.

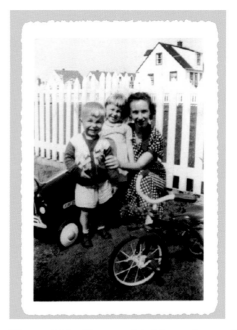

Figure 6.37: *The completed image is very different from the original photograph with its faded look and damaged areas.*

WORKSHOP 5 – REMOVING UNWANTED OBJECTS FROM A PHOTOGRAPH

Ever have this happen...you take a photograph of your favorite uncle, only to realize later that there's a pole or other object sticking out of his head. In this example, a light fixture on the left side of Uncle Pat's face detracts from the image, as shown in Figure 6.38.

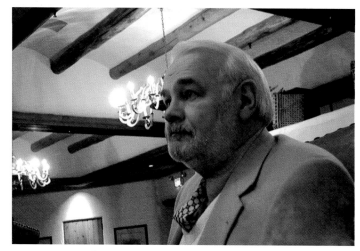

Figure 6.38: *The image is fine, except for that annoying light fixture.*

Let's start by removing the light fixture where it interacts with the wooden beam. This should be relatively easy because the image contains a large area of unobstructed beam. You will remove the light on the beam by copying a section of the beam on the left of the fixture and covering the offending section.

Photoshop has an abundance of selection tools and techniques; however, for this selection, we'll use the Pen tool.

Although Photoshop has many ways to create selections, one of the most versatile tools is the Pen tool. Once you master the use of the creating vector paths with pen points, you'll never want to return to the days of crawling-ant marquees. I strongly recommend getting comfortable with Photoshop's Pen tool.

1. Select the Zoom tool and enlarge the area of the screen that contains the wooden beam.
2. Select the Pen tool from the toolbox, and create a path around the beam. The beam represents a rectangular shape, so click once in each corner of the wooden beam to create the path, as shown in Figure 6.39.

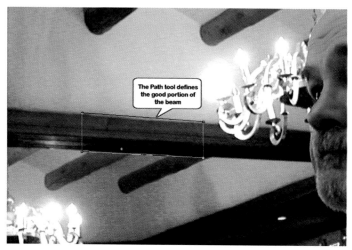

Figure 6.39: *Clicking once in each corner creates a rectangular path around the wooden beam.*

Avoid selecting the area of the beam that contains the reflection of the second light fixture.

3. Select the Paths palette by clicking on the Paths tab. If the Paths palette is not visible, select Window and choose Paths from the pull-down menu options.
4. Click on the Paths options button (located in the upper-right corner of the Paths palette), and choose Make Selection from the available options. Select a Feather Radius of 1, as shown in Figure 6.40.

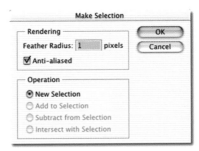

Figure 6.40: *The Make Selection dialog box lets you convert an existing path into a selection.*

5. Click the OK button to convert the path into a selection.

 The Pen path you created in step 2 now becomes a selection with a 1-pixel feather. If the path is not exactly what you want, choose the Direct Selection tool from the toolbox before converting the path into a selection. This gives you the ability to click on and move the individual pen points.

6. Return to the Layers palette by clicking the Layers tab.
7. Press CTRL+J (CMD+J: Macintosh). This instructs Photoshop to make a copy of the selected area (the wooden beam) and place the data into a separate layer.
8. Select the Move tool from the toolbox, and click and drag in the document window. Notice that you are moving the copied piece of the wooden beam.
9. Select Edit, and choose Flip Horizontal from the Transform fly-out menu. The layer containing the wooden beam flips horizontally, as shown in Figure 6.41.

Flip Horizontal was chosen for two reasons: the lighting on the left side of the beam blends better with the image if it is horizontally flipped, and flipping the image helps make it look less like a copy.

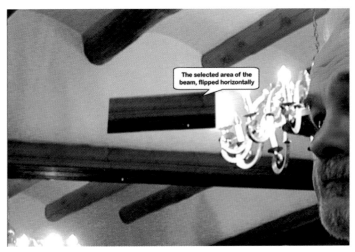

Figure 6.41: *The Flip Horizontal option flips the copy of the wooden beam left to right.*

10. Select Edit, and choose Free Transform from the available options. A bounding box appears around the image, as shown in Figure 6.42.
11. Move your mouse outside the bounding box and drag to rotate the beam counter-clockwise. Stop when the angle of the copied beam visually matches the angle of the original beam, as shown in Figure 6.43.

 If you're frustrated trying to visually align the copied beam with the original, press CTRL+H (CMD+H: Macintosh) to temporarily hide the bounding box. The Free Transform option is still in effect, but without the distracting bounding box. Press CTRL+H (CMD+H: Macintosh) to restore the bounding box.

12. Press the Enter key to apply the Free Transform rotation to the wooden beam.
13. Select the Move tool from the toolbox and move the copied beam into place. Don't worry if the beam covers part of Uncle Pat's face (it probably will). Work to visually align the beams, as shown in Figure 6.44, and we'll take care of the overlap problem later.

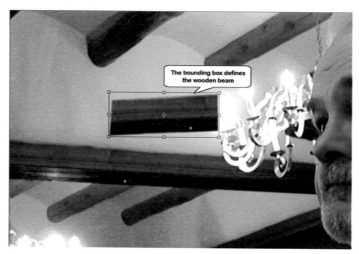

Figure 6.42: *The Free Transform command places a modifiable bounding box around the wooden beam.*

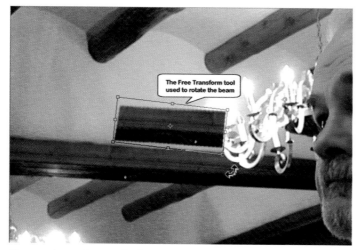

Figure 6.43: *Rotate the beam until the angle matches that of the original image.*

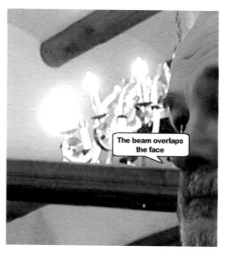

Figure 6.44: *The copied wooden beam replaces the lighting fixture, with a slight overlap onto uncle Pat's face.*

Organizing the Project

Start organizing this project by naming the individual layers. The Layers palette contains two layers: One named Background (the original image), and another named Layer 1 (containing the copy of the wooden beam).

Move your mouse into the Layers palette and double-click on the name Layer 1. This automatically selects the name of the layer. Now rename this layer wooden_beam.

Dealing with Repetitive Areas

The beam is restored except for one problem. The original beam contained a circular area with a small white spot. That area was copied and now we have two white spots, almost like a mirror image. This is where we call in the Clone Stamp tool to correct the problem.

1. Select the wooden beam layer from the Layers palette.
2. Select the Clone Stamp tool from the toolbox, and choose a small, soft brush. In this example, I selected a 20-pixel brush.
3. Click your mouse while holding down the Alt key (Option key: Macintosh) to sample the beam in between the two circular areas, as shown in Figure 6.45.

4. Move the Clone Stamp tool to the right, and click and drag the mouse, using small circular motions, to cover the circle, as shown in Figure 6.46.

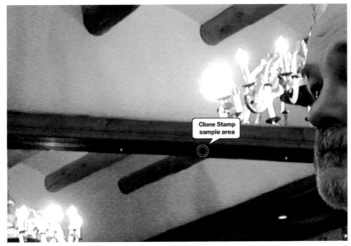

Figure 6.45: *Sample the area in between the two circular areas.*

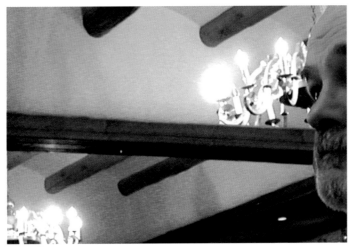

Figure 6.46: *The Clone Stamp tool replaced the circular area of the beam.*

WORKSHOP 6 – REMOVING THE REMAINDER OF THE LIGHTING FIXTURE

The next step is to remove the lighting fixture from the ceiling. As you can see, the image contains an area to the left of the fixture that might be used to cover the fixture. In addition, notice how the wall gets darker as it moves away from the light source.

While the obvious choice for removing the light fixture might be the Clone Stamp tool, the shifting brightness of the wall from light to dark would make this difficult to accomplish.

Another method would be to select a portion of the wall, and copy it over the lighting fixture. Although this would work, there is not enough of the wall to cover the upper portion of the wall.

To solve this problem, we're going to use a combination of color samples, the Gradient tool, and a couple of filters.

1. Select the Zoom tool from the toolbox and zoom in on the light fixture and the ceiling area to the left.

2. Select the Pen tool and create a path around the light fixture, paying close attention to the curved areas at the top of the ceiling and the outline of the face, as shown in Figure 6.47.

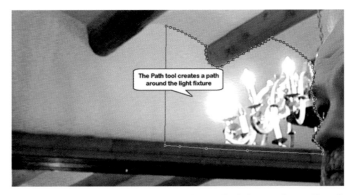

Figure 6.47: *The Path tool created a path defining the wall and the lighting fixture.*

 Because the wooden beam is in a separate layer, we've extended our path to include some of the beam.

3. Select the Paths palette by clicking on the Paths tab. If the Paths palette is not visible, select Window and choose Paths from the pull-down menu options.
4. Click on the Paths options button (located in the upper-right corner of the Paths palette), and choose Make Selection from the available options. Select a Feather Radius of 2.
5. Click the OK button to convert the path into a selection, as shown in Figure 6.48.

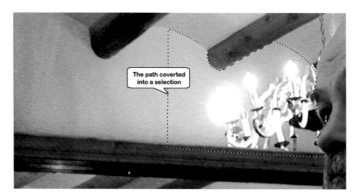

Figure 6.48: *The path converted into a selection with a 2-pixel feather.*

6. Select the Eyedropper tool from the toolbox.
7. Click the Sample Size option in the Options Bar, and change the Sample Size to 3 by 3 Average, as shown in Figure 6.49.

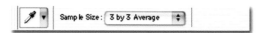

Figure 6.49: *Choose 3 by 3 Average for the Eyedropper Sample Size.*

8. Move the Eyedropper tool into the image and click your mouse on the left center border of the selection marquee. This changes the default foreground color to the sampled area, as shown in Figure 6.50.

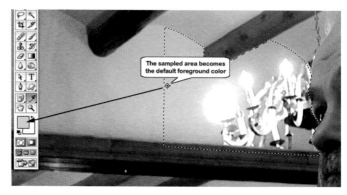

Figure 6.50: *Clicking the Eyedropper tool within the image changes the foreground color to match the sample area.*

9. Move the Eyedropper tool to the left about one inch from the left edge of the image, and click the mouse while holding down the Alt key (Option key: Macintosh). This changes the default background color to match the sampled area, as shown in Figure 6.51.

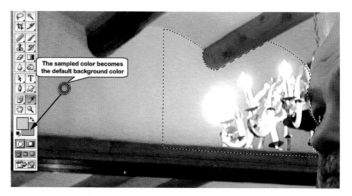

Figure 6.51: *clicking the Eyedropper tool while holding down, the Alt key (Option key: Macintosh) changes the background color to match the sample area.*

10. Create a new layer directly above the background layer. Name the new layer gradient, as shown in Figure 6.52.

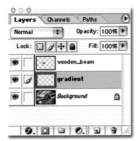

Figure 6.52: *The Layers palette contains three layers: wooden_beam, gradient, and Background.*

11. Select the layer named gradient.
12. Select the Gradient tool from the toolbox. Use a linear gradient, and choose the Foreground to Background option from the Gradient list on the Options Bar.
13. Drag the Gradient across the selected area from left to right, as shown in Figure 6.53.

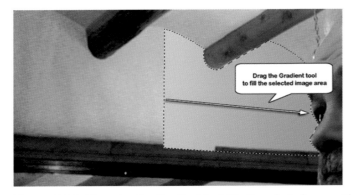

Figure 6.53: *Dragging the Gradient tool fills the selected area with a linear gradient using the foreground and background colors.*

14. Press CTRL+D (CMD+D: Macintosh) to deselect the selection marquee.
15. Move into the Layers palette, and choose the Lock Transparent Pixels option, shown in Figure 6.54. This prevents the transparent pixels in the gradient layer from being changed.

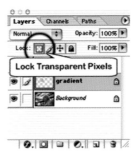

Figure 6.54: *The Lock Transparent Pixels option prevents the transparent pixels from changing.*

16. Select Filter and choose Add Noise from the available Noise options.
17. Choose a noise Amount of 3 percent, Gaussian Distribution, and Monochromatic, as shown in Figure 6.55. Click the OK button to apply the changes to the gradient layer.

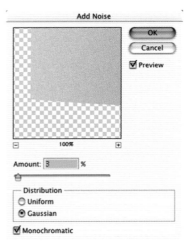

Figure 6.55: *The Noise dialog box adds a predefined amount of noise to the gradient selection.*

18. Select Filter and choose Motion Blur from the available Blur options.
19. Choose a –6 Angle and a Distance of 6 pixels, as shown in Figure 6.56. Click the OK button to apply the changes to the gradient layer.

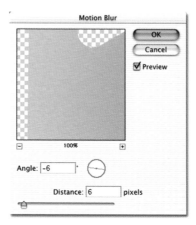

Figure 6.56: *The Motion Blur dialog box lets you blur the pixels within the gradient layer.*

 Using the Noise and Motion Blur filters on the gradient layer creates a surface texture that emulates the look of the real wall.

20. Select the gradient layer and unlock the transparent areas of the image, which you locked in step 15 by clicking once on the Lock Transparent Areas icon.
21. Select the Eraser tool from the toolbox and choose a medium size, soft brush. In this example, I selected a 65-pixel, soft brush.
22. Erase the area of the gradient that overlaps the wooden beam, as shown in Figure 6.57.
23. Using the Eraser tool, move carefully up and down the left edge of the gradient where it interacts with the real wall, using a left-to-right wavy motion. Stop when the gradient blends seamlessly with the real wall, as shown in Figure 6.58.

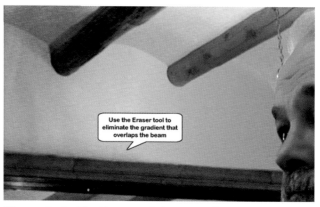

Figure 6.57: *The Eraser tool eliminates the area of the gradient that overlaps the wooden beam.*

Figure 6.58: *The lighting fixture has been successfully removed from the image.*

Eliminating the Hanging Chain

There is one more area to fix—the light fixture's hanging chain. Now it's just hanging there with nothing to do. Let's eliminate it using the Clone Stamp tool.

1. Move to the Layers palette and select the Background layer.
2. Select the Zoom tool from the toolbox, and zoom in on the area of the image that contains the chain, as shown in Figure 6.59.

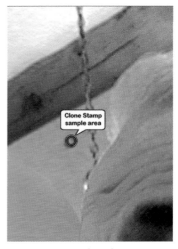

Figure 6.60: *The Clone Stamp sample is taken from the left of the chain.*

Figure 6.59: *The hanging chain in this image needs to be removed.*

3. Select the Clone Stamp tool from the toolbox, and choose a small, soft brush. In this example, I selected a 20-pixel soft brush.
4. Move to the left-center of the lower portion of the chain, and create a sample by clicking your mouse while holding down the Alt key (Option key: Macintosh), as shown in Figure 6.60.
5. Move over to the chain and carefully drag your mouse up and down on the chain, until it blends into the wall, as shown in Figure 6.61.

Figure 6.61: *The Clone Stamp tool successfully removed the lower portion of the chain.*

6. Use the same technique to remove the chain from the wooden beam. Sample the beam, this time to the right of the chain (the dark split in the beam is a good target).
7. Use the dark split to line up the Clone Stamp tool and then drag carefully up and down the beam until the chain is eliminated, as shown in Figure 6.62.
8. Finally, select an area to the left of the final piece of chain, and use the Clone Stamp tool to remove the remaining traces of the lighting fixture, as shown in Figure 6.63.

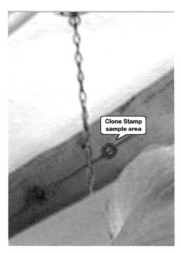

Figure 6.62: *The sample to repair the wooden beam is taken from the right center of the chain, and used to repair the beam.*

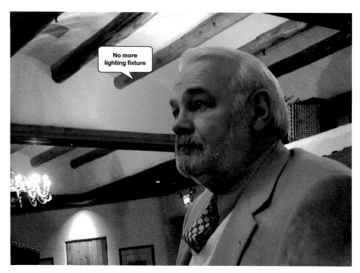

Figure 6.63: *The lighting fixture is successfully removed from the image.*

WORKSHOP 7 – FIXING THE WOODEN BEAM

There is one more small area to fix. If you remember, when we created the copy of the wooden beam, it was lying on top of the image and obscuring part of Uncle Pat's face.

1. Select the Zoom tool from the toolbox, and zoom in on the wooden beam where it interacts with Uncle Pat's face, as shown in Figure 6.64.
2. Turn off the wooden beam layer (click the eyeball icon), to expose the full face.
3. Use the Pen tool to make a path defining the edge of the face, as shown in Figure 6.65.
4. Select the Paths palette by clicking on the Paths tab. If the Paths palette is not visible, select Window and choose Paths from the pull-down menu options.

Figure 6.64: *The wooden beam slightly overlaps Uncle Pat's face.*

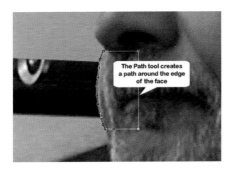

The Path tool creates a path around the edge of the face

Figure 6.65: *The path defines the edge of the face.*

Figure 6.66: *The completed image, sans lighting fixture.*

5. Click on the Paths options button (located in the upper-right corner of the Paths palette), and choose Make Selection from the available options. Select a Feather Radius of 1.
6. Click the OK button to convert the path into a selection.
7. Select and reactivate the wooden beam layer.
8. Click the Delete key to remove the selected area of the beam.
9. The image is now complete, as shown in Figure 6.66.

IMAGE TRICKS WITH PHOTOSHOP

PHOTOSHOP IS SUCH AN AWESOME TOOL. NOT ONLY CAN YOU CORRECT A DAMAGED IMAGE, YOU CAN USE PHOTOSHOP TO CREATE IMAGES THAT NEVER EXISTED IN THE REAL WORLD. FOR EXAMPLE, SAY YOU HAVE AN IMPORTANT FAMILY PHOTOGRAPH, BUT ONE OF THE FAMILY MEMBERS IS MISSING.

YOU HAVE TWO CHOICES: THE FIRST CHOICE IS TO TAKE ANOTHER PHOTOGRAPH AND INCLUDE THE MISSING FAMILY MEMBER. UNFORTUNATELY, IT COULD BE DIFFICULT TO REPLICATE THE EXACT CONDITIONS OF THE ORIGINAL IMAGE; IN MANY CASES, IT'S DOWNRIGHT IMPOSSIBLE.

IF YOU HAVEN'T ALREADY GUESSED, THE SECOND CHOICE IS TO ADD THE MISSING FAMILY MEMBER TO THE IMAGE USING PHOTOSHOP. THE TRICK IS PICKING THE CORRECT IMAGES AND KNOWING WHAT PHOTOSHOP TOOLS WILL DO THE JOB FOR YOU.

HOWEVER, IF YOU THINK YOU'RE LIMITED SIMPLY TO ADDING OR SUBTRACTING IMAGE INFORMATION, YOU ARE MISTAKEN. IN ADDITION TO IMAGE TRICKERY, PHOTOSHOP CAN BE USED, (IN CONJUNCTION WITH ADOBE ILLUSTRATOR) TO CREATE DETAILED VECTOR CLIPART FROM AN ORDINARY PHOTOGRAPH, OR SKIP ADOBE ILLUSTRATOR ALTOGETHER, AND USE THE POWER OF PHOTOSHOP TO CONVERT IMAGES INTO REALISTIC CHARCOAL SKETCHES. THIS WORKSHOP COVERS A FEW OF THE TRICKS YOU CAN PERFORM ON AN IMAGE.

WORKSHOP 1 – ADDING IMAGE INFORMATION: THE CASE OF THE MISSING PERSON

Okay, you have this picture, but the third member of the team is missing, as shown in Figure 7.1.

Figure 7.1: *This picture is missing someone.*

As previously stated, the trick is getting the correct images. In many cases, the missing person can be photographed later and added to the image, as shown in Figure 7.2.

Figure 7.2: *The image of the missing person was shot after the event.*

Things to consider when merging two images into one:

* The images should be in the same color space. For example, if the original image was photographed in RGB (red, green, and blue), the merge image should be taken (or scanned) in RGB.
* The resolution of the two images should match, or be very close.
* The lighting in the two images should match. For example, if the image was taken outdoors in the early afternoon sun, the second image should be taken at the same time and conditions (early afternoon, sun).
* Blend the two images in non-obvious ways. For example, if you're merging a head onto another body, don't simply merge the facial features; include the neck and parts (if feasible) of the chest and shoulders. When you blend two images together, the viewer's eyes will look in the obvious areas for traces of the merge. Avoiding these areas will help make the merge operation more realistic.

In this example, both images were taken using relatively the same lighting, and the resolution and color mode match. As you can see, our image (Figure 7.2) has two problems; it is larger than required, and it is slightly out of focus. Both of these problems can be solved in Photoshop.

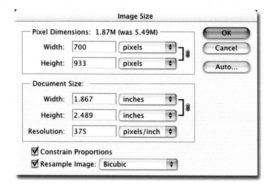

Figure 7.3: *The Image Size dialog controls the width and height of the image.*

Reducing the Image

Let's begin by reducing the size of the image. Click once in the window containing figure 2, and perform these steps:

1. Select Image - Rotate Canvas, and choose 90 CW to rotate the image 90 degrees clockwise.
2. Double-click on the Hand tool to fit the image to the available monitor size.
3. Select Image, and choose Image Size from the fly-out menu.
4. Select the Constrain Proportions option, and enter a Width of 700 pixels, as shown in Figure 7.3. Click the OK button to apply the Image Size adjustment.
5. Move into the Layers palette and drag the Background layer (the layer containing the image) into the document window of figure 1. Rename the layer Mike, as shown in Figure 7.4.

Sharpening and Positioning the Image

The next step is to bring the image into focus and remove certain portions of the image.

1. Select Filter - Sharpen, and choose Unsharp Mask from the fly-out menu. Choose an Amount of 150 percent, a Radius of 1.7 pixels, and a Threshold of 3 levels. Click OK to apply the Unsharp Mask to the Mark layer, as shown in Figure 7.5.

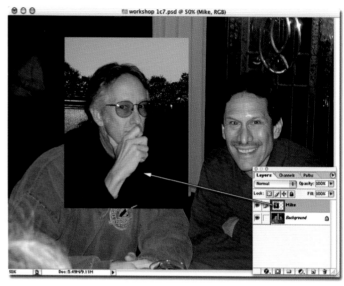

Figure 7.4: *Clicking and dragging the layer creates a copy in the second document.*

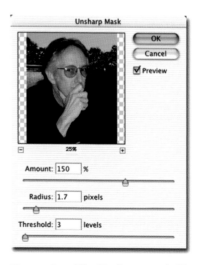

Figure 7.5: *The Unsharp Mask filter successfully brings the image into focus.*

2. Deactivate the Mike layer by clicking once on the eyeball icon, located to the left of the layer name.

3. Select the Lasso tool, and create a rough selection between the two gentlemen in the image, as shown in Figure 7.6.

 The rough selection is based on where you want the Mike layer to be displayed.

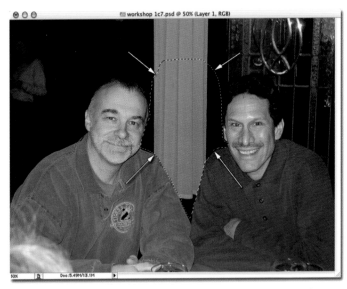

Figure 7.6: *Create a rough selection area between the two figures in the image.*

4. Reactivate the Mike layer, and click the Add layer mask icon, located at the bottom of the Layers palette, as shown in Figure 7.7.

The Add layer mask icon creates a mask based on the rough selection created between the two gentlemen in the image.

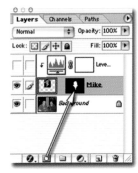

Figure 7.7: *Add a layer mask to the Mike layer.*

5. Select the Move tool, and click once on the chain icon, located between the image thumbnail and the mask thumbnail. This lets you move one of the layer elements (mask or image) without moving the other.

6. Click once on the image thumbnail in the Mike layer. Then move into the document window, and click and drag the image of Mike until he is correctly positioned between the other two gentlemen.

7. Click once on the mask thumbnail in the Mike layer. This activates the mask, and lets you make changes without impacting the image.

8. Select the Paintbrush, and choose a small, soft brush. In this example, I chose a 30-pixel softly feathered brush.

9. Choose black for your Foreground Color Swatch, and carefully paint around the top of Mike's head. You are painting the mask with black, so the areas of image associated with the black paint become transparent, as shown in Figure 7.8.

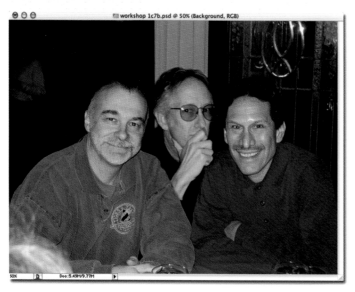

Figure 7.8: *The layer mask controls the visible areas of the image.*

⚠ If you paint too much out of the image, switch the color to white to restore image information. Remember: black removes, and white restores.

10. Move lower and touch up the mask around the shoulders and hands. In this image, Mike's hand was painted in to appear in front of the actor on the right.

⚠ It will take a bit of practice, but the results are impressive. Remember, the layer mask controls the visible elements of the Mike layer. As you work, remember to click on the image thumbnail when you need to move Mike, and click on the mask thumbnail when you need to paint the mask.

Balancing Image Light Levels

For the final step, you need to tone down the brightness levels of the Mike layer.

1. Move into the Layers palette and click once on the Mike layer. (This makes the Mike layer the active layer.)
2. Select Image - Adjustments, and choose Levels from the fly-out menu.
3. Select a mid-tone level adjustment of 0.85, as shown in Figure 7.9.
4. Click the OK button to apply the change to the image, as shown in Figure 7.10.

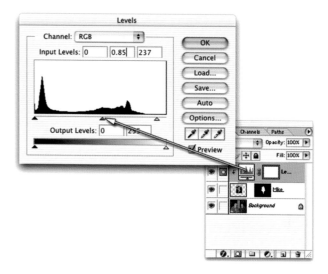

Figure 7.9: *The mid-tone levels adjustment balances the light levels in the Mike layer with the original image.*

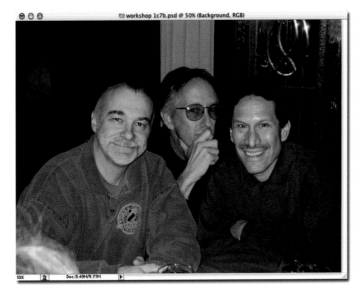

Figure 7.10: *The three amigos united once again.*

WORKSHOP 2 – CREATING CLIPART FROM A PHOTOGRAPH

Clipart, by definition, are non-photographic images, lacking the soft edges and shading evident in a photograph. However, what they lack in realism, they more than make up for in dynamic colors. Clipart can grab the attention of a viewer where a normal photograph would be passed over.

In addition, because of the sharp edges and solid colors associated with clipart, you can significantly reduce file sizes by either converting the image from raster (Photoshop) to vector (Illustrator) or skipping Photoshop altogether and designing the image in Adobe Illustrator.

In this example, you will take a raster image and convert it into a vector image, using Photoshop and Adobe Streamline.

Preparing the Image

The first step is the preparation of the image. Attempting to create a clipart image from a standard photograph would create a complex vector image. The problem is that Adobe Streamline will attempt to create vector shapes based on the colors in the image. You will solve this problem by reducing the number of colors in the image.

Open the file named patty.tif, from the Chapter 7 workshop folder, and perform these steps:

1. Select Image - Adjustments, and choose Posterize from the fly-out menu, as shown in Figure 7.11.

Figure 7.11: *The Posterize adjustment controls the number of colors within the active image.*

2. Enter the number 25 in the input levels, and click OK to apply the adjustment to the image, as shown in Figure 7.12.

 The purpose of using Posterize is to reduce the colors down to a manageable level. You're looking for a Levels input value that reduces color, not detail. If the image appears too blocky, increase the number of levels.

3. Select Filter - Artistic, and choose Cutout from the fly-out menu. The Cutout filter will solidify major color areas within the image.
4. Enter 7 for Number of levels, 1 for Edge Simplicity, and 3 for Edge Fidelity. Click OK to apply the Cutout filter to the image, as shown in Figure 7.13.
5. Select File - Save As, and name the converted image Patty2. Save the image in the tiff format, without using any of the compression options.

Figure 7.12: *The Posterize adjustment applied to the image.*

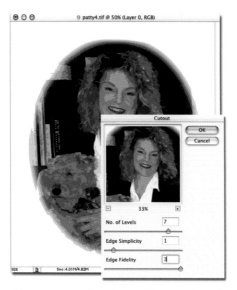

Figure 7.13: *The Cutout filter combines large, similar color areas into solid colors, creating a clipart look to the image.*

Working with Streamline

Adobe Streamline is a conversion program that converts raster images into vector images. Open Adobe Streamline, select File - Open, and open the patty2.tif file.

1. Select Options, and choose Color and B&W Settings from the pull-down menu.
2. Select Unlimited Colors from the Posterization pop-up menu, and an Edge Smoothing of Medium. Finally, select 15 for Complexity, and check Color Averaging, as shown in Figure 7.14.

Figure 7.14: *The Color Settings control the conversion of the raster image into a vector.*

3. Click the OK button to save the conversion settings.
4. Select File, and choose Convert to apply the color settings to the image, as shown in Figure 7.15.
5. To save the newly created vector image, select File, and choose Save As from the pull-down menu.
6. Select Illustrator from the available format options. Streamline will automatically rename the file patty.ai.

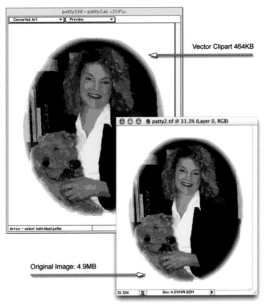

Figure 7.15: *The converted vector image, compared to the original raster image.*

There are very strong arguments for using vector images instead of raster images:

✳ The images are smaller: The patty.tif file is 4.9mb, and the converted patty.ai file is only 464kb.

✳ Vector images are not resolution dependent. That means you can resize a vector image without loss of image quality (not true of raster images).

✳ Vector images are becoming increasingly popular, and they can be used in a variety of Web-based applications, including Adobe LiveMotion and Macromedia's awesome Web animation application, Flash. The smaller file sizes give vector graphics the ability to download quickly, and speed is essential if you want to keep your visitor's attention.

WORKSHOP 3 – CREATING A CHARCOAL SKETCH FROM SCRATCH

Photoshop has a multitude of filters. In fact, there are more than 100 filters located under the Filters drop-down menu. Included within those filters is a series of Sketch filters, and one in particular, named Charcoal. The Charcoal filter produces interesting results, as demonstrated in Figure 7.16.

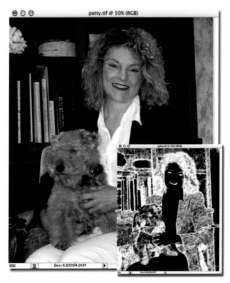

Figure 7.16: *The Charcoal filter applied to an image.*

However, using the Charcoal filter is not the only way to achieve a charcoal look. By following the workshops throughout the book, you should notice a pattern: you never use a single filter or adjustment. Creative and restorative work in Photoshop requires a combination of filters and adjustments. In fact, Adobe never intended Photoshop to be a "one-click-and-you're-done" program. Good design requires knowledge of all the filters and adjustments within Photoshop and the skill to combine two or more of Photoshop's elements to produce the final image. Which brings us back to the question at hand: How do you create a charcoal sketch without using the Charcoal filter? Let's find out.

Working the Image

The charcoal effect requires filters, adjustments, and blending modes, and is applicable to almost any image. However, the best images to use are those with bright colors and sharp contrast. To create the charcoal effect, open the patty.tif image used in the previous workshop, and perform these steps:

1. Select Image - Adjustments, and choose Posterize from the pull-down menu. Select a Levels value of 16, and click the OK button to apply the Posterize adjustment to the image.
2. Press CTRL + J (CMD + J: Macintosh) to create a copy of the Background layer, as shown in Figure 7.17.

Figure 7.17: *The CTRL + J command creates a copy of the selected layer.*

3. The Background copy layer retains the attributes of the Background layer, so you need to deselect the Lock position option. Click the Lock position icon located at the top of the Layers palette, as shown in Figure 7.18.

Figure 7.18: *The Lock position icon prevents the contents of a layer from being moved.*

4. Click the Blending mode button and select Difference from the blending mode options. The image will go black, as shown in Figure 7.19.
5. Select the Move tool, and press the right arrow key twice and the down arrow key twice. When you select the Move tool, the arrow (or nudge) keys are linked to the active layer (Background copy). By offsetting the image, the Difference blending mode creates a color outline of the original image, as shown in Figure 7.20.
6. Press CTRL + E (CMD + E: Macintosh) to merge the Layer 1 copy layer back into the Background layer.
7. Select Image - Adjustments, and choose Invert from the fly-out menu. This inverts the colors in the image and creates the beginning of the sketch effect.
8. To remove the color from the photo, select Image - Adjustments, and choose Desaturate from the fly-out menu, as shown in Figure 7.21.
9. Press CTRL + J (CMD + J: Macintosh) to make a copy of the Background layer.
10. Select the Background copy (named Layer 1).
11. Select Image - Adjustments, and choose Threshold from the fly-out menu. Select a Threshold Level of 240, and click OK to apply the Threshold adjustment to the image, as shown in Figure 7.22.

Figure 7.19: *The Difference blending mode converts the viewable image in the document window to black.*

Figure 7.21: *The Desaturate adjustment converts the colors in the active layer to shades of gray.*

Figure 7.20: *The offset image creates a colored sketch outline of the original image.*

Figure 7.22: *The Threshold adjustment converts the colors in the image into black and white.*

12. Deactivate Layer 1, and select the original Background layer.
13. Select Image - Adjustments, and choose Equalize from the fly-out menu, as shown in Figure 7.23.
14. Reselect Layer 1, then choose Filter Brush Strokes, and select Sprayed Strokes from the fly-out menu.
15. Choose a Stroke Length of 18 and a Spray Radius of 20. The Stoke Direction is optional; in this example, I chose Right Diagonal. Click the OK button to apply the Sprayed Strokes filter to the image, as shown in Figure 7.24.
16. Move into the Layers palette and change the blending mode for Layer 1 to Soft Light, as shown in Figure 7.25.

Figure 7.23: *The Equalize adjustment brings out detail in the active layer.*

Figure 7.24: *The Sprayed Strokes filter distorts the sketch lines.*

Figure 7.25: *The Soft Light blending mode blends the background image with Layer 1.*

Adding Image Detail

The final step is to add a bit of image detail back into the image. This will give the sketch depth and character.

1. Select the original Background layer.
2. Click the Create a new layer icon, located at the bottom of the Layers palette. In turn, a new layer is created (named Layer 2) directly above the Background.
3. Select the History brush, and paint back a portion of the image. In this example, I painted the model's body and the dog back into the image. Because the Soft Light blending mode is applied to Layer 1, a portion of the image blends through the layer.
4. To maintain the charcoal effect, select Image - Adjustments, and choose Desaturate from the fly-out menu. This reduces the colors in Layer 2 to shades of gray, as shown in Figure 7.26.
5. To illustrate the versatility of this process, Figure 7.27 displays the sketch workshop applied to a portrait image.

Figure 7.26: *The Desaturate command converts the colors in the image into shades of gray.*

Figure 7.27: *The sketch effect applied to the patty.tif file.*

WORKSHOP 4 – COLORIZING A SKETCH OR LINE ART DRAWING

In the previous workshop, you converted an image into a sketch. Typically, sketches are created using shades of gray; however, line art and (sometimes) sketches can benefit from a bit of added color. In this workshop, you will breath the life of color into a sketch and a piece of line art. First you will take a sketch created from a photograph and add detail and color from the original image. Open flowers.tif from the Chapter 7 workshop folder, and perform these steps:

1. Press CTRL + J (CMD + J: Macintosh) twice, to create two copies of the Background image (named Layer 1, and Layer 1 copy), as shown in Figure 7.28.

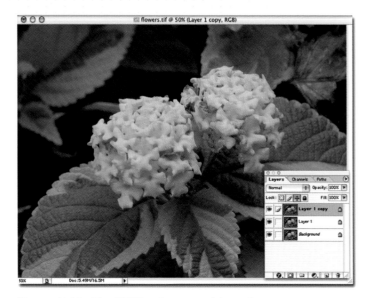

Figure 7.28: *The CTRL + J command is used to create two copies of the Background layer.*

Figure 7.29: *Offsetting the Layer 2 image creates a sketch-like appearance to the image.*

2. The copy layers retain the attributes of the Background layer, so you need to deselect the Lock position option. Click the Lock Position icon located at the top of the Layers palette for Layer 1 (it is not necessary to deselect the Lock position option for Layer 1 copy).

3. Click the Blending mode button and select Difference from the blending mode options. The image will go black.

4. Select the Layer 1 copy, then select the Move tool and press the right arrow key twice and the down arrow key twice. By offsetting the image, the Difference blending mode creates a color outline of the original image, as shown in Figure 7.29.

5. Press CTRL + E (CMD + E: Macintosh) to merge the Layer 1 copy into Layer 1 (the Background layer is still a separate layer).

 When using the CTRL + E command in a multi-layered document, first select the layer you want to merge. When you press CTRL + E, Photoshop will merge the selected layer with the one directly below it.

6. Select Image - Adjustments, and choose Invert from the fly-out menu. This inverts the colors in Layer 1.

7. To remove the color from the photo, select Image - Adjustments and choose Desaturate from the fly-out menu, as shown in Figure 7.30.

8. Select Image - Adjustments, and choose Equalize from the fly-out menu, as shown in Figure 7.31.

9. Click the Blending mode button and select Overlay from the blending mode options. The color from the original image blends into the sketch; however, the facial features are less than desirable, as shown in Figure 7.32.

10. Select the Eraser tool and, with Layer 1 selected, erase the areas of the image that correspond to the foreground flowers. In this example, I also removed the area covering the dog, as shown in Figure 7.33.

The final image contains sections of the original image combined with portions of the sketch. Because every image will be different, you can use the Eraser tool to expose different areas of the image. Experimentation is the key to a successful image.

Figure 7.30: *The Desaturate adjustment removes the color from the image.*

Figure 7.32: *The Overlay blending mode mixes the image elements of Layer 1 with the Background layer.*

Figure 7.31: *The Equalize adjustment brings out the image detail.*

Figure 7.33: *The erased areas of layer 1 create a composite image.*

Working with Line Art

Line art is not a sketch. Where sketches have lines and fills defining the image, line art is typically composed of black lines on a white background (hence the name, line art). However, both sketches and line art can benefit from a little color. Colorization of line art is fairly simple; the trick is to isolate the line art colors in a separate layer and use selection to define the areas that require coloring.

To colorize a piece of line art, open the bus.tif file located in the Chapter 7 folder on the companion Web site, and perform these steps:

1. Click the Add new layer icon, located at the bottom of the Layers palette.
2. Rename the layer color, and move the layer underneath the bus layer, as shown in Figure 7.34.

Figure 7.34: *The color layer will contain all the colors used in the image.*

3. Change the blending mode of the bus layer to Multiply.

 The Multiply blending mode will blend the colors you add to the color layer, while preserving the black lines of the artwork.

4. Reselect the color layer (this layer will remain selected throughout this workshop).
5. Select the Magic Wand tool from the toolbox. Choose a Tolerance value of 15, and select Use All Layers, Contiguous, and Anti-aliased, as shown in Figure 7.35.

Figure 7.35: *The Magic Wand tool lets you select areas based on a shift of brightness of the image pixels.*

6. Hold down the Shift key and click inside each one of the letters (the Shift key lets you add to a selection). You should have the interior of each one of the letters selected.
7. Choose Select - Modify, and choose Expand from the fly-out menu. Expand the selection by 1 pixel.
8. Click once on a color in the Color Swatches palette. In this example, I chose a deep cyan color.
9. Press Alt + Backspace (Option + Delete: Macintosh) to fill the selected areas with the color, as shown in Figure 7.36.

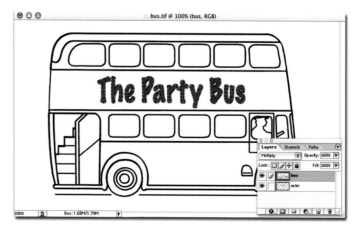

Figure 7.36: *The Alt + Backspace command fills the selected area with the current foreground color.*

10. Using the Magic Wand, select the area of the bus behind the letters, paying attention to select the interiors of the letters e, p, a, and b.

11. Expand the selection (Select - Modify, Expand) by 1 pixel, and select a color for the selected area. In this example I chose a rainbow, linear gradient to fill the background behind the letters, as shown in Figure 7.37.

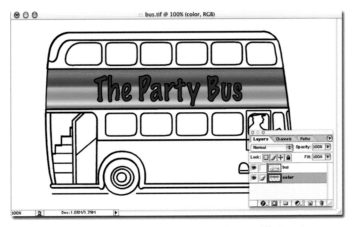

Figure 7.37: *The background behind the letters filled with a rainbow, linear gradient.*

12. Continue moving through the image, using the routine of selecting, expanding, and filling, until all of the image areas are filled, as shown in Figure 7.38.

13. Remember, the colors are placed in the color layer, and the Multiply blending mode lets the colors blend through the bus layer, as shown in Figure 7.39.

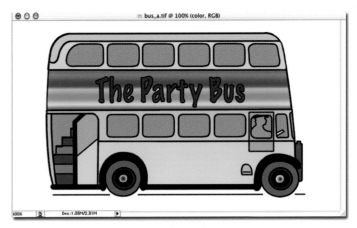

Figure 7.38: *The bus.tif file colorized.*

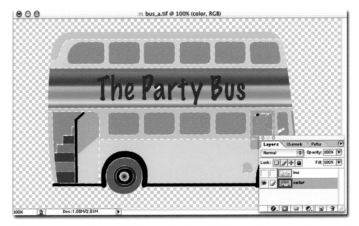

Figure 7.39: *The color layer displays all the colors associated with the bus image.*

Take Line Art to a New Level

To spice up a piece of line art, perform the above steps with one exception: do not expand the selections, just select and fill. Once you have all the areas filled with color, perform these additional steps:

14. Select the color layer.
15. Click the Add a layer style icon, located at the bottom of the Layers palette, and choose Bevel and Emboss from the pop-up menu.
16. Select an Inner Bevel with a Depth of 125 percent and a Size of 7 pixels. Click the OK button to apply the Bevel and Emboss to the image, as shown in Figure 7.40.

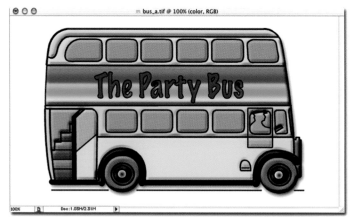

Figure 7.40: *The bus image using the Bevel and Emboss filter on the color layer.*

As you can see, the Bevel and Emboss layer style adds a sense of depth to the otherwise flat line art image. Again, experimentation is the key to a successful image. Try some of the other layer styles, including Gradient Overlay and Stroke, and see what happens. Have fun.

CREATIVE FUN WITH
ALPHA CHANNELS

EVER SINCE LAYERS WERE INTRODUCED TO PHOTOSHOP IN
VERSION 3, MANY DESIGNERS DROPPED CHANNELS TO THE
BOTTOM OF THEIR CREATIVE LIST. CHANNELS, HOWEVER, ARE
VERY IMPORTANT TO THE PHOTOSHOP DESIGNER. IN FACT,
CHANNELS ARE THE GLUE THAT HOLDS A DIGITAL IMAGE
TOGETHER, FOR CHANNELS DEFINE THE VERY COLORS WITHIN A
DIGITAL PHOTOGRAPH.

IF YOU HAVE ANY DOUBT AS TO THE IMPORTANCE OF
CHANNELS, JUST REMEMBER THAT PHOTOSHOP EXISTED
WITHOUT LAYERS FOR SEVERAL YEARS, BUT THERE HAS NEVER
BEEN A VERSION OF PHOTOSHOP WITHOUT CHANNELS.

THIS CHAPTER DEALS WITH THE CONCEPT OF CHANNELS; NOT
ONLY DO WE COVER THEIR ABILITY TO HOLD COLOR
INFORMATION, BUT WE'LL ALSO USE THEM TO CREATE AND
STORE COMPLICATED SELECTIONS. BEFORE WE JUMP INTO A
WORKSHOP, I NEED TO EXPLAIN THE CONCEPT OF CHANNELS
AND HOW THEY DIFFER FROM LAYERS.

UNDERSTANDING ALPHA CHANNELS

Okay, so what exactly are channels? Channels define percentages within a Photoshop image. In their primary role, channels define the percentages of inks used to display image colors. For example, an RGB image contains three individual channels of red, green, and blue. The channels that define an image's colors are know as native color channels, as shown in Figure 8.1.

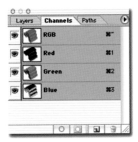

Figure 8.1: *The native color channels of an RGB image.*

Every Photoshop document defines image colors using a unique set of channels. For example, a CMYK image defines color using cyan, magenta, yellow, and black channels, and a grayscale image contains only one channel called gray, as shown in Figure 8.2.

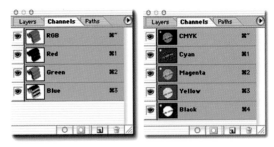

Figure 8.2: *The native color channels for CMYK and Grayscale images.*

In contrast, layers do not define the colors in an image; they display the colors. Think of a layer as a piece of acetate, or clear plastic. For example, when you open an RGB image in Photoshop, the document window displays the image in full color; it is the channels that instruct the computer as to the percentages of red, green, and blue to mix to produce those colors. When you look at the channels, they look like three grayscale images, as shown in Figure 8.3.

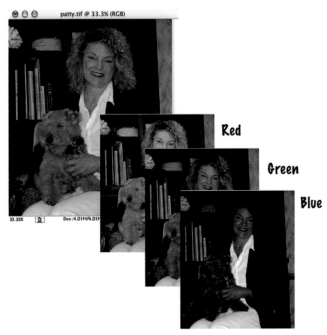

Figure 8.3: *The native color channels are defined using shades of gray.*

Each channel has the capability of displaying 256 steps of gray; or more precisely—1 black, 1 white, and 254 intermediate shades of gray. This is where Photoshop get is the information it needs to display the colors you see. Think of the shades of gray in a particular color channel as masking out color. The deeper the shade of gray, the less color. For example, if the red channel contained an area of pure black, that would instruct Photoshop to use zero percent red. Conversely, if an area of the green channel contained pure white, that would instruct Photoshop to use 100 percent green. Figure 8.4 illustrates the relationship between shades of gray and percentages of ink.

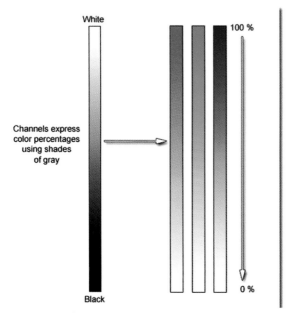

Figure 8.4: *The shades of gray correspond to percentages of color.*

Photoshop combines the percentage combinations of the color channels together, and mathematically mixes the percentages to create the visible colors within the image. Each channel is capable of producing a maximum of 256 steps, so multiplying 256 x 256 x 256 produces 16,777, 215 possible color combinations in an RGB image. To the computer it's all about the math.

Fortunately for us, it is not necessary to become a mathematician because Photoshop takes care of the math internally and displays the colors externally in the document window. However, if you were one of those questioning high school students that believed math would never help you in the "real" world, now you know. Even in the world of creative design, things like math provide a better understanding of what you're doing... the more you know, the more you control.

WORKSHOP 1 – USING ALPHA CHANNELS TO MAKE AND SAVE A SELECTION

Channels control the colors within an image; however, they can do more than mix colors, they can be used to create and store complicated selections. Selection is an important part of Photoshop because selections define the work area of the active image. Say, for example, you want to change the background behind the photograph of the American flag shown in Figure 8.5.

To change the background, you would first need to select it. Selection of the background defines the work area and protects the unselected areas (the flag) from change. With the background selected, you are free to make changes as you see fit, as shown in Figure 8.6.

Figure 8.5: *The background behind this image needs to be changed.*

Figure 8.6: *Selected areas define the changeable areas of an image.*

The problem with selections is their lack of permanence. Say, for example, you change the background and decide to try a different background two days later. Selections are not automatically saved with an image, so you will be required once again to reselect the flag's background.

Fortunately, you can use a channel to solve the problem of preserving a selection. To use a channel to preserve a selection, open the Chapter 8 folder on the CD, open the flag.tif file, and perform these steps:

1. Select the area surrounding the flag. In this example, I used the Magic Wand with a Tolerance of 32. First, I selected the sky in the background with a single click. Then, holding down the Shift key, I added the two interior areas between the flag and the pole added to the selection, as shown in Figure 8.7.

Figure 8.7: *The background selected around the American flag.*

2. Now, activate the Channels palette. If the Channels palette is not visible, select Window, and choose Channels from the pull-down menu.
3. Click the Create a new channel icon located at the bottom of the Channels palette. Photoshop creates a new channel and names it Alpha 1, as shown in Figure 8.8.
4. Press the Delete key to remove the sky portions of the image from the Alpha 1 channel (your background color swatch must be white, or this operation will not work), as shown in Figure 8.9.

 You have created a selection mask. The white areas of the mask (the sky) represent the selected areas of the image, and the black areas (the flag) represent the masked areas.

5. Double-click on the name Alpha 1, and rename the channel sky.
6. Save the image in psd format using the name flag2.psd.

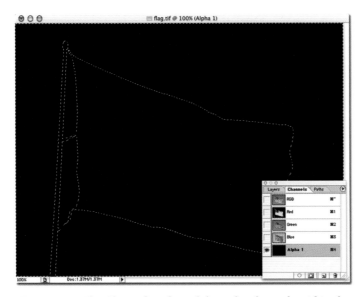

Figure 8.8: *The Channels palette defines the channels within the active image.*

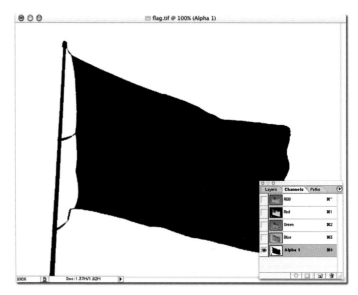

Figure 8.9: *The flag, with the background removed.*

Using Alpha Channel Selections

Alpha channel selections are saved with the Photoshop document, so they can be reactivated any time they're needed. To reactivate an alpha channel selection, open the flag2.psd image, and perform these steps:

1. Open the flag2.psd image. Notice that the sky is no longer selected. Selection boundaries are not saved with the file.
2. To reselect the sky, choose Select, and choose Load Selection from the pull-down menu.
3. Click the Channel bar, and choose sky from the available options. Leave the remainder of the options on their default values, as shown in Figure 8.10.
4. Click the OK button to load the selection, as shown in Figure 8.11.

As you can see, the selection was recreated with the click of a button. Alpha channel selections are easy to create and can save you time. The next time you create a complicated selection and you think you might use it again, simply save it as an alpha channel.

Figure 8.10: *The Load Selection dialog box.*

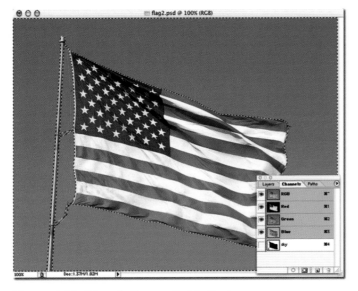

Figure 8.11: *The selection applied to the image.*

Modifying an Alpha Channel Selection

Once an alpha channel selection is created, you can add or subtract from the selection by painting directly onto the channel. For example, say you want to select the flag, but not the flagpole. To remove the flagpole, perform these steps:

1. Click and drag the sky channel over the Make new channel icon located at the bottom of the Channels palette. Photoshop creates a copy of the sky channel named sky copy.
2. Double-click on the name sky copy, and rename the channel flag.
3. Click once on the flag channel. Photoshop displays the flag channel in the document window, as shown in Figure 8.12.

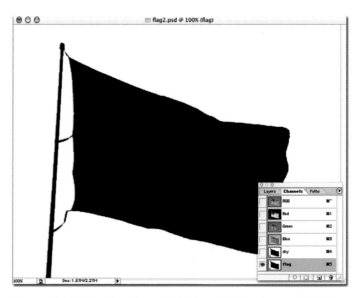

Figure 8.12: *The flag channel displayed in the document window.*

4. Select Image - Adjustments, and choose Invert from the fly-out menu. This defines the flag and the flagpole as the selected portions of the image.

5. Select the Paintbrush, and paint out the flagpole using a foreground color of black, as shown in Figure 8.13.

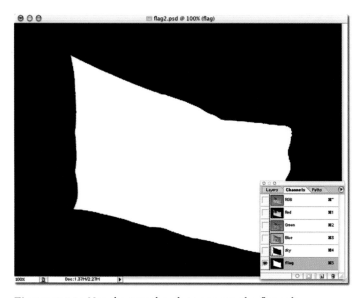

Figure 8.13: *Use the paintbrush to remove the flagpole.*

6. Reactive the document by clicking once on the RGB channel icon.

7. To select the flag, choose Select, and choose Load Selection from the pull-down menu. Repeat the steps in the previous segment (using alpha channel selections), except choose flag as the active channel.

As you can see, channels are not just for holding color information; they can be used for saving and holding simple and complicated selections. In the following workshops, you will see some practical applications of channels in the real world.

WORKSHOP 2 – USING ALPHA CHANNEL SELECTIONS TO CREATE AND SAVE UNIQUE IMAGE BORDERS

Unique image borders...you've seen them in magazines and brochures. Instead of a standard straight-edged border around an image, it contains a distinctive edge, as shown in Figure 8.14.

Figure 8.14: *An image containing a unique image border.*

In this workshop, you will create three unique image borders, save them as alpha channels, and use them to create unique borders in other Photoshop documents. When you create alpha channel selections for use in other documents, the width, height, and resolution of the alpha channel is important.

For example, if you move an 800 x 600 alpha channel saved at a resolution of 72 ppi into a 1600 x 1200 document saved at a resolution of 144 ppi, the alpha channel, when it's moved, will be smaller (half its original size). The larger width and height of the new document forces the alpha channel into a smaller area, as shown in Figure 8.15.

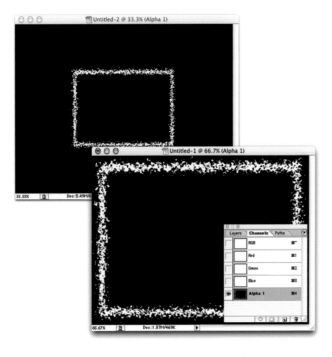

Figure 8.15: *The alpha channel mask moved into an image with a higher width, height, and resolution.*

In this workshop, you will create and move alpha channels into same-sized documents. To create and move unique border channels, select File, and choose New from the pull-down menu. Create a new document with a width and height of 800 x 600 pixels, a resolution of 72 ppi, and the RGB color mode, as shown in Figure 8.16.

Figure 8.16: *The New document window.*

Creating a Spatter Border

1. Activate the Channels palette, and click once on the Create a new channel icon located at the bottom of the Channels palette. Photoshop creates a new channel called Alpha 1.
2. Double-click on the name Alpha 1, and rename the channel spatter.
3. Select the Rectangular marquee tool and create a rectangle within the spatter channel with a 50-pixel edge, as shown in Figure 8.17.
4. Choose Select, and choose Inverse from the pull-down menu. Photoshop reverses the selection.
5. Press the Delete key (make sure white is your background color) to fill the border section with white.
6. Click and drag the spatter channel over the Create a new channel icon. Photoshop creates a copy of the spatter channel named spatter copy.
7. Repeat step 6 and create a second copy of the spatter channel named spatter copy 2.
8. Rename one of the copy channels sprayed and the other channel freeform.
9. Press CTRL + D (CMD + D: Macintosh) to deselect the marquee border.
10. Select the spatter channel.
11. Select Filter - Brush Strokes, and choose Spatter from the fly-out menu. Select a Spray Radius of 20 and a Smoothness of zero. Press the OK button to apply the Spatter filter to the channel, as shown in Figure 8.18.

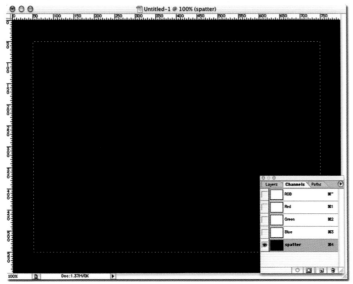

Figure 8.17: *The Rectangle tool creates a selection within the spatter channel.*

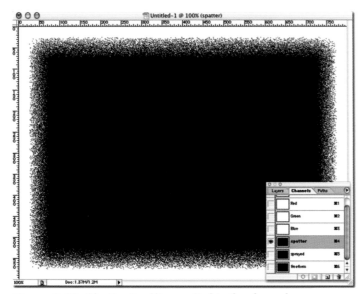

Figure 8.18: *The Spatter filter applied to the channel.*

Creating a Sprayed Strokes Border

1. Select the sprayed channel.
2. Select Filter - Brush Strokes, and choose Sprayed Strokes from the fly-out menu. Choose a Stroke Length of 4, a Spray Radius of 15, and a Stroke Direction of Right Diagonal. Click the OK button to apply the Sprayed Strokes filter to the channel, as shown in Figure 8.19.
3. Select Filter - Distort, and choose Ripple from the fly-out menu. Choose an Amount of 400 percent and a Size of Medium. Click the OK button to apply the Ripple filter to the channel.

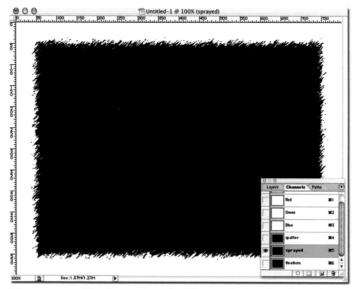

Figure 8.19: *The Sprayed Stroke filter applied to the channel.*

Creating a Freeform Border

1. Select the Freeform channel.
2. Select Filter - Blur, and choose Gaussian Blur from the fly-out menu. Choose a Blur Radius of 10 pixels, and click the OK button to apply the Gaussian filter to the freeform channel, as shown in Figure 8.20.

Figure 8.21: *The chalk dynamic brush will be used to create the edges in the freeform channel.*

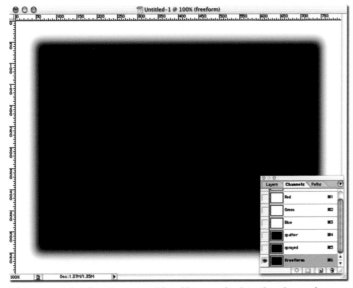

Figure 8.20: *The Gaussian Blur filter applied to the channel.*

3. Select the Brushes palette and choose one of the new dynamic brushes. In this example, I chose the chalk brush, as shown in Figure 8.21.
4. Paint the edges of the black rectangular box using the color white, as shown in Figure 8.22.
5. Select Filter - Brush Strokes, and choose Spatter from the fly-out menu. Choose a Spray Radius of 20 and a Smoothness of 15. Click the OK button to apply the Spatter filter to the freeform channel.
6. Select File, and choose Save As from the pull-down menu. Save the document in psd format using the name edges.psd.

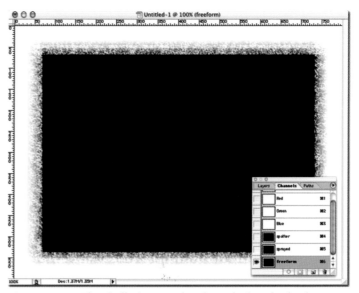

Figure 8.22: *The chalk dynamic brush applied to the freeform channel.*

Applying the Edges to Photoshop Documents

Now that you have created some artistic edges, let's apply them to some images. Open the edges.psd file and the document you want to apply the edges to. In this example, I used the file landscape.psd from the Chapter 8 folder on the CD.

1. Select Window - Documents, and choose Tile from the fly-out menu. In this example, the Tile command placed the reduced-size images within the work area, as shown in Figure 8.23.

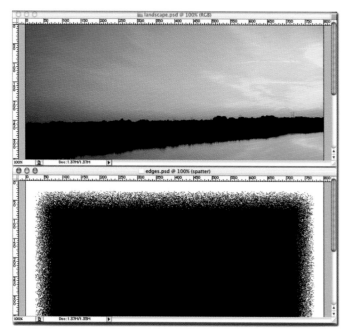

Figure 8.23: *The Tile command divides the work area between the open images.*

2. Click once in the edges.psd document window.
3. Activate the Channels palette, then click and drag one of the channels (in this example spatter) from the Channels palette and drop it in the landscape.psd document window, as shown in Figure 8.24.

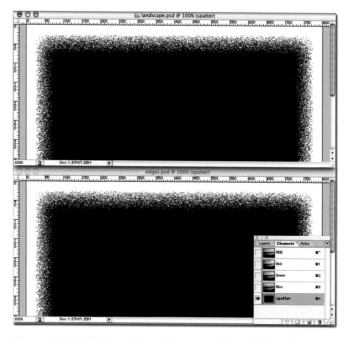

Figure 8.24: *Click and drag the spatter channel from the edges document to the landscape document.*

4. Close the edges.psd file, and expand the landscape.psd file to fill the work area by double-clicking on the Hand tool.
5. Press the letter D on your keyboard to default your foreground and background color swatches to black and white.
6. Click on the RGB channel in the Channels palette to reactivate the color image.

7. To activate the spatter channel, choose Select, and choose Load Selection from the pull-down menu. Choose spatter from the channel options, and click OK to apply the spatter channel selection to the image.

8. Press the Delete key to erase the selected areas of the channel to white, as shown in Figure 8.25.

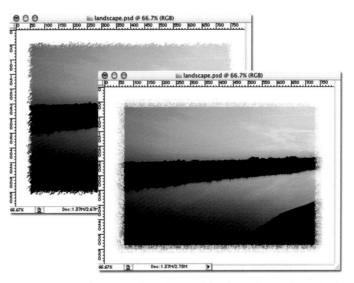

Figure 8.26: *The sprayed strokes and freeform channels applied to the landscape image.*

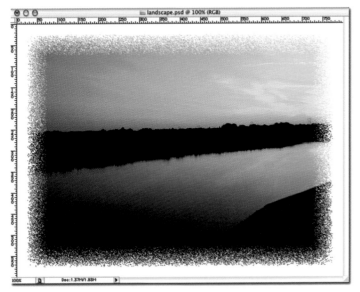

Figure 8.25: *The delete key fills the selected areas with the current background color (white).*

9. Figure 8.26 shows how the landscape.psd file appears with the remaining two alpha channels.

As you can see, alpha channels can be used for more than saving simple image selections. Knowledge of what channels are and how they use black and white to define selections within an image gives you control over a Photoshop document.

WORKSHOP 3 – USING ALPHA CHANNELS TO DEFINE SELECTION PERCENTAGES

In the previous workshops, you created selections and saved them in alpha channels. In an alpha channel, the color white represents selection and the color black represents masked. However, up to this point, shades of gray have not been discussed. Understand that a shade of gray represents a percentage of an area.

If you create an alpha channel using 50 percent gray, the resulting selection area would be 50 percent selected. That may not make a whole lot of sense, but it will become perfectly clear as we work through this workshop exercise.

Say, for example, you want to create motion in a Photoshop image. Photoshop is not an animation program, so you actually want to create the illusion of motion. Photoshop has filters (such as the Motion Blur filter) that

handle the illusion of motion, but the trick is to properly select the areas of the image to blur.

An excellent way to create the illusion of movement in a vehicle is to generate more motion blur at one end of the vehicle; this makes it appear to streak past the camera. However, that involves creating a selection that would apply the motion blur more aggressively on one side and less aggressively on the other. That's where alpha channels come into play.

To create a motion blur based on an alpha channel selection, open motion.psd in the Chapter 8 folder, and perform these steps:

1. Activate the Channels palette, and click once on the Create a new channel icon, located at the bottom of the Channels palette. Photoshop creates a new channel called Alpha 1.
2. Double-click on the name Alpha 1, and rename the channel motion.
3. Select the Linear Gradient tool, and choose the Foreground to Background gradient option.
4. Click and drag from the left side of the motion channel to the right side (hold the Shift key to draw a straight line), as shown in Figure 8.27.

Figure 8.27: *The linear gradient tool applied to the motion channel.*

The linear gradient tool created a black to white gradient across the motion channel. The black areas of the channel are completely masked, and the areas of the mask that are white are 100 percent selected. The areas of the mask that are in shades of gray are selected according to the percentage of gray.

5. Click the RGB channel in the Channels palette to reactivate the image.
6. To activate the motion channel, choose Select, and choose Load Selection from the pull-down menu. Choose motion from the channel options, and click OK to apply the motion channel selection to the image, as shown in Figure 8.28.

A selection is only visible as a marquee border when the area is at least 50 percent selected, so the marquee resembles a rectangle. However, don't let that fool you; the image is still selected on a gradient from right to left.

Figure 8.28: *The motion channel selection applied to the image.*

7. Select Filter - Blur, and choose Motion Blur from the fly-out menu. Select an Angle of 0 degrees, and a distance of 120 pixels.
8. Click the OK button to apply the Motion Blur to the image, as shown in Figure 8.29.

Figure 8.29: *The Motion Blur filter applied to the vehicle image.*

Notice how the Motion Blur filter drops off as it moves from right to left. This is due to the motion channel selection and the use of the gradient tool. As the areas of the channel progressively got darker, the corresponding areas of the image received less and less of the Motion Blur filter.

Cleaning Up the Image

Although the image looks good, the Motion Blur filter was applied to areas other than the vehicle. To clean the image up, you'll use the History brush and an additional layer.

1. Activate the Layers palette, and click the Create a new layer icon, located at the bottom of the Layers palette.
2. Double-click on the new layer and name it restore.
3. Select the History brush and, using a small, soft brush, carefully paint back the areas of the image surrounding the vehicle, using the restore layer to control the process, as shown in Figure 8.30.

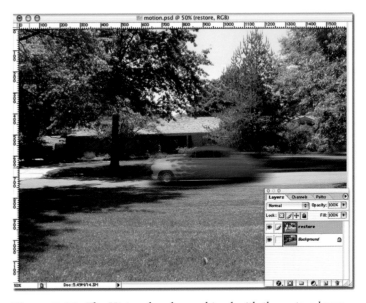

Figure 8.30: *The History brush, combined with the restore layer, helps clean up the effects of the Motion Blur filter.*

4. Click on the Create a new layer icon, and create another layer. Rename the layer vehicle.

5. Use the History brush to restore the vehicle, being careful to restore only the vehicle.

6. Reduce the opacity of the vehicle layer to 35 percent. This restores some of the detail lost in the application of the Motion Blur filter, as shown in Figure 8.31.

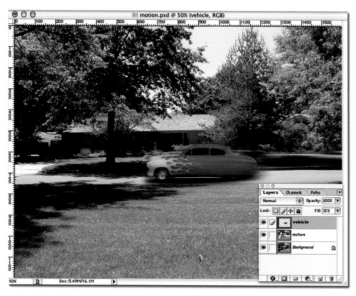

Figure 8.31: *The vehicle layer helps restore some of the detail lost from the application of the Motion Blur filter.*

The secret is out. Channels are not just for holding color information, and they are not just for making simple black and white selections. The use of the gradient tool can create unique selections and give you an entirely new way to apply filters and adjustments to an image.

WORKSHOP 4 – CONVERTING A COLOR IMAGE TO GRAYSCALE USING ALPHA CHANNELS

Converting a color image into grayscale is not difficult; you open the image in Photoshop, select Image - Mode, and choose Grayscale from the fly-out menu. Photoshop then performs a conversion of the image by removing the hue and saturation, leaving only the lightness values. This leaves you with an image made up solely of black, white, and shades of gray.

However, sometimes the results are less than satisfactory. Many times, the grayscale image appears too dark and requires additional work, as shown in Figure 8.32.

Figure 8.32: *An RGB image converted directly into grayscale sometime creates a dark image.*

The reason the grayscale image suffers is in how Photoshop performs the conversion. When you convert an image into grayscale, Photoshop averages the color channels to get information on the hue, saturation, and lightness of the pixels. It then extracts the hue and saturation, while preserving the lightness. Each color value (hue, saturation, and lightness) is represented by a number from zero to 255, so the resulting grayscale image contains a maximum of 256 possible values—1 black, 1 white, and 254 shades of gray.

If, for example, the image begins as an RGB document, Photoshop averages the red, green, and blue channels to produce the final grayscale image. Sometimes this can cause an oversaturation of the colors and result in a dark grayscale image.

To solve this problem, use channels to make the final conversion. Open the image named convert.tif in the Chapter 8 folder, and perform these steps:

1. Activate the Channels palette. The palette displays the red, green, and blue channels, as shown in Figure 8.33.

Figure 8.33: *The native color channels of an RGB image.*

2. Select Image - Mode, and choose Lab Color from the fly-out menu. The Channels palette changes to channels named Lightness, a, and b, as shown in Figure 8.34. The three channels in Lab Color mode convert the image into its three components of lightness, color hue, and color saturation.

Figure 8.34: *The channels for Lab Color mode.*

3. Click once on the Lightness channel. Photoshop deactivates the a and b channels and displays a perfect grayscale image.

4. Select Image - Mode, and choose Grayscale from the fly-out menu. A dialog box appears asking if you want to discard the other channels. Click the OK button to convert the image into grayscale, as shown in Figure 8.35.

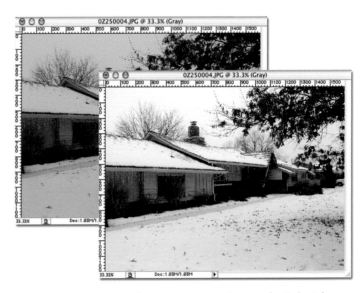

Figure 8.35: *A grayscale image converted using the Lab Color mode.*

While no conversion method is perfect, there is less chance of the image becoming overly dark if you convert using the Lab Color mode. The one exception to this rule is if the image is being exported out to a film recorder for conversion into a negative. In that case, you might want to convert the image directly, using Image - Mode, and choosing Grayscale. The darker shades of gray produced using this method work well for film recorders.

WORKSHOP 5 – USING CHANNELS TO CREATE SPOT COLORS

Spot colors are special premixed ink colors, such as the Pantone Color Matching System, and are used to print specific colors for a brochure, magazine, or other process printing job. The problem with printing presses (typically four-color presses using cyan, magenta, yellow, and black) is that they can't produce every color using CMYK.

That is where spot colors come into play. Spot colors are premixed inks applied to an image using a separate plate, as shown in Figure 8.36.

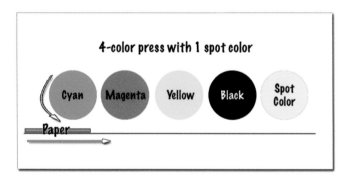

Figure 8.36: *Spot colors are applied to an image using a printing press, and separate color plates.*

Spot colors are employed when absolute color matching is important, such as the colors used in a corporate logo. For example, the red ink used in the Adobe corporate logo is a special shade of red and even has a special name: Adobe Red. You know you're important when you have a color named after you.

Image Preparation

The first stage in creating a spot color channel is preparing the image. Open the image named travel.psd, located in the Chapter 8 folder, and perform these steps:

1. Activate the layer named ski, and using the Move tool, position the text in the upper-left quadrant of the image, as shown in Figure 8.37.

Figure 8.37: *The text moved to the upper-left quadrant of the image.*

2. Click once on the Foreground Color Swatch. Photoshop opens the Color Picker dialog box. Click the Custom button, and select the spot color from the available options. In this example, I chose the Pantone DS 187-1 C color from the Pantone process coated book, as shown in Figure 8.38.

Figure 8.38: *The Color Picker dialog box.*

3. Press Alt + Shift + Delete (Option + Shift + Delete: Macintosh) to fill the ski layer with the selected Pantone color.

The Alt + Shift + Delete command is a neat shortcut that lets you fill a layer with the foreground color while locking out the transparent areas.

Creating the Knockout

1. To create the knockout for the logo, press the letter D on your keyboard to default the foreground and background colors to black and white.
2. Press the letter X to reverse the colors.
3. Press Alt + Shift + Delete (Option + Shift + Delete: Macintosh) to fill the ski layer with white, as shown in Figure 8.39.

When the color plates are created for the printing job, the white areas of the image (corresponding to the logo) will create a knockout. That way the spot color is not printing on top of the other colors.

Figure 8.39: *The Alt + Shift + Delete key fills the logo with white.*

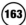

Creating the Spot Color Channel and Creating a Color Trap

1. Hold down the CTRL key (CMD key: Macintosh) and click once on the ski layer. Photoshop creates a selection based on the logo, as shown in Figure 8.40.

A color trap allows the inks to slightly overlap between the spot color plate and the other image plates. When the paper moves through the press, slight movements in the paper and the press cause the inks to slightly overlap. If there were no trapping assigned to the channel, it could cause gaps in the final image, usually viewed as white edges around the logo. The trap helps to reduce the effect of misregistered plates. Although we will create a trap for our example, it is always best to ask the print operator for the size of the trap.

Figure 8.40: *The logo selected using the shortcut of CTRL + Click.*

2. To create the trap, choose Select - Modify, and choose Expand from the fly-out menu. Choose an Expand value of 1 pixel, and click the OK button to apply the expansion to the selection.
3. Activate the Channels palette, and click once on the black triangle, located in the upper-right corner of the Channels palette. Select New Spot Channel from the available options.
4. Click the Color button in the Spot Color dialog box, reselect the Pantone DS 187-1 C process Pantone color, and click the OK button. The Spot Color dialog box now displays the name PANTONE DS 187-1 C, as shown in Figure 8.41.

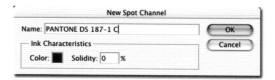

Figure 8.41: *The Spot Color dialog box.*

5. Click the OK button to create the Spot Color channel, as shown in Figure 8.42.

Figure 8.42: *The Spot Color channel added to the Channels palette.*

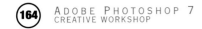

Final Preparation

Before converting the image to CMYK, it is advisable to contact the printer and get advice. In many cases, the printers will have a conversion that works best for their particular printing systems, and they can walk you through the conversion steps.

Typically, your printer will ask you to save the file in DCS 2.0 format.

That's it. If you followed the steps in this workshop and the advice of your printer, you should have a perfect image output.

WORKING IN THE
THIRD DIMENSION

COMPUTERS PRESENT THE DESIGNER WITH A UNIQUE CHALLENGE: TRANSFERRING A THREE-DIMENSIONAL WORLD ONTO A TWO-DIMENSIONAL SURFACE. WHILE THIS PROBLEM IS NOT UNIQUE TO COMPUTER DESIGNERS (ARTISTS HAVE BEEN DOING THE SAME THING SINCE THE BEGINNING OF RECORDED TIME), IT STILL REQUIRES A BIT OF THOUGHT. FOR EXAMPLE, IF YOU COMPARE THE ARTWORK CREATED IN ANCIENT EGYPT WITH ARTWORK TODAY, THE DIFFERENCE IS STRIKING. ART DURING THE TIME OF THE PHARAOHS WAS FLAT, WHILE TODAY'S ART CONTAINS DEPTH, AS SHOWN IN FIGURE 9.1.

Egypt - 2000 BC Greece 100 AD Rembrant 1664 AD

Figure 9.1: *Through the centuries, art has slowly evolved from two to three dimensions.*

As time moved forward, designers and artists added computer monitors to their list of creative tools, but whether you paint with oils, water colors, or electronic pixels, the principles of depth and design are still the same. The easiest way to illustrate depth is to create a working template, as shown in Figure 9.2.

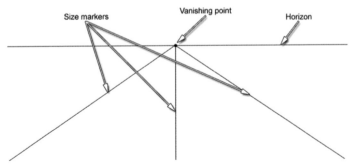

Figure 9.2: *A working template defines the depth in the image.*

The small dot in the middle of the screen represents the vanishing point in this particular image, and the converging lines represent size markers for the individual elements of the image. Once you create the working template, the next step is to add the image elements, using the template to guide their placement, as shown in Figure 9.3.

Figure 9.3: *Image elements added according to the working template.*

This workshop discusses depth and visual perception and how using layers, filters, and adjustments can help you create awesome three-dimensional artwork.

WORKSHOP 1 – CREATING THE ILLUSION OF DEPTH WITH GAUSSIAN BLUR

In this workshop, you will select portions of an image and apply the Gaussian Blur filter to give the impression of depth. Photographs that have blurred backgrounds are said to have *shortened depth of field*, or what occurs when you take a photograph with a low f-stop.

In addition to creating a sense of depth, blurring parts of an image helps focus the viewer's eyes (and their attention) on a specific point within the photograph. To generate image depth, open the image named soldier.psd, located in the Chapter 9 work folder, as shown in Figure 9.4.

Figure 9.4: *The solder.psd file displays a soldier and background in sharp focus.*

Selecting the Background

The first step is to decide what portions of the image will receive the Gaussian Blur filter. In this case, the soldier will remain in focus, and the background (the Lincoln Monument) will receive the blurring.

However, in order to control the effect, you will select the soldier, not the background, and isolate his pixels within a separate layer.

1. Using Photoshop's selection tools make a selection marquee around the soldier. In this example, I used the Magnetic Lasso to make the initial selection and the Freeform Lasso to clean up.
2. Choose Select, and choose Feather from the pull-down menu. Choose a Feather Radius of 1 pixel. Click the OK button to apply the feather to the selection, as shown in Figure 9.5.

Figure 9.5: *The Feather command visually softens the edge of the selection by creating semi-transparent pixels.*

3. Press CTRL + J (CMD + J: Macintosh) to create a new layer with a copy of the soldier.
4. Rename the layer containing the copied pixels soldier.

 If you are having trouble getting an accurate copy of the soldier, the Channel palette for the soldier.psd contains an alpha channel selection.

Working with the Background

The next step is to generate a soft Gaussian blur on the Background layer.

1. Move to the Layers palette, and click once on the Background layer.
2. Select Filter - Blur, and choose Gaussian Blur from the fly-out menu. Choose a Radius of 3.5 pixels.
3. Click the OK button to apply the Gaussian Blur filter to the Background layer, as shown in Figure 9.6.

Figure 9.6: *The Gaussian Blur filter adds a sense of depth to the background.*

Adding the Final Touches

The application of the Gaussian Blur creates a sense of image depth by isolating the soldier from the background. To further enhance the effect there are two things left to do: Make the image appear more like a photograph, not a digital image, and add a bit more depth by isolating the steps from the actual Lincoln Monument.

1. Make the Background the active layer.
2. Select Image - Artistic, and choose Film Grain from the fly-out menu. Enter the following variables: Grain 2, Highlight Areas 2, and Intensity 0. Click the OK button to apply the Film Grain filter to the Background layer, as shown in Figure 9.7.

Figure 9.7: *The Film Grain filter adds noise in the shape of negative film grain.*

3. Select Image - Adjustments, and choose Hue and Saturation from the fly-out menu. Change the Saturation value to −10 percent, and click OK to apply the Hue and Saturation adjustment to the Background layer.
4. Click the Create a new layer icon, located at the bottom of the Layers palette, and rename the layer stairway.
5. Place the stairway layer directly above the Background layer.
6. Select the History brush, and paint the stairs and columns at the head of the stairs into the stairway layer, as shown in Figure 9.8.

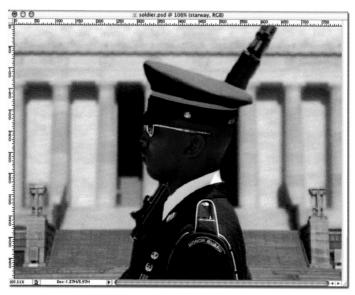

Figure 9.9: *The Gaussian Blur filter softens the stairway layer.*

The final assembled image illustrates the use of the Gaussian Blur filter to simulate depth in an image, and the Film Grain filter was used to add a bit of graininess to the out-of-focus areas. Finally, the Hue and Saturation adjustment was employed to reduce the saturation levels (out-of-focus and distant images typically contain less color saturation).

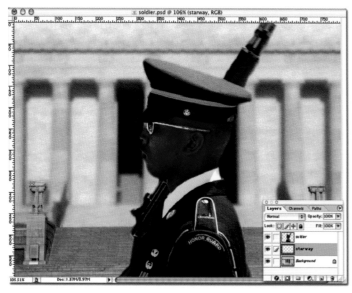

Figure 9.8: *The columns and stairs painted into the stairway layer with the History brush.*

WORKSHOP 2 – EXTRUDING OBJECTS USING LINES AND FILLS

7. Select Filter - Blur, and choose Gaussian Blur from the fly-out menu. Choose a Blur Radius of 2 pixels, and click OK to apply the Gaussian Blur filter to the stairway layer, as shown in Figure 9.9.

In this workshop, you'll create a three-dimensional book, using simple line-drawing tools and color fills. Begin by selecting File, and choosing New from the pull-down menu. Create a New Photoshop document 800 by 600 pixels with a resolution of 72 ppi in the RGB color mode.

Creating the Outline

The first step is to create the framework for our book.

1. Click the Create a new layer icon, located at the bottom of the Layers palette.
2. Rename the new layer lines.
3. Select the Line tool from the toolbox, and choose a Weight of 1 pixel, as shown in Figure 9.10,

Figure 9.10: *The Line tool creates straight lines in the active layer.*

4. Use the Line drawing tool to create an outline similar to Figure 9.11 (this will be the foundation for the open book).

Figure 9.11: *The Line tool created the framework for the open book.*

5. Press CTRL + J (CMD + J: Macintosh) to create a copy of the lines layer.
6. Select the Move tool, then click and drag the lines copy layer down while holding the Shift key. The Shift key will force the copy layer to move straight down, as shown in Figure 9.12.

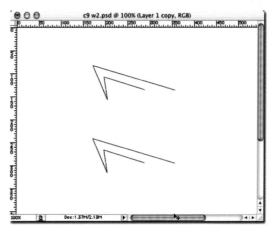

Figure 9.12: *The copy of the lines layer placed directly below the original lines layer.*

7. Press CTRL + E (CMD + E: Macintosh) to merge the lines copy layer with the lines layer.
8. Select the Line tool, and connect the two outlines together using straight lines (hold the Shift key while using the Line tool), as shown in Figure 9.13.

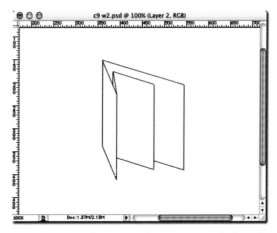

Figure 9.13: *The Line tool creates straight lines between the two line layers.*

Generating the Fills

To complete the effect, you will need to fill the enclosed spaces with color.

1. Click the Create a new layer icon, and rename the layer fills.
2. Position the fills layer directly above the background layer.
3. Select the Paint Bucket tool, set the tolerance to 1, and select the All Layers option, as shown in Figure 9.14.

Figure 9.14: *The Paint Bucket tool will be used to fill the enclosed areas of the book with solid color.*

4. Select the fills layer.
5. I used a 50-percent gray for the foreground panels, a 60-percent gray for the back panel, and a 70-percent gray for the small exposed triangular panel, as shown in Figure 9.15.

Figure 9.15: *The line art created for the open book, filled with solid colors.*

Once you understand the concept of extruding objects, you can take this demonstration and combine it with images and other effects. For example, Figure 9.16 illustrates the use of the extruded book, with the inner panels removed, and the use of graphics and a drop shadow to create a restaurant menu.

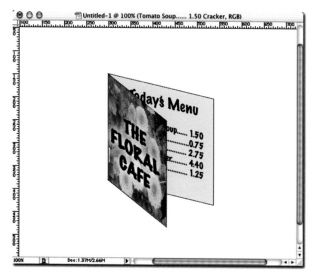

Figure 9.16: *A menu created from a modification of the open book.*

Figure 9.17 creates a completely different type of book by using a different framework for the pages.

Figure 9.17: *A second example of a book created using the same technique used to create the open book.*

WORKSHOP 3 – CREATING A SPIRAL RIBBON USING THE GRADIENT TOOL

Depth by blurring (Workshop 1), and depth by extrusion (Workshop 2) are two excellent ways to achieve that elusive third dimension in a Photoshop image. Another way to put a bit of depth into your graphics is with the gradient tool. The Gradient tool creates shades of color, which can be used to simulate light and dark within an image.

Creating the Gradient

To create the spiral ribbon, open the file named ribbon.psd in the Chapter 9 work folder, and perform these steps:

1. Select the ribbon layer (the ribbon was created in Adobe Illustrator and opened in Photoshop).

2. Press the letter D on your keyboard to default the foreground and background color swatches to black and white.

3. Move to the Swatches palette and click on the 80 percent gray color swatch (this changes the foreground color to 80 percent gray), as shown in Figure 9.18.

Figure 9.18: *The Swatches palette controls the colors used within the active Photoshop document.*

4. Select the Linear Gradient tool, and choose the Foreground to Background gradient, as shown in Figure 9.19.

Figure 9.19: *Choose the Foreground to Background default gradient.*

5. Select the Lock transparent pixels option for the ribbon layer, then click and drag the Gradient tool from the left to the right edge of the ribbon, as shown in Figure 9.20.

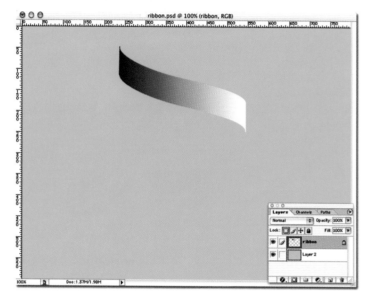

Figure 9.20: *The Linear Gradient tool applied to the ribbon shape.*

Creating the Ribbon

All the hard work is complete; now it's a matter of copying and dragging.

1. Select the ribbon layer.
2. Select the Move tool.
3. Click and drag the ribbon straight down while holding the Alt key (Option key: Macintosh). This creates a copy of the ribbon layer, as shown in Figure 9.21.
4. Select the ribbon copy layer.
5. Select Edit - Transform, and choose Flip Horizontal from the fly-out menu. Photoshop flips the ribbon copy layer left to right.
6. Use the Move tool to position the ribbon copy layer, as shown in Figure 9.22.

Repeat steps 3 thru 6 until you have enough ribbon loops, as shown in Figure 9.23.

As illustrated in Figure 9.23, the Gradient tool, combined with the unique shape of the ribbon, created a spiraling ribbon effect.

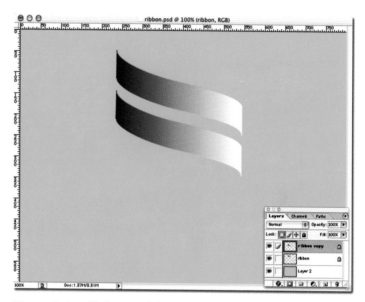

Figure 9.21: *Clicking and dragging while holding down the Alt key creates a copy of the dragged layer.*

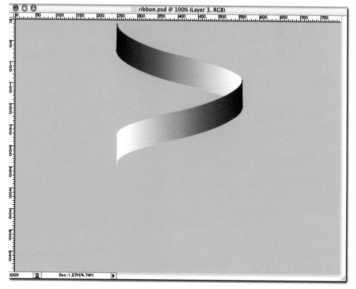

Figure 9.22: *The Move tool aligns the copy layer with the original layer.*

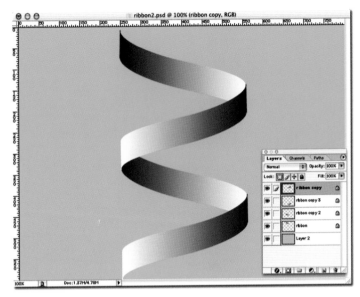

Figure 9.23: *The completed ribbon.*

WORKSHOP 4 – QUICK THREE-DIMENSIONAL BOXES AND CANISTERS

When you create a three-dimensional box, the viewer (depending on the angle) can see one, two, or three sides of the box; the viewer's relationship to the box determines the number of visible sides. In this workshop, you will create a three-dimensional box displaying three sides. To begin the project, open dartbox.psd located in the Chapter 9 work folder.

Getting Started

The dartbox.psd file contains four layers: a background, top, front, and side. The top, front, and side layers contain the individual elements of the box. If you choose, you can create your own box.

When you create your own box, remember to make the width of the top and front box faces the same. The height of the side should match the height of the front, and the width of the side face should match the width of the top, as shown in Figure 9.24.

Figure 9.24: *The elements of the box are contained in separate layers.*

Creating the Box

1. Select the side layer.
2. Select Edit - Transform, and choose Free Transform from the fly-out menu.
3. Choose a Width of 57.36 percent. Click the Checkmark icon to record the change to the side layer, as shown in Figure 9.25.
4. Select the front layer.
5. Select Edit - Transform, and choose Free Transform from the fly-out menu.
6. Choose a Width of 81.92 percent. Click the Checkmark icon to record the change to the front layer, as shown in Figure 9.26.

Figure 9.25: *The Width transformation applied to the side layer.*

Figure 9.26: *The Width transformation applied to the front layer.*

7. Select the side layer.
8. Select Edit - Transform, and choose Skew from the fly-out menu.
9. Choose a Skew Vertical angle of 47.57 degrees. Click the Checkmark icon to record the change to the side layer, as shown in Figure 9.27.

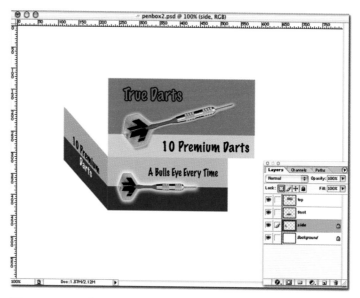

Figure 9.27: *The Vertical Skew transformation applied to the side layer.*

10. Select the front layer.
11. Select Edit - Transform, and choose Skew from the fly-out menu.
12. Choose a Vertical Skew of −28.21 degrees. Click the Checkmark icon to record the change to the front layer, as shown in Figure 9.28.
13. Select the top layer.
14. Select Edit - Transform, and choose Free Transform from the fly-out menu.
15. Choose a Rotation value of −28.21 degrees, a Horizontal Skew of 14.21 degrees, a Height of 83 percent, and a Width of 93 percent. Click the Checkmark icon to record the change to the side layer, as shown in Figure 9.29.

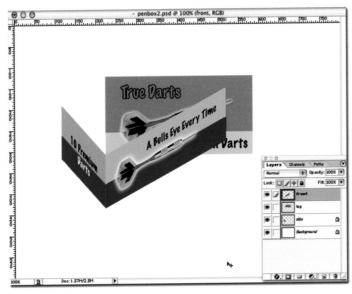

Figure 9.28: *The Vertical Skew transformation applied to the front layer.*

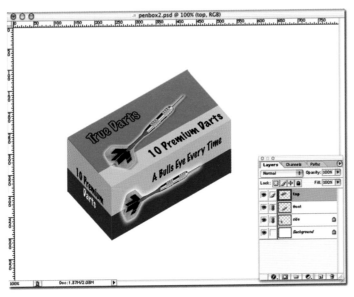

Figure 9.29: *The completed three-dimensional box.*

Creating a Canister

A canister is simply a box without corners. Creating a canister is relatively straightforward with one exception: you will apply the image or text to the canister after creating it, not before. To build the canister, create a new Photoshop document with the following characteristics: 800 by 600 pixels, a resolution of 72 ppi, in the RGB color mode. Next, perform these steps:

1. Click the Create a new layer icon, located at the bottom of the Layers palette.
2. Name the new layer canister.
3. Select the Elliptical Marquee tool and draw an oval in the canister layer. This oval will represent the top and bottom of your canister.
4. Press the letter D on your keyboard to default the foreground and background color swatches to black and white.
5. Select Edit, and choose Stroke from the pull-down menu. Choose a 1-pixel stroke; Location, Center, and click the OK button to apply the stroke to the oval in the canister layer, as shown in Figure 9.30.

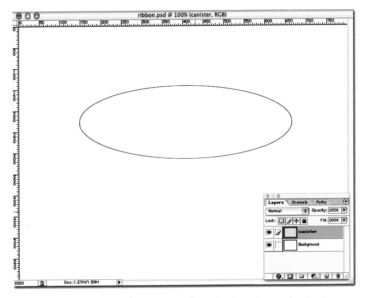

Figure 9.30: *The Stroke command applied to the oval selection.*

6. Select the Move tool.
7. Select the canister layer.
8. Press CTRL + J (CMD + J: Macintosh) to make a copy of the canister layer.
9. Move into the document window, and click and drag the copy of the canister straight down (hold the Shift key during the move), as shown in Figure 9.31.

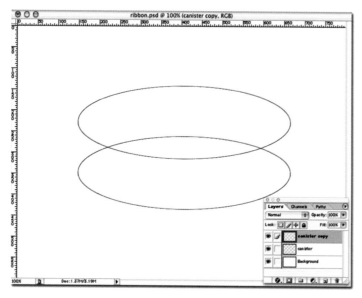

Figure 9.31: *The copy of the canister layer moved directly below the original layer.*

10. Select the Line tool, and connect the left and right sides of the canister together with straight lines, as shown in Figure 9.32.
11. Press CTRL + E (CMD + E: Macintosh) to merge the canister copy into the canister layer.
12. Select the Eraser tool.
13. Erase the top portion of the bottom of the canister, as shown in Figure 9.33.

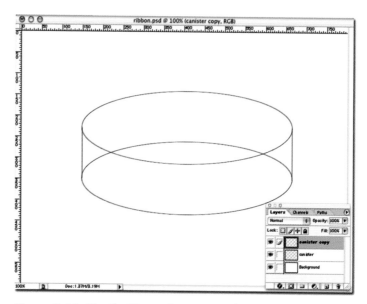

Figure 9.32: *Use the Line tool to connect the two ovals together.*

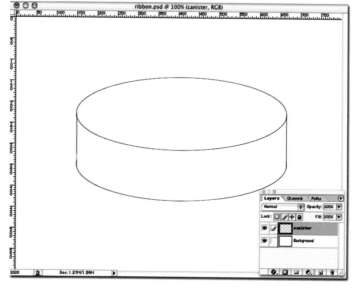

Figure 9.33: *The Eraser tool successfully removed the top portion of the oval representing the bottom of the canister.*

Adding the Fills

1. Click the Create a new layer icon, and rename the layer fills.
2. Position the fills layer directly above the background layer.
3. Select the Magic Wand tool, set the tolerance value to 10, and select the All Layers option, as shown in Figure 9.34.

Figure 9.34: *The Magic Wand tool makes selections based on a shift of brightness in the image pixels.*

4. Select the canister layer.
5. Click once with the Magic Wand in the bottom portion of the canister. The Magic Wand tool selects the front of the canister.
6. Select the Linear Gradient tool, and choose the Copper gradient from the default gradient set.
7. Select the fills layers.
8. Click and drag the Gradient tool from left to right across the selection, as shown in Figure 9.35.

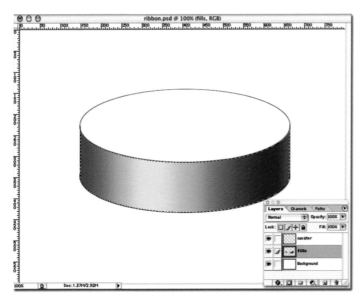

Figure 9.35: *The default Copper gradient applied to the selected area of the image.*

Creating the Top of the Canister

The next step is to create the top of the canister

1. Create two vertical guides, defining the left and right limits of the canister, as shown in Figure 9.36.

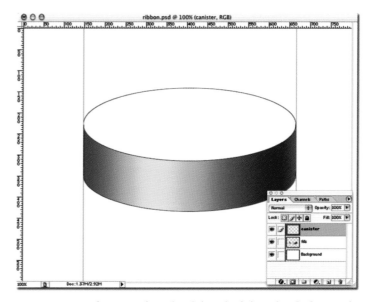

Figure 9.36: *The vertical guides define the left and right limits of the canister.*

2. Click the Create new layer icon, located at the bottom of the Layers palette, and rename the layer top.
3. Select the Elliptical Marquee tool, and draw a circle (hold the Shift key) the width of the vertical guides, as shown in Figure 9.37.
4. Select a 70 percent gray color from the Swatches palette.
5. Choose the Radial Gradient tool, and select the Foreground to Background gradient option.
6. Click and drag from the center of the circle to the edge to create a radial gradient in the top layer, as shown in Figure 9.38.

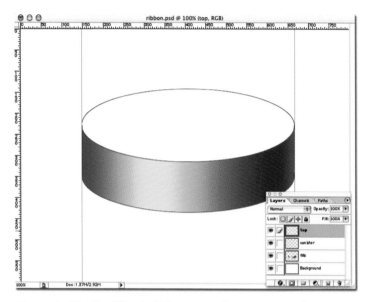

Figure 9.37: *The Elliptical Marquee tool creates a circular selection the width of the two guidelines.*

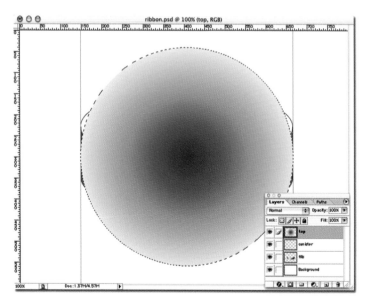

Figure 9.38: *A radial gradient tool applied to the circle selection.*

7. Click the Add a layer style icon, located at the bottom of the Layers palette, and select the Satin layer style.
8. Choose the Ring-Triple Contour option, and change the Size to 200 percent. Click the OK button to apply the Satin layer style to the top layer, as shown in Figure 9.39.

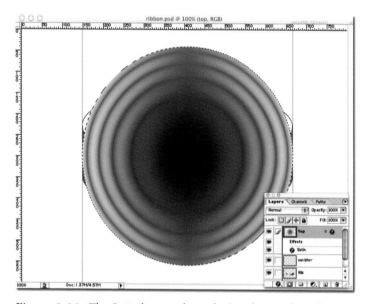

Figure 9.39: *The Satin layer style applied to the circular selection.*

9. Select Edit - Transform, and choose Scale from the fly-out menu.
10. Reduce the vertical size of the circle until it fits into the dimensions of the oval top for the canister. Press the Enter key to set the transform, as shown in Figure 9.40.

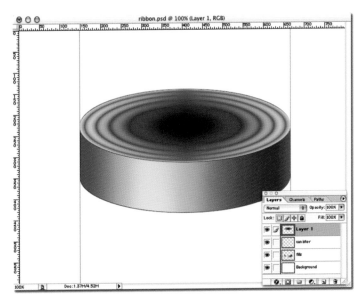

Figure 9.40: *The vertical dimension of the circle reduced using the Scale Transformation command.*

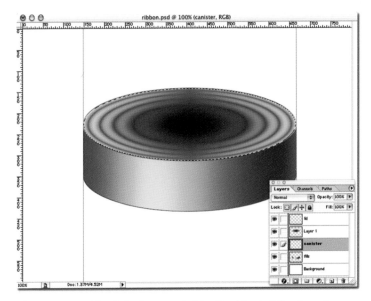

Figure 9.41: *The Selection created by the Magic Wand conforms to the top of the canister.*

Adding the Lip on the Canister

1. Create a new layer, and rename the layer lip.
2. Move the new layer to the top of the layer stack.
3. Select the Magic Wand tool (turn off the Use All Layers option).
4. Select the layer named canister, and click once on the newly created top. The canister layer is selected, so the selection conforms to the oval defining the top of the canister, as shown in Figure 9.41.
5. Select the layer named lip.
6. Select Edit, and choose Stroke from the pull-down menu.
7. Select a 6-pixel stroke with a Location of Center. Click the OK button to apply the Stroke command to the selection in the top layer.
8. Click the Add a layer style icon, located at the bottom of the Layers palette, and select the Bevel and Emboss layer style.
9. Choose the Inner Bevel Style using a Chisel Hard Technique, and add a default Gradient Overlay. Click the OK button to apply the layer style to the top layer, as shown in Figure 9.42.

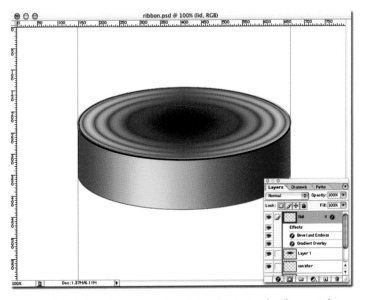

Figure 9.42: *The Hard Chisel and Gradient Overlay layer styles applied to the lip layer.*

10. Press CTRL + J (CMD + J: Macintosh) to make a copy of the lip layer.
11. Move the newly copied layer to the bottom of the Layers palette, directly above the Background layer.
12. Select the Move tool.
13. Move the copy layer to the bottom of the canister, and create a lip at the bottom, as shown in Figure 9.43.

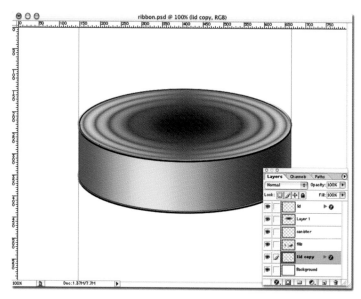

Figure 9.43: *The copy of the lip layer, moved to the bottom of the canister.*

Adding Text and Images

The last step would be to add some text, and possibly a graphic. The graphic was a stock graphic image, moved into the image and resized to fit using the Free Transform tool. The text was added to a separate layer, and curved to fit the surface of the can using the Text Warp feature, as shown in Figure 9.44. For more information on using text with Photoshop images, check out Chapter 11, "Working with Text."

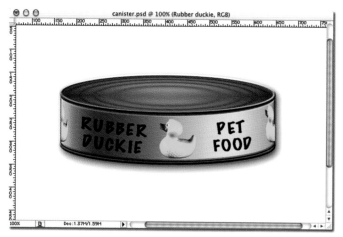

Figure 9.44: *Text and graphics applied to the canister.*

It should be noted that there are programs in the market, such as Bryce, StrataVision, and Universe, which specifically deal with the creation of three-dimensional objects. If you are interested in creating high-end, broadcast quality three-dimensional object and scenes, Bryce is an excellent, low-cost doorway into the world of three dimensions.

CHAPTER 10

WORKING WITH
PHOTOSHOP SPECIAL
EFFECTS

SPECIAL EFFECTS HAVE ALWAYS BEEN PART OF THE
DESIGNER'S WORLD, AND AS EACH NEW VERSION OF
PHOTOSHOP HITS THE MARKET, IT COMES PACKED WITH MORE
AND MORE EFFECTS, COURTESY OF THE GOOD FOLKS AT
ADOBE. THIS WORKSHOP DEALS WITH SPECIAL EFFECTS,
FOCUSING PRIMARILY ON PHOTOSHOP'S AWESOME LAYER
STYLES, ADJUSTMENT LAYERS, AND LAYER MASKS.

WORKSHOP 1 - CREATING A SPOTLIGHT

Setting the Stage

Shakespeare once said that all the world's a stage, but in Photoshop, you move beyond being merely a player—you control the players and you actually get to build the stage.

If you're going to create a spotlight, the first thing you will need is a stage. Create a new Photoshop document 800 by 600 pixels, with a resolution of 72 ppi, a color mode of RGB, and perform these steps:

1. Move into the Swatches palette and choose a color for the stage curtains. In this example, I chose a light cyan color.
2. Click the Create a new layer button, located at the bottom of the Layers palette, and rename the new layer backdrop.
3. Press Alt + Backspace (Option + Delete: Macintosh) to fill the backdrop layer with the cyan color.
4. Select Filter - Noise, and choose Add Noise from the fly-out menu. Select an Amount of 25 percent and Gaussian Distribution. Select the Monochromatic option and click the OK button to apply the noise filter to the backdrop layer, as shown in Figure 10.1.
5. Select Filter - Blur, and choose Motion Blur from the fly-out menu. Select an Angle of 90 degrees and a Distance of 50 pixels. Click the OK button to apply the motion blur to the backdrop layer, as shown in Figure 10.2.
6. Select the Rectangular Marquee tool, and create a selection marquee at the top of the document window from left to right, about 100 pixels tall.
7. Press CTRL + J (CMD + J: Macintosh) to create a copy of the selected area of the curtain layer, as shown in Figure 10.3.
8. Rename the new layer curtain.
9. Create a sculpted look to the edge of the curtain, by selecting the Elliptical Marquee tool and drawing a circle approximately 50 pixels in diameter.
10. Place the circular selection halfway over the bottom of the curtain on the far left, and press the Delete key. The selection deletes the bottom portion of the curtain. Then use the arrow keys to nudge the selection to the right, and continue to delete semi-circular sections of the curtain, as shown in Figure 10.4.

Figure 10.1: *The Add Noise filter applied to the curtain layer.*

Figure 10.2: *The Motion Blur filter applied to the curtain layer.*

Figure 10.3: *The CTRL + J key creates a copy of the curtain layer.*

Figure 10.4: *The sculpted edge of the curtain, created using a circular selection and the delete key.*

To best view how the Elliptical Marquee tool deletes the sections of the curtain, hide the backdrop layer.

11. Select the Add a layer style icon, located at the bottom of the Layers palette. Add a Drop Shadow, Pattern Overlay, and Stroke to the curtain layer using the following settings:

Drop Shadow
 Angle: 90 degrees
 Distance: 20 pixels
 Spread: 15 pixels
 Size: 15 pixels

Pattern Overlay
 Pattern: Crayon on Sketch Pad
 Blend Mode: Multiply

Stroke
 Size: 3 pixels
 Color: Yellow

12. Click the OK button to apply the layer styles to the curtain layer, as shown in Figure 10.5.

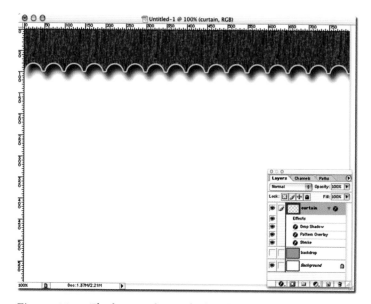

Figure 10.5: *The layer styles applied to the curtain layer.*

13. Select the backdrop layer.
14. Select the Rectangular Marquee tool, and make a selection the width of the document window and 200 pixels tall. To avoid the drop-off at the bottom of the backdrop, make the selection in the middle of the document window.
15. Press CTRL + J (CMD + J: Macintosh) to create a copy of the selected pixels. Rename the layer stage.
16. Select the Move tool, and move the stage layer to the bottom of the document window, as shown in Figure 10.6.

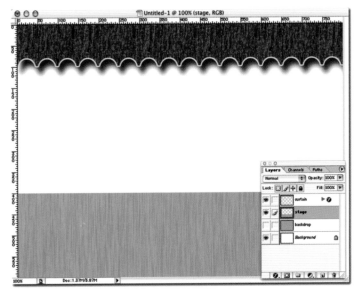

Figure 10.6: *Move the state layer to the bottom of the document window.*

17. Select a sepia or brown color from the Swatches palette.
18. Select Image - Adjustments, and choose Hue/Saturation from the fly-out menu. Select the Colorize option, and change the Saturation value to 50 percent. Click the OK button to apply the Hue/Saturation filter to the stage layer, as shown in Figure 10.7.

Figure 10.7: *The Hue/Saturation filter applied to the stage layer.*

19. Reduce the view of the document window to 50 percent and expand the window, as shown in Figure 10.8.
20. Select Edit - Transform, and choose Perspective from the fly-out menu.
21. Click and drag the lower-right anchor point to the right, as shown in Figure 10.9.
22. Press the Enter key to apply the transform to the stage layer.
23. Select the backdrop layer.
24. Select Image - Adjustments, and choose Levels from the fly-out menu. Select a mid-tone level of 0.40, and click the OK button to apply the Levels adjustment to the backdrop layer, as shown in Figure 10.10.

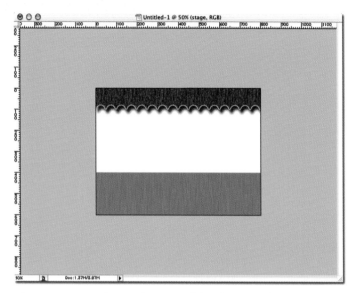

Figure 10.8: *Reducing the view of the document lets you expand the size of the window.*

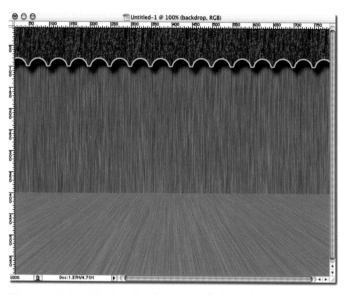

Figure 10.10: *The Levels adjustment darkens the curtains behind the stage.*

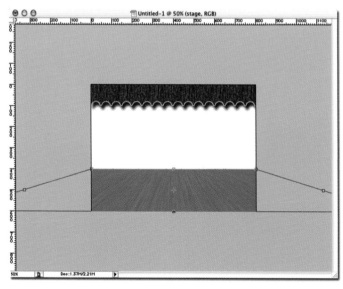

Figure 10.9: *The Perspective transformation pulls the bottom of the stage layer left and right, and creates the illusion of a wooden stage.*

Creating the Spotlight

1. Create a new layer between the curtains and stage layers. Rename the new layer spotlight, as shown in Figure 10.11.
2. Select the Elliptical Marquee tool and draw an oval selection in the spotlight layer. This oval represents the light falling on the stage, as shown in Figure 10.12.
3. Select the Polygon Marquee tool, and create the cone of light that connects with the oval selection. To connect the polygon selection to the existing oval selection, you will need to hold down the Shift key as you draw, as shown in Figure 10.13.
4. Choose a medium gray color from the Swatches palette, and press Alt + Backspace (Option + Delete: Macintosh) to fill the selection with the light gray color.
5. Press CTRL + D (CMD + D: Macintosh) to remove the selection marquee.
6. Select Filter - Blur, and choose Gaussian Blur from the fly-out menu. Select a Blur Radius of 2, and press the OK button to apply the blur to the spotlight layer, as shown in Figure 10.14.

Figure 10.11: *The spotlight layer is placed between the curtains and the stage layers.*

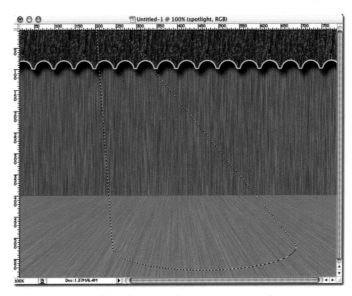

Figure 10.13: *The Polygon tool creates a cone selection.*

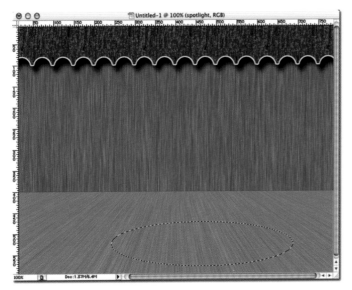

Figure 10.12: *The Elliptical Marquee tool creates an oval selection in the spotlight layer.*

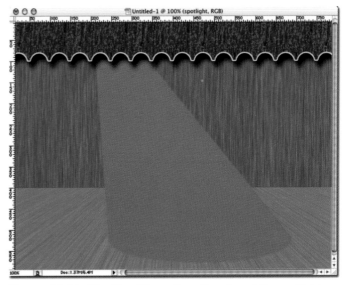

Figure 10.14: *The Blur filter softens the edge of the spotlight.*

7. Move into the Layers palette and change the Fill of the spotlight layer to zero percent. The spotlight layer is now transparent.

8. Select the Add a layer style icon, located at the bottom of the Layers palette, and choose Inner Glow from the available options.

9. Change the Opacity to 70 percent, a Choke of 5 percent, and a Size of 20 percent. Click the Set color of glow button and change the glow color to yellow. Click the OK button to apply the Inner Glow to the spotlight layer, as shown in Figure 10.15.

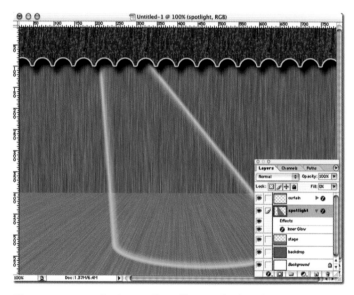

Figure 10.15: *The Inner Glow filter applied to the spotlight layer.*

Darkening the Stage

10. Move into the Layers palette and click once on the spotlight layer, while holding down the CTRL key (CMD key: Macintosh). This creates a selection based on the gray-colored spotlight.

11. Choose Select, and choose Invert from the pull-down menu. This reverses the selection and selects the background.

12. Select the Create a new fill or adjustment layer icon (the half-moon), and choose Levels from the pop-up menu. Choose a midtone Input Level of 0.50, and click the OK button to apply the Levels adjustment to the image, as shown in Figure 10.16.

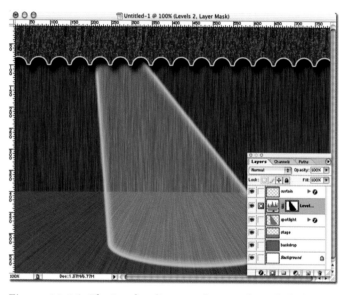

Figure 10.16: *The Levels adjustment layer and mask darken the stage without darkening the spotlight.*

Adding Elements

1. Open a Photoshop document that contains the image element you want to use on the stage. In this example, I chose the ducky.psd file.

2. Select the Move tool, then click and drag the image from the ducky file into the stage file.

3. Place the ducky layer directly above the stage layer, as shown in Figure 10.17.

4. Create a new layer directly below the ducky layer. Rename the layer shadow.

5. Select the oval tool and create an oval under the duck, as shown in Figure 10.18.

6. Press the letter D on your keyboard, and then press Alt + Backspace (Option + Delete: Macintosh) to fill the selection with black.

7. Select CTRL + D (CMD + D: Macintosh) to remove the selection marquee.

8. Select Filter - Blur, and choose Gaussian Blur from the fly-out menu. Select a Blur Radius of 5, and press the OK button to apply the Gaussian Blur filter to the shadow layer.

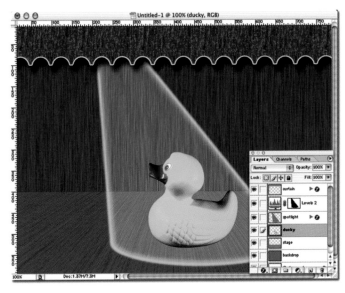

Figure 10.17: *The ducky layer placed above the stage layer.*

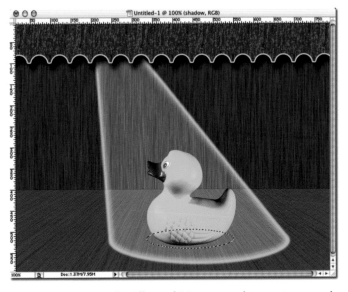

Figure 10.18: *Use the Elliptical Marquee tool to create an oval selection underneath the duck.*

9. Select the Move tool and position the shadow layer underneath the duck, as shown in Figure 10.19.

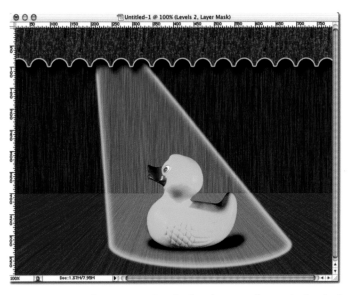

Figure 10.19: *Positioning the shadow layer underneath the duck completes the effect.*

Variations on a Theme

Once the document is complete, you can adjust the relative contrast of the background and spotlight by accessing the Levels adjustment layer and mid-tone Input Level. In addition, you can adjust the opacity and fill of the spotlight layer to change the intensity of the spotlight. To soften the outer glow effect, select the spotlight layer and perform these steps:

1. Click the Add a layer mask icon, located at the bottom of the Layers palette.

2. Select a 50 percent gray foreground color and a black background color.

3. Select the Linear Gradient tool, and choose the Foreground to Background gradient option.
4. Drag the Linear Gradient tool from the bottom of the spotlight to the top, as shown in Figure 10.20.

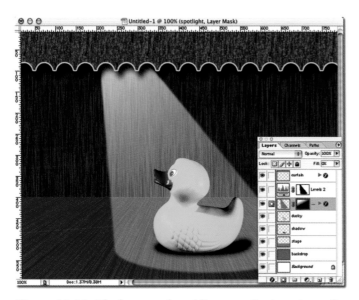

Figure 10.20: *The layer mask and linear gradient create a softer spotlight.*

WORKSHOP 2 – CREATING A FANCY PICTURE FRAME

Digital picture frames can be boring rectangles surrounding an image, or they can be exciting and eye-catching. In this workshop, you will create a cloth frame, using the magic of layer styles and a bit of creativity.

Creating the Cloth Frame

Begin this segment by creating a new Photoshop document 800 x 600 pixels, a resolution of 72 ppi, and the RGB color mode. Once you get the hang of creating frames, you can create a frame using any size or resolution you desire.

1. Click the Add a new layer icon, located at the bottom of the Layers palette, and rename the new layer frame.
2. Select the Rectangular Marquee tool, and make a selection 25 pixels from the top, bottom, right, and left edges of the document window.
3. Fill the selection with a color (any color will do). In this example, I used a light gray color to fill the selection, as shown in Figure 10.21.

Figure 10.21: *The rectangular selection filled with light gray.*

4. Press CTRL + D (CMD + D: Macintosh) to remove the selection marquee.
5. Use the Rectangular Marquee tool to create another selection, this time 100 pixels from the top, bottom, left, and right sides of the document window.
6. Press the Delete key to remove the selected pixels and create a frame border, as shown in Figure 10.22.

Figure 10.22: *The interior of the gray rectangle removed, creating a 75-pixel wide two-dimensional frame.*

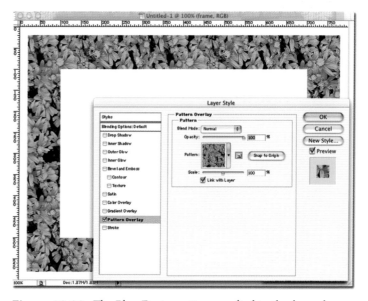

Figure 10.23: *The Blue Dasies pattern applied to the frame layer.*

7. Select the Add a layer style icon, located at the bottom of the Layers palette, and select Pattern Overlay from the available options.
8. Click once on the default pattern. A pop-up box appears with the available patterns.
9. Click once on the triangle located in the upper-right corner of the patterns pop-up box, and select Nature Patterns from the available options.
10. Select the Blue Daisies pattern, as shown in Figure 10.23.
11. Select the Bevel and Emboss layer style and use the Inner Bevel with a Depth of 100 percent, a size of 25, and the remainder of the Bevel and Emboss options at their default values.
12. Select the Contour option, and choose the Half Round contour; leave the remainder of the options at their default values.
13. Select the Texture option, and Choose the Woven pattern with a depth of 80 percent. Leave the remainder of the Texture options at their default values.
14. Click the OK button to apply the layer styles to the frame layer, as shown in Figure 10.24.
15. Save the file using the name border_a.psd.

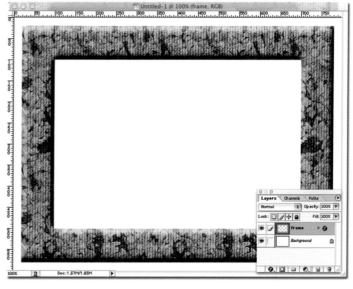

Figure 10.24: *The Bevel and Emboss, Contour, and Texture layer styles applied to the frame layer.*

Adding the Image

1. Open the couple.psd file located in the Chapter 10 work folder, or choose an image of your own.
2. Select the Move tool, and click and drag the lovers layer from the couple file into the border_a document.
3. Position the layer beneath the frame layer, and use the Move tool to position the image, as shown in Figure 10.25.

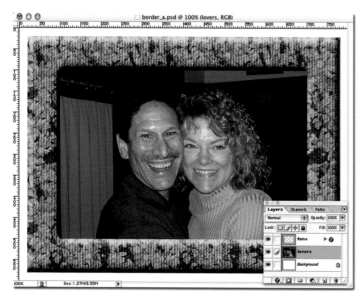

Figure 10.25: *The couple.psd image positioned underneath the frame layer.*

Generating Depth

1. Create a new layer directly above the lovers layer, and name the layer innershadow.
2. Move to the Layers palette and select the frame layer
3. Select the Magic Wand tool and click in the middle of the frame. This creates a selection of the frame's interior.
4. Move to the Layers palette and select the innershadow layer.

5. Fill the selected area with white. The photograph is now covered with white.
6. Change the Fill of the innerglow layer to zero. The photograph reappears.
7. Select the Add a layer style icon, and choose Inner Shadow from the available options. Leave all the options at their default values.
8. Select the Stroke layer style. Choose a 1-pixel stroke, using the color black, and change the Position option to Inside. Click the OK button to apply the layer styles to the innershadow layer, as shown in Figure 10.26.

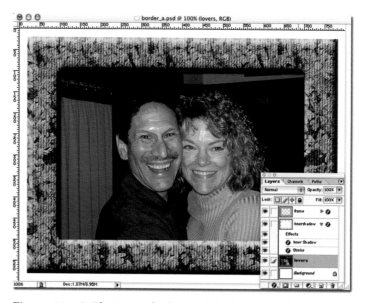

Figure 10.26: *The Inner Shadow and Stroke layer styles applied to the innershadow layer.*

Don't stop here. Experiment using different Texture and Contour options, as well as different Pattern Overlays. You can even create your own custom patterns to make totally unique frames.

WORKSHOP 3 – CREATING A METALLIC FRAME

To create a metallic frame, repeat the first five steps in the previous workshop, and perform these steps:

1. Select the Add a layer style icon, located at the bottom of the Layers palette, and select Gradient Overlay from the available options.
2. Click once on the small black arrow located to the right of the default gradient. A pop-up box appears with the available gradients.
3. Click once on the triangle located in the upper-right corner of the gradient pop-up box, and select Metals from the available options.
4. Select the Silver gradient, and change the gradient angle to 45 degrees, as shown in Figure 10.27.
5. Select the Bevel and Emboss layer style and use the Inner Bevel with a Depth of 160 percent. Leave the remainder of the Bevel and Emboss options at their default values.

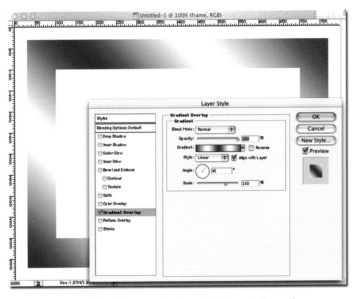

Figure 10.27: *The Silver gradient applied to the frame layer.*

6. Select the Texture option, and choose the Watercolor pattern with a depth of 200 percent. Leave the remainder of the Texture options at their default values.
7. Select the Stroke layer option and choose a black, 1-pixel stroke, using a Position of Center.
8. Click the OK button to apply the layer styles to the frame layer, as shown in Figure 10.28.
9. Save the file using the name border_b.psd.

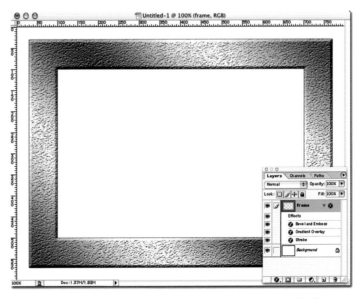

Figure 10.28: *The Bevel and Emboss, Texture, and Stroke layer styles applied to the frame layer.*

Adding an Image

Refer to the previous workshop segment "Adding an Image," except use the file named vail.psd, or choose an image of your own.

Creating a Nameplate

This segment creates a three-dimensional nameplate for the bottom of the metallic picture frame.

1. Create a new layer called nameplate, and move the layer to the top of the Layers palette.
2. Select the Rounded Rectangle tool from the Drawing tool, and choose a Radius of 60 pixels, as shown in Figure 10.29.

Figure 10.29: *The Rounded Rectangle drawing tool options.*

3. Create a rounded rectangle in the nameplate layer (the fill color is not important), and position the rectangle over the bottom center of the frame, as shown in Figure 10.30.

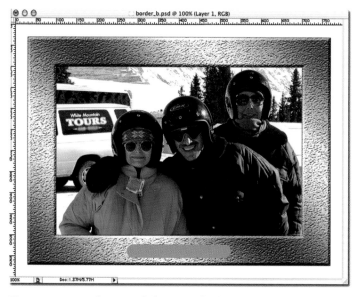

Figure 10.30: *The Rounded Rectangle drawing tool creates a fill shape in the nameplate layer.*

4. Select the Add a layer style icon, and choose Gradient Overlay from the available options. Choose the Copper gradient, an Angle of 95 degrees, and a Scale of 150 percent.
5. Select the Bevel and Emboss layer style, and choose the Emboss Style; leave the other options at their default values.
6. Select the Stroke layer style, and choose a black, 1-pixel stroke with a Position of Outside. Click the OK button to apply the layer style to the nameplate layer.
7. Select the Elliptical Marquee tool, and create a small round selection on the left of the nameplate. This selection will represent the brad that attaches the nameplate to the frame, as shown in Figure 10.31.

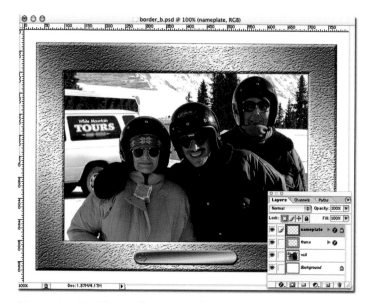

Figure 10.31: *The small circular selection represents the brad that holds the nameplate to the metallic frame.*

8. Press CTRL + J (CMD + J: Macintosh) to create a new layer with a circular copy of the nameplate. The circular copy takes on the same layer styles applied to the nameplate and creates the first brad.
9. Rename the layer brad.

10. Increase the Stroke of the brad layer to 2 pixels.

11. Select the Move tool, then click and drag the brad to the right while holding down the Alt key (Option key: Macintosh). This creates a copy of the brad layer. Use the Move tool to position the copied brad layer to the right of the nameplate, as shown in Figure 10.32.

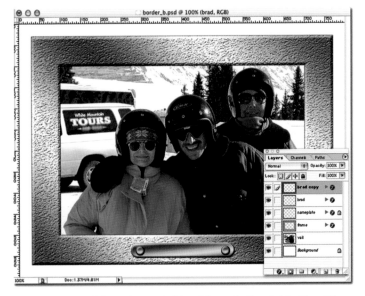

Figure 10.32: *Move the copied brad layer to the right side of the nameplate*

Adding the Text

1. Select the Text tool and choose a color from the Swatches palette. In this example, I chose black.

2. Click in the document window and type the nameplate text. In this example, I used the font Marker Felt at a size of 30 points.

3. Use the Move tool to position the text over the nameplate, as shown in Figure 10.33.

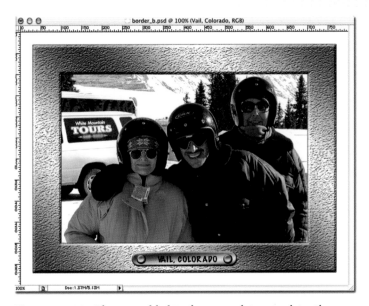

Figure 10.33: *The text added to the nameplate completes the effect.*

WORKSHOP 4 – CREATING EXOTIC FRAMES WITH LAYER MASKS

In the previous two workshops, you created cool-looking frames in cloth and metallic patterns. However, the two similarities between the two frames were straight edges and 90-degree corners. In this workshop, you will create exotic borders using layer masks.

Layer masks are important creative tools, because they let you define the visible elements of a layer using the mask. By painting the mask with black and white, you alternately mask and expose sections of the active layer, as shown in Figure 10.34.

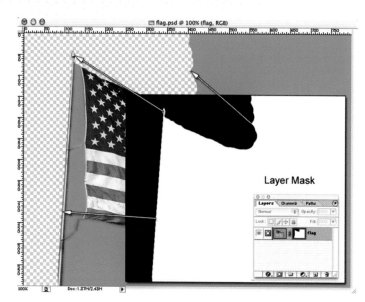

Figure 10.34: *A layer mask generates transparent areas in a layer, based on painting the mask with black and white, or shades of gray.*

To begin this workshop, open the exotic.psd file in the Chapter 10 work folder, and perform these steps:

1. Create a new layer (click the Add a new layer icon), and name the layer exotic.
2. Click the Add a layer mask icon, located at the bottom of the Layers palette, and add a layer mask to the exotic layer.
3. Click once on the layer mask while holding down the Alt key (Option key: Macintosh). The document window switches to the mask, as shown in Figure 10.35.
4. Select the Rectangular Marquee tool, and create a rectangular selection 50 pixels from the top, bottom, left, and right sides.
5. Press the letter D on your keyboard and then press Delete to fill the selected area with black.
6. Create another rectangular selection 100 pixels from the top, bottom, left, and right sides.

Figure 10.35: *Clicking on the mask thumbnail while holding down the Alt key exposes the mask in the document window.*

7. Press the letter X on your keyboard (reverses the foreground and background colors), and then press the Delete key to fill the area with white.
8. Select Image - Adjustments, and choose Inverse from the fly-out menu. The black and white colors reverse, as shown in Figure 10.36.

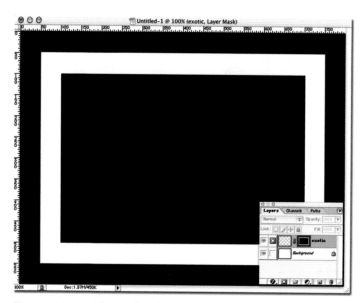

Figure 10.36: *The mask colors reverse, creating a mask in the shape of a rectangular frame.*

9. Click once on the layer thumbnail for the exotic layer. Photoshop reactivates the layer and the photograph is visible in the document window.

10. Select Edit, and choose Fill from the pull-down menu. Choose the Grass fill pattern, and click OK to apply the Fill command to the exotic layer. The mask controls the visible areas of the exotic layer, so the fill is visible in the white areas of the mask; appearing within a strict rectangle, as shown in Figure 10.37.

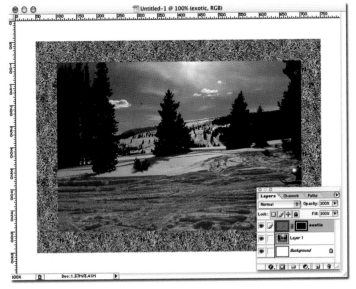

Figure 10.37: *The Fill command fills the masked areas of the frame with the grass pattern.*

11. Click once on the layer mask thumbnail. Photoshop selects the layer mask, but since you didn't hold down the Alt key (Option key: Macintosh), the image and border are still visible.

12. Select Filter - Brush Strokes, and choose Sprayed Strokes from the flyout menu. Choose a Stroke Length of 12, a Spray Radius of 7, and a Right Diagonal Stroke Length. Click the OK button to apply the Sprayed Strokes filter to the Exotic layer mask, as shown in Figure 10.38.

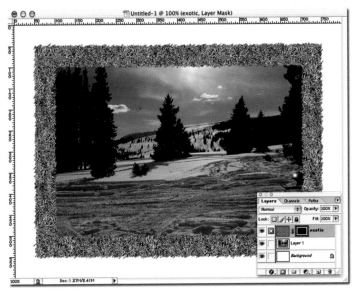

Figure 10.38: *The Sprayed Strokes filter applied to the mask creates a change in the visible image in the document window.*

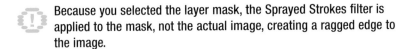 **Because you selected the layer mask, the Sprayed Strokes filter is applied to the mask, not the actual image, creating a ragged edge to the image.**

13. Select the Add a layer style icon, located at the bottom of the Layers palette, and choose Bevel and Emboss from the available options.

14. Select an Inner Bevel with a Depth of 50 percent and a Size of 35 pixels. Leave the other options at their default values.

15. Select the Texture option, choose the Gouache Light on Watercolor from the Pattern options, and click OK to apply the layer styles to the exotic layer, as shown in Figure 10.39.

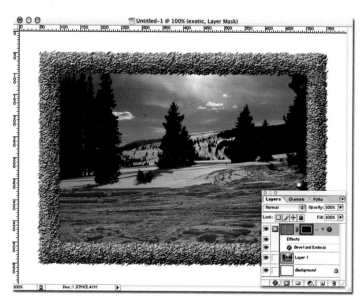

Figure 10.39: *The Bevel and Emboss layer style with the Texture option applied to the frame layer completes the effect.*

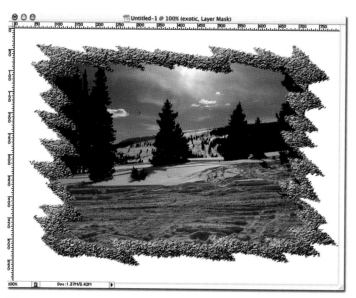

Figure 10.40: *A custom shape used to create the layer mask.*

Variations on a Theme

Once you understand the flexibility and control offered by layer masks, you can create frames in any size, shape, or style desired. For example, Figure 10.40 uses a layer mask created with the Custom Shape tool, and Figure 10.41 illustrates the use of Photoshop's Dynamic Brush palette to create a unique border.

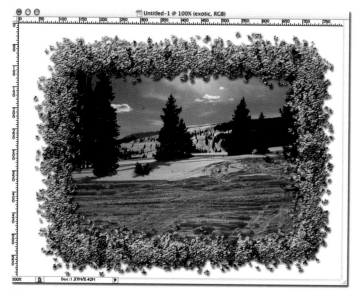

Figure 10.41: *The Dynamic Brush tool used to create the mask.*

WORKSHOP 5 – CREATING A REALISTIC CHISEL EFFECT WITH LAYER STYLES AND FILL

Creating the illusion of three dimensions on a flat surface involves a blending of highlights and shadows. In Photoshop, the Bevel and Emboss layer style performs the job for us, and, if done correctly, the effect can be quite impressive.

The effect typically involves creating a copy of the flat surface in a separate layer, and applying the Bevel and Emboss layer style to the copied layer. While this is an effective way to create a chiseled effect, it does require copying and pasting image data; and if you don't like the placement of the chisel effect, you have to start all over.

That was before Photoshop 7 hit the market. Photoshop 7 includes a new layer option called Fill. The Fill option lets your remove the image, just like the Opacity option has been doing for years; however, if you have a layer style applied to a layer, the fill option removes the image information while retaining the layer style. Nowhere is this new feature better demonstrated than in the creation of a chiseled effect.

To begin this workshop open the file named stone.psd, and perform these steps:

1. Move into the Layers palette and select the chisel layer.
2. Change the Fill for the chisel layer to zero percent, as shown in Figure 10.42.
3. Select the Add a layer style icon, and choose Bevel and Emboss from the available options.
4. Choose an Inner Bevel with a Chisel Hard Technique. Change the Depth to 150 percent, and the size to 10 pixels. To create the visual impression of depth, choose a Direction of Down.
5. Click the OK button to apply the Bevel and Emboss to the chisel layer, as shown in Figure 10.43.
6. Move to the Layers palette and click once on the chisel layer while holding down the CTRL key (CMD key: Macintosh). A selection is created based on the original chisel pattern.

Figure 10.42: *The Fill option controls the transparency of the pixels in the chisel layer.*

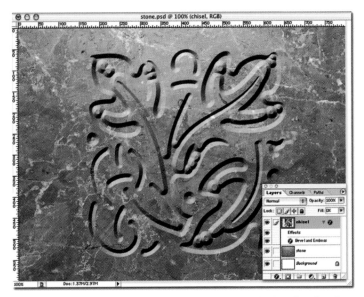

Figure 10.43: *The Bevel and Emboss filter applied to the chisel layer.*

7. Select the Add a layer style icon (the half-moon), and select Levels from the available options. A Levels adjustment layer is created with a mask defined by the selection created in step 6.

8. Adjust the mid-tone Input Level to 0.70, and click the OK button to apply the Levels adjustment to the image. The adjustment of the mid-tone Input Level creates a darkening of the areas associated with the chisel effect, as shown in Figure 10.44.

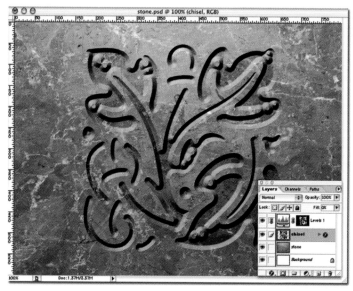

Figure 10.44: *The Levels adjustment layer, with the associated mask, darkens the chiseled areas of the image, while leaving the remaining areas unaffected.*

The visual information represents live information from the stone layer (not a copy of the stone layer), so you can alter the chisel effect by modifying the options in the Levels adjustment layer, and you can move the chisel without destroying the effect.

To move the chisel effect, chain link the Levels adjustment layer to the chisel layer, choose the Move tool, and click and drag the image. As you can see, the chisel effect is perfectly compatible anywhere you move the image, as shown in Figure 10.45.

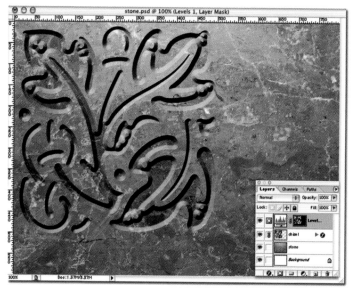

Figure 10.45: *Moving the image does not affect the chisel effect.*

Variations on a Theme

Knowing that the chisel layer and layer styles control the chisel effect, experiment by painting on the chisel layer with one or more of Photoshop's new dynamic brushes. For example, I used the Grass dynamic brush to paint over the chisel layer to create a weathered look in the marble, as shown in Figure 10.46.

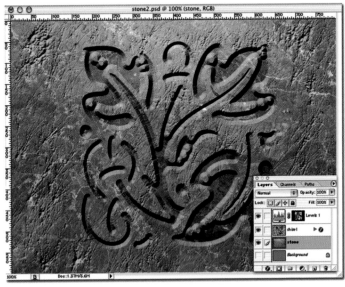

Figure 10.46: *Painting on the chisel layer with the Grass dynamic brush creates a weathered look to the marble.*

WORKING WITH TEXT

OVER THE YEARS, ADOBE HAS CHANGED HOW PHOTOSHOP HANDLES TEXT. EARLIER VERSIONS OF PHOTOSHOP LET DESIGNERS WORK WITH TEXT, BUT IN A VERY LIMITED WAY. FOR EXAMPLE, A DESIGNER COULD CREATE TEXT IN A PHOTOSHOP DOCUMENT, BUT PHOTOSHOP CONVERTED THE TEXT INTO PIXELS (A PROCESS KNOWN AS RASTERIZING) AS SOON AS THE TYPE WAS ENTERED INTO THE TYPE DIALOG BOX. UNFORTUNATELY, IF THE DESIGNER WISHED TO CHANGE THE TEXT AT A LATER DATE, THE ONLY OPTION WAS TO DELETE THE OLD TEXT AND START FROM SCRATCH. NOT A VERY USER-FRIENDLY WAY TO DESIGN TEXT.

TO HANDLE THIS PROBLEM, PHOTOSHOP CREATED A TYPE LAYER. THIS PRESERVED THE VECTOR NATURE OF THE TEXT AND GAVE DESIGNERS GREATER FLEXIBILITY; HOWEVER, PHOTOSHOP STILL CONVERTED THE TYPE INTO PIXELS WHEN THE DESIGNER OUTPUT THE FILE TO PRINT. THIS CAUSED QUALITY PROBLEMS FOR THE FINAL PRINTED DOCUMENT.

That was the past. Today, current versions of Photoshop let designers create vector text, and Photoshop preserves the vector nature of the text all the way through the output process; that's just the beginning. Photoshop contains a wealth of new creative styles and even a warp-text feature, which helps designers create text in any size, shape, pattern, and color desired.

To create text in Photoshop, create a new document or open an existing image, and select the Type tool. Photoshop type comes in four versions: horizontal and vertical type, and horizontal and vertical type masks. To access a specific typing tool, click and hold your mouse on the Type tool and select the specific type option from the fly-out menu, as shown in Figure 11.1.

Figure 11.1: *Photoshop 7 contains a variety of typing tools.*

To begin typing, click once on the screen (this defines the text insertion point), and type the desired text. Photoshop places the type (just as it's typed) into a specific layer, called a Type layer, as shown in Figure 11.2.

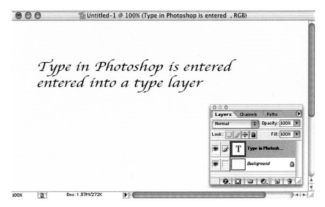

Figure 11.2: *The Type layer controls the text in a Photoshop document.*

Photoshop visually identifies type layers by displaying the letter T in the layer thumbnail. Type layers give designers the ability to change their minds without starting all over. Say, for example, you notice a misspelled word (Photoshop 7 comes equipped with its own spell checker). It's a simple matter to select the Type tool, select the misspelled word, and fix it. The same is true for applying different font sizes, faces, and layer styles. If the current text is incorrect, simply change it.

This workshop will explore some of the common and creative ways to employ text within a Photoshop document.

WORKSHOP 1 – CREATING AND MODIFYING BASIC TEXT IN PHOTOSHOP

To experiment with some of Photoshop's text tools, create a new 800 x 600 pixel document in Photoshop using the RGB color mode, and a resolution of 72 ppi.

Select the Horizontal Type tool from the Type options, click in the document window, and type the word "Photoshop." Depending on your default font, the text appears in the document window, as shown in Figure 11.3.

The text color defaults to the current foreground color swatch (in this example, black).

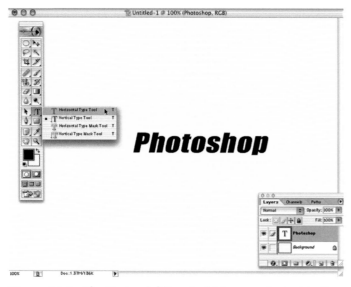

Figure 11.3: *The Horizontal Type tool lets you enter text in the active document.*

Changing the Orientation of Text

To change the orientation of the text, move to the Options bar, and click once on the text orientation button. The horizontal text (the word Photoshop) converts to vertical text, as shown in Figure 11.4.

Figure 11.4: *Horizontal text is converted to vertical text with the click of a button.*

Text orientation applies to the entire text layer; it is not necessary to select the text, just click the button. As you might expect, the text orientation button is a toggle—clicking the button changes the text from horizontal to vertical, and vice versa.

Changing the Font

To change the font (family, size, color, and justification), first select the text you want to change. It is not necessary to change all of the text, only selected text will change. In this example, I selected the entire word Photoshop.

To change the font family, move to the Options bar and click on the down arrow icon, located to the right of the font name. Then select a font from the available options. In this example, I chose the font Impact, as shown in Figure 11.5.

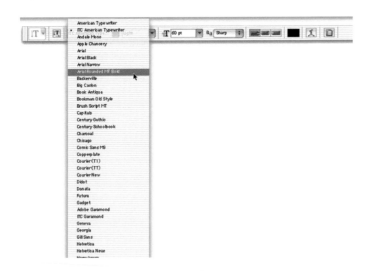

Figure 11.5: *Fonts are changed by selecting the desired font from the Options bar.*

The fonts displayed in the font family pop-up box are available on your specific computer. If you move a Photoshop document that contains type to another computer system, the receiving computer must have the same fonts available, or you will not be able to edit or correctly print the document.

Some fonts come with additional styles, such as italic and bold. If the chosen font contains additional styles, they will be available from the Font Styles pop-up menu, located to the right of the Font Family dialog box. Figure 11.6 displays the available font styles for the Ariel font.

Figure 11.6: *The Font Style pop-up menu displays the styles available for a specific font.*

To change the size of the selected font, choose from the available options in the font-size dialog box, as shown in Figure 11.7.

Figure 11.7: *Change the size of the selected font (or portion of the font) from the Font Size option on the Options bar.*

If the desired font size is not available from the pop-up menu, simply type a font size in the font-size input box. Photoshop uses the standard PostScript measurement for fonts of 72 points per inch.

The color of the text is determined at the time of typing (or later) by selection. To change the color of the text, you must first select all or a portion of the text. In this example, I selected the letters Photo. Then simply click on the text-color icon, and choose a new color from the Color-Picker dialog box, as shown in Figure 11.8.

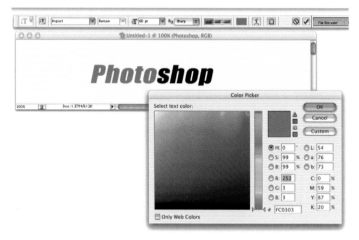

Figure 11.8: *Selected fonts can be changed to virtually any color.*

Changing the justification of the text (left, center, right) requires there be more than one line of text. Text justification applies to all the text within the type layer, so it is not necessary to select the text. Moving into the Options Bar and clicking the left, center, or right buttons changes the justification of the text. Figure 11.9 displays each style.

Using Anti-Aliasing on Text

Photoshop lets you apply anti-aliasing techniques to make the text appear smoother when displayed on a computer monitor. Anti-aliasing is applied to the type layer (not the individual text elements), so it is not necessary to select the text.

To apply anti-aliasing to the type layer, click on the anti-aliasing button, and choose from the available options. Figure 11.10 displays text using all five of the available anti-aliasing options.

Justified text is easy to
use and can be
controlled left, center, or right

Justified text is easy to
use and can be
controlled left, center, or right

Justified text is easy to
use and can be
controlled left, center, or right

Figure 11.9: *Justification of text is controlled by the Options Bar.*

None

Sharp

Crisp

Strong

Smooth

Figure 11.10: *Anti-aliasing controls the visual smoothness of the text within the type layer.*

Creating Warped Text

The Warp Text option has been in Photoshop since version 6, and is an excellent tool for distorting and manipulating text. To warp text, click the Warp Text button, and select from the available options, as shown in Figure 11.11.

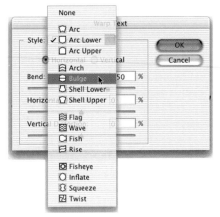

Figure 11.11: *The Warp Text option lets you choose from a variety of text warping options.*

One of the advantages of using the Warp Text option is that the text is still editable after the effect is applied. No longer does creating unique text shapes require sacrificing control of the text. Figure 11.12 illustrates a few warp text options.

Working with the Character and Paragraph Palettes

The Character and Paragraph palettes let you control the finer points of typesetting, such as kerning and leading, as well as language requirements for hyphenation and spelling.

To access the palettes, click the Character and Paragraph button, located to the right of the Warp Text button. Figure 11.13 illustrates the options available with the Character and Paragraph palettes.

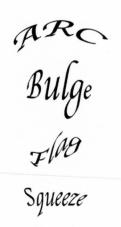

Figure 11.12: *A few of the warp options applied to various selections of text.*

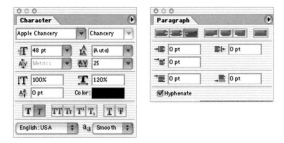

Figure 11.13: *The Character and Paragraph palettes control the size, font face, and color of a font, and more.*

As you can see, Adobe has made many changes to text processing since the first versions of Photoshop hit the market. The remainder of this workshop will explore ways of creatively incorporating text into a Photoshop document.

However, before moving into some of the other workshops, take some time to experiment with the basic text options discussed in this workshop. Adobe has given us a tremendous amount of control over the text in a Photoshop document, and you can use that control to create astonishing documents with text that leaps off the page.

WORKSHOP 2 – WRAPPING TEXT AROUND A CURVED SURFACE USING WARPED TEXT

Creating text on a curved surface is a snap, if you have access to a program such as Adobe Illustrator. There have been many workaround solutions to creating text in something other than a straight line, even additional plug-ins you could purchase. However, nothing has made curving text in Photoshop as easy as using the Warp Text option. To curve text along a surface, open the file named curves.psd in the Chapter 11 folder or create a new file, then perform these steps:

1. Select the Horizontal Type tool, and enter some text in the document window. It's important that the length of the text fit the first half of the curved line. In this example, I typed the words "Big Yellow Daffodils like to grow" using the Gill Sans font face and a point size of 16, as shown in Figure 11.14.

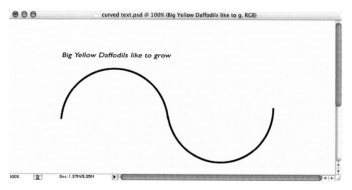

Figure 11.14: *The horizontal text is entered into the document window.*

2. Click the Warp Text button, and choose the Arc Style, Horizontal with a 90-degree Bend. Leave the Horizontal and Vertical Distortion values at zero. Click the OK button to apply the Warp Text to the type layer, as shown in Figure 11.15.

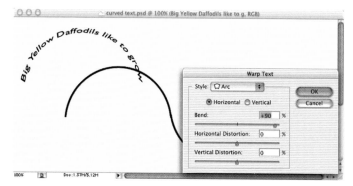

Figure 11.15: *The Warp Text option Arc, applied to the Type layer.*

3. Select the Move tool, and position the Type layer over the left portion of the circle, as shown in Figure 11.16.

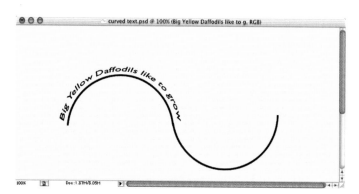

Figure 11.16: *The Move tool positions the type over the circle.*

4. Select Edit, and choose Free Transform from the pull-down menu. Transform the text until it fits the circle. Press the Enter key to apply the Free Transform command to the type layer, as shown in Figure 11.17.

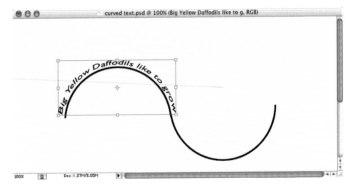

Figure 11.17: *The Free Transform command applied to the Type layer.*

5. Create another Type layer with the words "on the sunny side of sloping hills". Repeat step 2, and apply the Arc Warp Text style; however, this time, apply a –90 degree Bend. Click the OK button to apply the Warp Text to the second type layer.
6. Move and transform the text (refer to steps 3 and 4), so that it appears on the inside curve of the second circle, as shown in Figure 11.18.

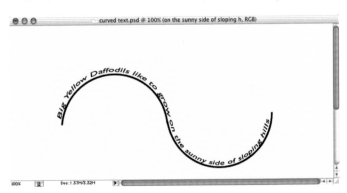

Figure 11.18: *The type positioned on the inside of the second curve.*

7. Select the Type tool.
8. Click on the original text, Big Yellow Daffodils… (this will select the original type layer).
9. Click the Warp Text button and change the Vertical Distortion option to –25 percent. Click the OK button to apply the Vertical Distortions to the text, as shown in Figure 11.19.

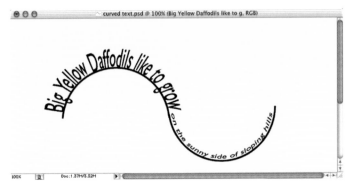

Figure 11.19: *The Vertical Distortion option applied to the text.*

10. Use the Move tool, if necessary, to reposition the text over the circle.
11. Repeat steps 7 through 9, to the second text layer, except use a Vertical Distortion of +25. The results are displayed in Figure 11.20.

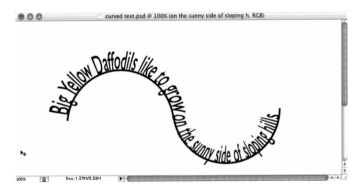

Figure 11.20: *The text appears to be curving around the circle.*

As you can see, the Arc style and a 90 percent bend created the illusion of bending text. However, we completed the effect with the Free Transform command and the Vertical Distortion option.

Remember, in Photoshop, it is not just clicking one button or applying a single filter that will produce the results that you are looking for in the final document.

WORKSHOP 3 – SCULPTING TEXT WITH LAYER MASKS

In the previous workshop, I modified a type layer using the Warp Text command. While the Warp Text command creates some interesting shapes, it does nothing to the edges of the text. Say, for example, you want text with a distorted or ragged edge. One way to accomplish this would be to rasterize the text and apply a Brush Stroke filter, such as the Spatter filter. However, once the text is rasterized, you can no longer edit the original text.

To solve this problem, you can create text and use a layer mask to control the sculpting of the edges. Create a new 800 x 600 pixel Photoshop document, using the RGB Color Mode and a resolution of 72 ppi, and then follow these steps:

1. Select the Horizontal Text tool and create a type layer in the open document. In this example, I typed the words "JAGGED EDGE" using the Impact font, with a 150-point size, as shown in Figure 11.21.
2. Select the Move tool and position the text in the center of the document window.
3. Select Edit, and choose Free Transform from the pull-down menu. Rotate the text 45 degrees counter-clockwise, then press the Enter key to apply the Free Transform command to the text, as shown in Figure 11.22.
4. Click once on the type layer while holding down the CTRL key (CMD key: Macintosh). This creates a selection based on the text within the type layer.
5. Click the Add layer mask icon, located at the bottom of the Layers palette. A layer mask is created based on the selection, as shown in Figure 11.23.

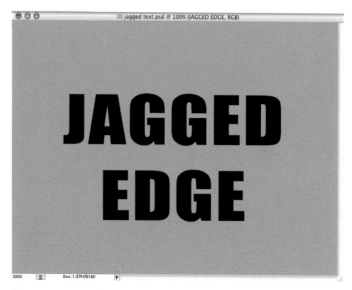

Figure 11.21: *The Horizontal Type tool lets you enter text in the active document.*

Figure 11.22: *The Free Transform command applied to the type layer.*

Figure 11.23: *The Layer mask applied to the type layer will create a mask based on the selected areas of the layer.*

6. Select Filter - Brush Strokes, and choose Sprayed Strokes from the fly-out menu. Select a Stroke Length of 15, a Spray Radius of 15, and a Stroke Direction of Vertical. Click the OK button to apply the Sprayed Strokes filter to the layer mask, as shown in Figure 11.24.

Figure 11.24: *The Sprayed Strokes filter applied to the layer mask.*

Adding the Final Touches

1. Click the Add layer style button, located at the bottom of the Layers palette.
2. Add a Drop Shadow layer style using a 120-degree Angle, a Distance of 5, Spread of 0, and a Size of 5. All other options are set to their default values.
3. Add a Bevel and Emboss layer style using an Inner Bevel Style, and default values for all other options.
4. Add a Contour option using the Triple Ring Contour, and a 50 percent Range.
5. Add a Texture option using the Washed Watercolor Paper Pattern, with a Scale of 100 percent and a Depth of 90 percent.
6. Add a Gradient Overlay layer style using the Steel Bar Gradient, and leave the remainder of the options at their default values.
7. Add a Stroke layer style, using a 1-pixel black stroke. Leave the remaining options at their default values.
8. Click the OK button to apply the layer styles to the type layer, as shown in Figure 11.25.

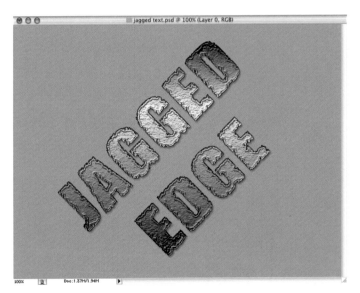

Figure 11.25: *The final sculpted-text image.*

WORKSHOP 4 – WRITING IN WET CONCRETE

Ever had the temptation to write something in wet concrete? We all have had the temptation once or twice in our lives. So, do you act on that temptation? If you're using Photoshop, you can write in wet concrete and not even get your fingers dirty. To create text in wet concrete, open the concrete.psd file located in the Chapter 11 directory on the companion Web site, or create your own concrete, and follow these steps:

1. Select the Channels palette. If the Channels palette is not visible, select Window, and choose Channels from the pull-down menu.
2. Click the Create new channel icon, located at the bottom of the Channels palette. A new channel is created. Name the new channel text.
3. Select the Horizontal Type tool and enter some white text in the new channel. Choose a font that resembles handwriting. In this example, I used the font face Marker Felt at a point size of 125.
4. Select the Move tool and position the text in the middle of the text channel.
5. Select Edit, and choose Free Transform from the pull-down menu. Rotate the text 30 to 40 degrees counter-clockwise, and press the Enter key to apply the Free Transform command to the text channel, as shown in Figure 11.26.
6. Drag the text channel over the Create new channel icon. A copy of the text channel is created with the name text copy.
7. Select Filter - Stylize, and choose Diffuse from the fly-out menu. Select a mode of Lighten Only, and click the OK button to apply the Diffuse filter to the text copy channel.
8. Press CTRL + F (CMD + F: Macintosh) 4 times, to reapply the Diffuse filter.
9. Choose Select, and choose Load Selection from the pull-down menu.
10. Choose the original text Channel, and click the OK button to apply the selection to the Background layer, as shown in Figure 11.27.
11. Select Filter - Blur, and choose Gaussian Blur from the fly-out menu. Choose a Blur Radius of 4 pixels, and click the OK button to apply the Gaussian Blur filter to the text copy channel, as shown in Figure 11.28.

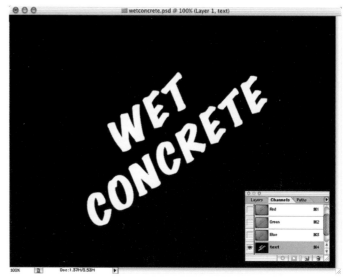

Figure 11.26: *The Free Transform command applied to the text channel.*

Figure 11.27: *The Load Selection command creates a selection based on the selected channel.*

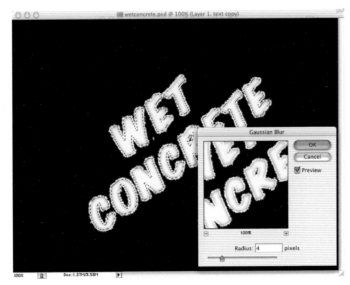

Figure 11.28: *The Gaussian Blur filter applied to the text copy channel.*

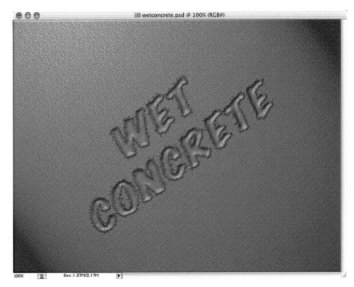

Figure 11.29: *The final image resembles text written in wet cement.*

12. Choose Image - Adjustments, and choose Invert from the pull-down menu. The selected area is inverted.
13. Press CTRL + D (CMD + D: Macintosh) to deselect the text.
14. Select the Layers palette and click once on the Background layer. This selects and displays the Background layer in the document window.
15. Select Filter - Render, and choose Lighting Effects from the fly-out menu. Choose the Default Style. Choose a Gloss of –45, a material of –30, an Exposure of –10, and an Ambience of –20. Select the text copy layer as the Texture Channel with a Height of 45.
16. Direct the light source to the upper-left corner, and focus the beam as not to wash out the image. Click the OK button to apply the Lighting Effects filter to the document, as shown in Figure 11.29.

WORKSHOP 5 – CREATING REFLECTED TEXT

Photoshop's filters and layer styles let you create awesome special effects, but there is a limit to what a single piece of text can produce. In this workshop you will create a reflection on a surface using two text layers, and a little help from Photoshop's filters and layer blending modes. To begin this workshop, open the file named reflections.psd in the Chapter 11 work folder, or open an image of your own, and perform these steps:

1. Select the Horizontal Type tool, and enter some text in the document window. In this example, I entered the word "REFLECTIONS" using the Nuptial Script font, at a font size of 100 points. I chose yellow with a 1-pixel black stroke to contrast the text with the background.

Note: If you don't have the Nuptial Script font, any cursive font such as Brush Script, or Apple Chancery, will do just as well. Experimenting with different fonts adds to the originality of the reflected image.

2. Select the Move tool and position the text, as shown in Figure 11.30.

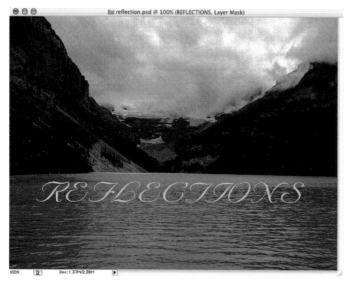

Figure 11.30: *Use the Move tool to position the text over the water.*

3. Press CTRL + J (CMD + J: Macintosh). A copy of the text layer is created.
4. Select the copy layer.
5. Select Edit - Transform, and choose Flip Vertical from the fly-out menu.
6. Select the Move tool and position the copied layer directly underneath the original text layer, as shown in Figure 11.31.
7. Select the text layer copy, and choose the Overlay blending mode.
8. Select Edit and choose Free Transform from the pull-down menu. Reduce the height of the copy text layer to 60, as shown in Figure 11.32.

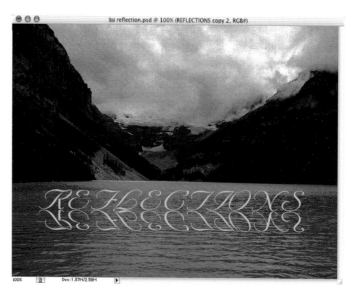

Figure 11.31: *The Move tool positions the copied layer underneath the original text.*

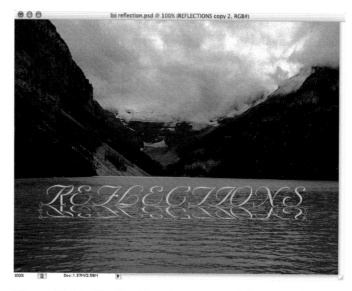

Figure 11.32: *The Free Transform command lets you reduce the height of the selected text.*

9. Press the Enter key to apply the Free Transform to the copy text layer.
10. Press the letter D on your keyboard to default the foreground and background colors to black and white.
11. Click the Add a layer mask icon, located at the bottom of the Layers palette, to add a layer mask to the text copy layer.
12. Select the Linear Gradient tool and drag the gradient tool across the layer mask from the top of the text to approximately a half-inch below the text, as shown in Figure 11.33.

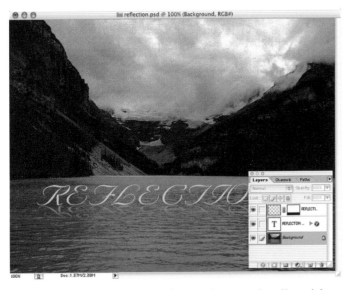

Figure 11.33: *The Linear Gradient tool creates the effect of the reflected text fading into the water.*

The gradient applied to the layer mask creates the illusion of the reflection fading as it moves further away from the original text.

Variations on a Theme

Figure 11.34 shows the reflection using the ZigZag filter, and Figure 11.35 shows how a layer mask can be used on the original text layer to make the text appear as if it's rising out of the water.

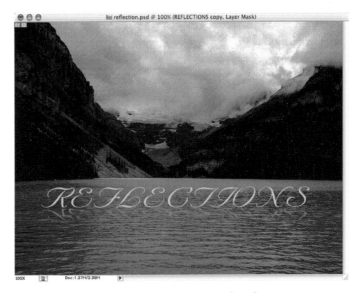

Figure 11.34: *The text against a mirrored surface.*

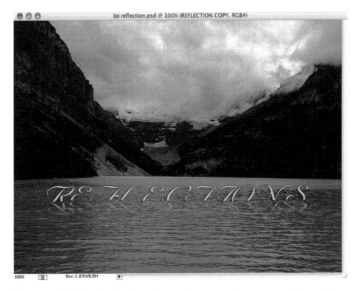

Figure 11.35: *The text, using a layer mask, appears to be rising out of the lake.*

WORKSHOP 6 – CREATING PEELING TEXT

Creating peeling text is a cool effect and quite simple to create. After you've mastered the technique you can apply it to virtually any text and surface. To create peeling text, create a new document in Photoshop (in this example, 800 x 600, 72 ppi, RGB), and perform these steps:

1. Select the Text tool, and create text in the document window (this effect works best with a good thick font). In this example, I typed the word "PEELING" using the Impact font and at a font size of 125, as shown in Figure 11.36.

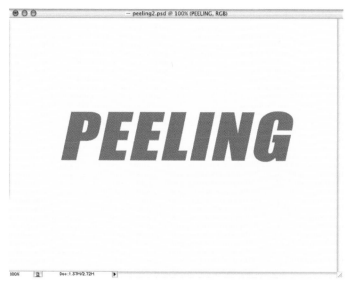

Figure 11.36: *The word PEELING is entered into the new document.*

2. Select Layer - Rasterize, and choose Type from the fly-out menu. This converts the text layer from type to pixels.

You won't be able to change the font after you rasterize the layer, so make sure you like the font face and that it is spelled correctly.

3. Select the Polygon text tool, and select the upper-left corner of the letter P, as shown in Figure 11.37.

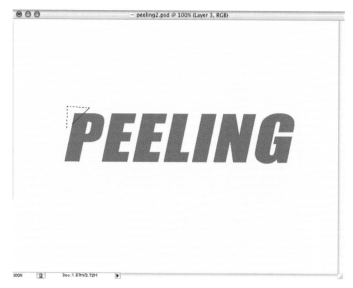

Figure 11.37: *The upper-left portion of the letter P is selected using the Polygon selection tool.*

4. Press CTRL + J (CMD + J: Macintosh). A copy of the selected area is created in a new layer named Layer 1. Rename the layer peeling_1.
5. Select Edit, and choose Free Transform from the pull-down menu.
6. Rotate the peeling_1 layer 150 degrees, as shown in Figure 11.38.

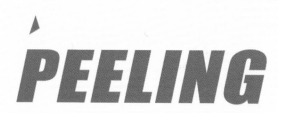

Figure 11.38: *The Free Transform tool rotates the peeling_l layer 150 degrees.*

7. Press the Enter key to apply the Free Transform to the peeling_1 layer.
8. Select the Lock transparent pixels option for the peeling_1 layer.
9. Select the Linear Gradient tool, and choose the Steel Bar gradient, as shown in Figure 11.39.

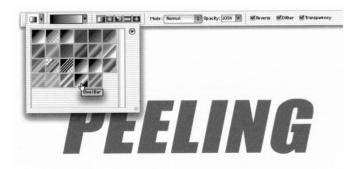

Figure 11.39: *The Steel Bar gradient creates an alternately dark, light, dark gradient, perfect for creating peeling text.*

If the Steel Bar gradient is not available, click the triangle in the upper-right corner of the gradient and select the Metals gradient from the pull-down menu.

10. Drag the Gradient tool across the copied section of the letter P until you see something like Figure 11.40.

Figure 11.40: *The Steel Bar gradient applied to the peeling_1 layer.*

11. Select the Eraser tool.
12. Select the original peeling layer.
13. Use the Eraser tool to erase the upper-left portion of the original text, as shown in Figure 11.41.

Figure 11.41: *The upper-left portion of the letter P is erased using the Eraser tool.*

14. Select the Move tool.
15. Select the peeling_1 layer.
16. Click and drag the peeling_1 layer while holding down the Alt key (Option key: Macintosh). A copy of the peeling_1 layer is created. Rename the layer peeling_2.
17. Use the Move tool to position the peeling_2 layer over the upper-left corner of the letter, L.
18. Create a copy of the peeling_2 layer (Alt/Option + drag), and position it over the letter N, as shown in Figure 11.42.

Figure 11.42: *Position the peeling_2 layer over the letters L and N.*

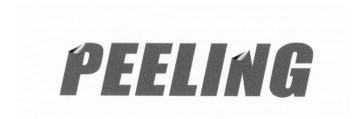

19. Select the original text layer, and use the Eraser tool to erase the upper-left portions of the text, as shown in Figure 11.43.

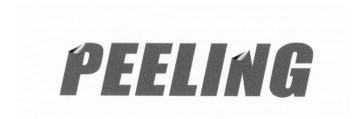

Figure 11.43: *The upper-left portion of the letters N and L are erased using the Eraser tool.*

20. To complete the effect, create various size triangular selections of the original peeling layer (refer to steps 4 through 11), until you create the effect you're looking for; possibly something similar to Figure 11.44.

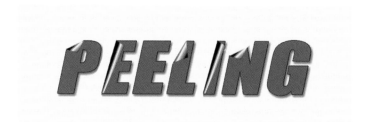

Figure 11.44: *The final version of the Peeling Text workshop.*

WORKSHOP 7 – CREATING GRASSY TEXT

This effect gives an overgrown look to the text. To begin the workshop, create a new Photoshop document (in this example, 800 x 600, 72 ppi, RGB), and perform these steps:

1. Select a color for the text (in this example, green) and type the text into the document window. I typed the word "GRASS" using the Apple Chancery font face, at a size of 100 points.
2. Click on the Type layer while holding down the CTRL key (CMD key: Macintosh). A selection is created based on the font in the Type layer.
3. Open the Channels palette, and click the Save selection as channel icon, located at the bottom of the palette. A channel is created (named Alpha 1) based on the selection. Rename the channel grass_1, as shown in Figure 11.45.

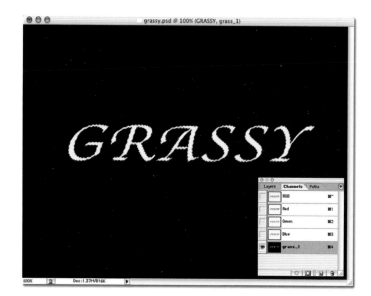

Figure 11.45: *The grass_1 channel will be used to create the grassy text.*

4. Press CTRL + D (CMD + D: Macintosh) to deselect the text.
5. Select Image - Adjustments, and choose Invert from the fly-out menu.
6. Select Image - Rotate Canvas, and choose 90 CW, to rotate the image 90 degrees clockwise.
7. Select Filter - Stylize, and choose Wind from the fly-out menu. Select Wind, and choose a direction to the Right. Click the OK button to apply the Wind filter to the grass_1 channel.
8. Select Filter - Stylize, and choose Wind from the fly-out menu. Select Wind, and choose a direction to the Left. Click the OK button to apply the Wind filter a second time to the grass_1 channel.
9. Select Image - Adjustments, and choose Invert from the fly-out menu.
10. Make a copy of the grass channel and name it grass_2.
11. Press CTRL + F (CMD + F: Macintosh). The last filter used (the Wind filter) is applied to the grass_2 channel.
12. Press CTRL + I (CMD + I: Macintosh). The colors in the grass_2 channel reverse.
13. Repeat steps 11 and 12 two more times, until the grass_2 channel looks similar to Figure 11.46.

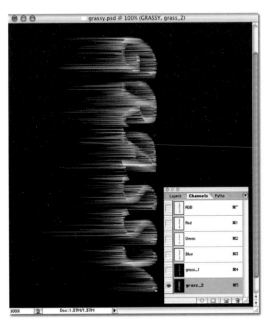

Figure 11.46: *The Inverse and Wind filters applied three times to the grass_2 channel.*

14. Select Image - Rotate Canvas, and select 90 CCW. The document window rotates 90 degrees counter-clockwise.
15. Select a color from the Swatches palette for the grassy part of the text. In this example, I chose a lighter shade of green.
16. Move into the Layers palette and CTRL + click (CMD + click: Macintosh) on the type layer. The text in the layer is selected.
17. Select Layer - Rasterize, and choose Type from the fly-out menu. The type layer is converted into pixilated (rasterized) text.
18. Choose Select, and choose Load Selection from the pull-down menu. Select the grass_1 channel, and choose Subtract from Selection options. Click the OK button to apply the Load Selection command to the type layer.
19. Press Alt + Backspace (Option + Delete: Macintosh) to fill the selected areas with the foreground color, as shown in Figure 11.47.

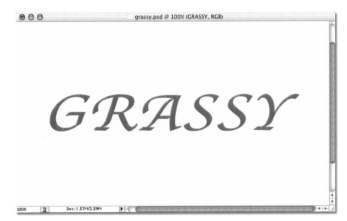

Figure 11.47: *The foreground color applied to the selected areas of the text.*

20. Click the Add new layer button, located at the bottom of the Layers palette. Rename the layer grass, and position the layer at the top of the Layers palette.
21. Choose Select, and choose Load Selection from the pull-down menu. Select the grass_2 channel, and choose New Selection from the Selection options. Click the OK button to apply the Load Selection command to the grass layer.

22. Click the Add layer mask icon. A layer mask is added to the grass layer, based on the grass_2 channel selection, as shown in Figure 11.48.

Figure 11.48: *A layer mask is added to the grass layer, based on the selection created with the grass_2 channel.*

23. Select a medium green color from the Swatches palette.
24. Click on the grass layer image thumbnail. The image, not the layer mask, is selected.
25. Press Alt + Backspace (Option + Delete: Macintosh) to fill the grass layer with the foreground color. Since the mask controls the visible parts of the image, only the grass shows through, as shown in Figure 11.49.

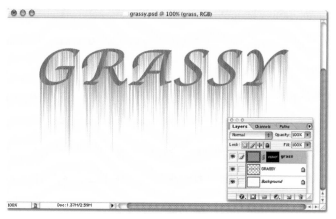

Figure 11.49: *The color is applied to the unmasked areas of the grass_2 layer.*

26. Select Filter - Distort, and select the ZigZag filter. Choose an Amount of 10 percent, Ridges of 4, and a Style of Out from Center. Click the OK button to apply the ZigZag filter to the grass layer, as shown in Figure 11.50.

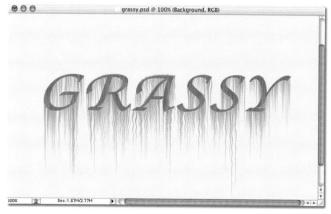

Figure 11.50: *The ZigZag filter applied to the layer mask in the grass_2 layer.*

27. Select the Rectangular Marquee tool and create a selection containing the grass hanging off the bottom of the letters (the layer mask is still selected), as shown in Figure 11.51.

 In order for this next step to work properly, make sure the background color swatch is pure black.

28. Select Image, and choose Free Transform from the pull-down menu. A bounding box replaces the selection marquee.
29. Click and drag the anchor point (bottom, center) and reduce the height of the selection area by approximately 50 percent.
30. Right-click your mouse in the middle of the bounding box, and select Perspective from the pop-up, context-sensitive menu.

31. Move to the lower-right anchor point and drag outward, until the angle of the bounding box sides approaches 45 degrees, as shown in Figure 11.52.

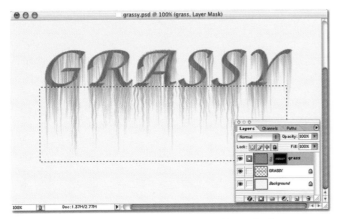

Figure 11.51: *The selection marquee encloses the bottom portion of the grass_2 layer.*

32. Press the Enter key to apply the Free Transform command to the selection.
33. Press CTRL + D (CMD + D: Macintosh). The selected areas of the grass layer are removed.
34. To finish the effect, click the Add new layer style icon, and add a default Drop Shadow and Inner Shadow to the grass layer, as shown in Figure 11.53.

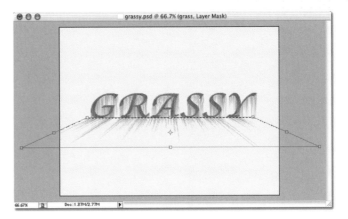

Figure 11.52: *The Perspective command applied to the selected area of the grass_2 layer.*

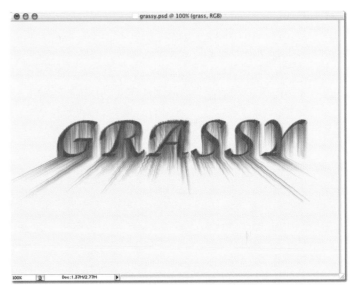

Figure 11.53: *The final grassy image.*

Variations on a Theme

Skip steps 27 through 33, and let the grass hang from the edges of the words; then create a background and apply the ZigZag filter using the Pond Ripples Style to create waves on the surface of the water, as shown in Figure 11.54.

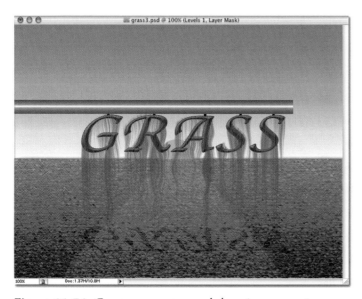

Figure 11.54: *Grassy, or mossy, words hanging over water.*

C
R
E
A
T
I
N
G

T
H
E

U
N
I
V
E
R
S
E

CREATING THE UNIVERSE
WITH PHOTOSHOP

PHOTOSHOP IS A TREMENDOUSLY VERSATILE TOOL, AN
EXCELLENT PROGRAM FOR WORKING ON, MANIPULATING, AND
RESTORING PHOTOS, IMAGES, AND GRAPHICS. HOWEVER,
PHOTOSHOP IS ALSO A CREATIVE TOOL IN ITS OWN RIGHT. THIS
WORKSHOP WILL DISCUSS SOME OF THE TECHNIQUES YOU CAN
USE TO CREATE OBJECTS AND LANDSCAPES FROM SCRATCH.

WORKSHOP 1 – CREATING AN EVENING LANDSCAPE

A fundamental part of creating a landscape is dividing the sky from the land. To create a horizon, create a new document in Photoshop (800 x 600, 72 ppi, RGB), and perform these steps:

1. Click the Create a new layer icon, located at the bottom of the Layers palette. Name the new layer horizon.
2. Select the Paintbrush tool, and use the Lasso tool to draw a horizon similar to Figure 12.1.

Figure 12.1: *The Lasso tool is used to draw the horizon line.*

3. Press the letter D on your keyboard to default the foreground and background colors to black and white.
4. Press Alt + Backspace (CMD + Delete: Macintosh) to fill the selected portion of the horizon layer with the foreground color (black), as shown in Figure 12.2.

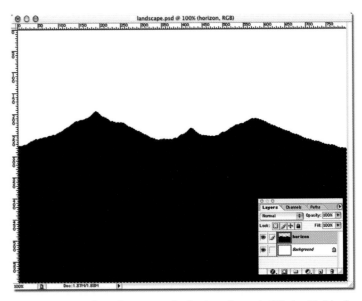

Figure 12.2: *The selection in the horizon layer is filled with black.*

5. Select a foreground and background color appropriate for a night sky. In this example, I selected dark violet and magenta as the foreground and background colors.
6. Select the Magic wand tool and click in the upper portion of the horizon layer. The top portion of the horizon layer (the sky) is not selected.
7. Choose Select - Modify, and choose Expand from the fly-out menu. Expand the selection by 2 pixels, and press the Enter key to apply the Expand option to the selection.
8. Select the Linear gradient tool and choose the Foreground to Background gradient option, as shown in Figure 12.3.

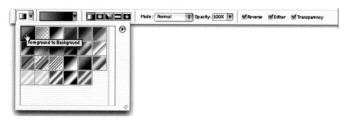

Figure 12.3: *The Foreground to Background option in the Options Bar.*

9. Drag the Linear Gradient tool from the top of the document window to the bottom lowest portion of the visible horizon. The violet and magenta gradient is applied to the selection and gives the appearance of a night sky just after sunset, as shown in Figure 12.4.

Figure 12.4: *The violet/magenta linear gradient applied to the image.*

Adding Stars

In this section, you will fill your beautiful evening sky with stars, because no evening sky would be complete without stars.

1. Click the Add new layer icon, and name the new layer stars. Position the stars layer at the top of the Layers palette.
2. Press the letter D, then the letter X, on your keyboard. The foreground and background colors reverse to white and black.
3. Select the Paintbrush tool, and using a 1-, 2-, and 3-pixel brush, randomly paint stars into the image using the stars layer, as shown in Figure 12.5.

The best approach to creating realistic stars is to begin with a scattering of 1-pixel stars, then add a random sampling of 2-pixel stars, and finally add a smattering of 3-pixel stars.

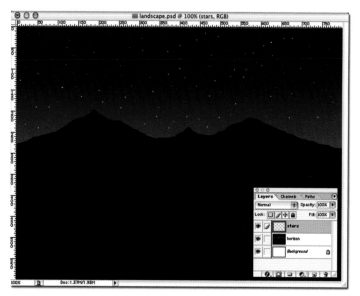

Figure 12.5: *The stars randomly painted using a 1-, 2-, and 3-pixel white brush.*

4. Click the Add layer mask icon, located at the bottom of the Layers palette. A layer mask is added to the stars layer. Make sure the layer mask is selected.

5. Select the Linear Gradient tool, and choose the Foreground to Background gradient option.

6. Drag the Linear Gradient tool from the top of the document window to the horizon. The white-and-black gradient, applied to the layer mask, will mask the stars and make them appear fainter as they approach the horizon, as shown in Figure 12.6.

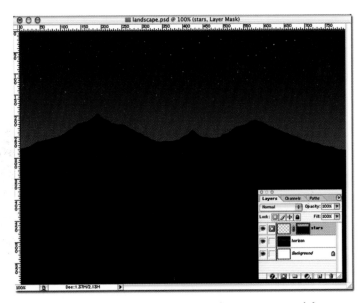

Figure 12.6: *The linear gradient gives the appearance of the stars fading.*

7. Make the horizon layer the active layer.

8. To add a hint of texture, select the Magic Wand tool, and click once in the black portion of the horizon layer. The black land areas are selected.

9. Select Filter - Noise, and choose Add Noise from the fly-out menu. Choose an amount of 7 percent, Distribution of Uniform, and select the Monochromatic option. Click the OK button to apply the Add Noise filter to the selection in the horizon layer, as shown in Figure 12.7.

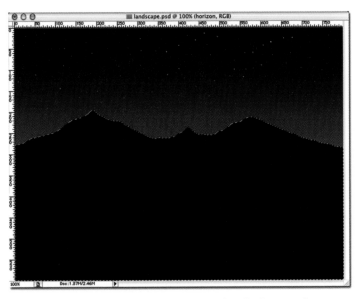

Figure 12.7: *The Add Noise filter applied to the horizon layer.*

10. Press CTRL + D (CMD + D: Macintosh) to deselect the selection marquee.

11. Select the Blur tool, and choose a 40-pixel, soft brush from the Brushes palette.

12. Carefully, drag the Blur tool left-to-right over the edge of the mountains, leaving half of the Blur tool on the mountains and half in the sky. The Blur tool will soften the hard edge of the mountains, and give the appearance of a horizon viewed from a distance, as shown in Figure 12.8.

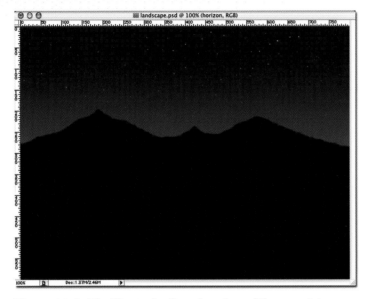

Figure 12.8: *The Blur tool softens the edges of the mountains.*

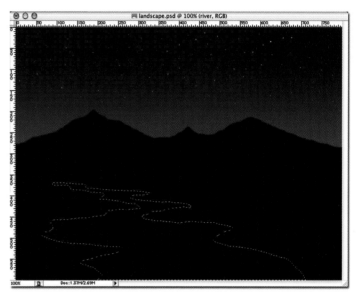

Figure 12.9: *The Lasso creates a selection for the river.*

There you have it, a simple evening landscape, courtesy of Photoshop. In the following workshops, you will add additional objects and dimension to this image. Before proceeding to the next workshop, save this file, using the name landscape.psd.

WORKSHOP 2 – CREATING A STREAM (A RIVER RUNS THROUGH IT)

In the previous workshop, you created a simple evening landscape. A nice effect here might be to add a lake or stream to the foreground area. Open the landscape.psd image and perform these steps:

1. Click the Add new Layer icon, and rename the new layer river. Position the new layer directly above the horizon layer.
2. Select the Lasso tool and experiment with creating a selection in the river layer similar to Figure 12.9.

The effect you're going for is a river receding into the distance. This is a good time to remember that you can add from a selection by holding down the Shift key or subtract by holding the Alt/Option key.

3. Select the Eyedropper tool, and click once on the upper (darker) portion of the night sky. The selected color becomes the foreground color. Then hold down the Alt/Option key and click once on the lower (lighter) portion of the night sky. The selected color becomes the background color, as shown in Figure 12.10.
4. Select the Linear Gradient tool, and choose the Foreground to Background gradient option.
5. Click and drag the Linear Gradient tool from the top of the selection to the bottom of the document window. The linear gradient is applied to the selection in the river layer, as shown in Figure 12.11.

Each application of the Gradient tool overwrites the previous application, so if you don't see what you want, reapply the gradient by dragging over the selection a second (or third) time.

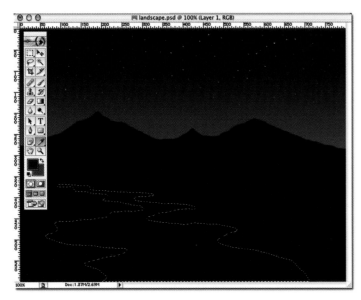

Figure 12.10: *The Eyedropper tool helps select the foreground and background colors used for the river.*

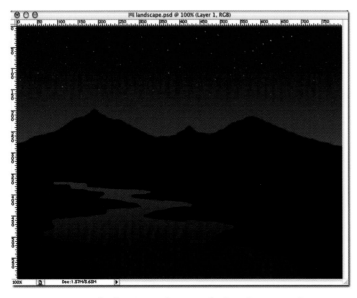

Figure 12.11: *The linear gradient applied to the river selection.*

6. Click the Add layer style icon, located at the bottom of the Layers palette, and select Inner Shadow from the available options. Choose a standard Inner Shadow, except change the angle to 90 degrees. Click the OK button to apply the inner shadow to the river layer.
7. Change the Fill option of the river layer to 90 percent, as shown in Figure 12.12.

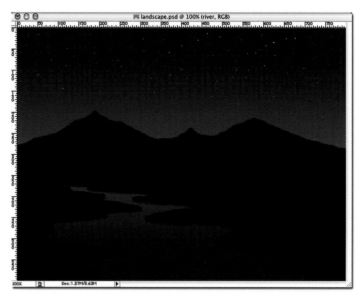

Figure 12.12: *The Fill option softens the river layer, and creates a reflective look to the surface.*

Creating a Reflection of the Stars in the River

1. Click and drag the star layer over the Add new layer icon, located at the bottom of the Layers palette. A copy of the star layer is created.
2. Select Edit - Transform, and choose Flip Vertical from the fly-out menu. The star copy layer is flipped vertically.
3. Select the Move tool and drag the star copy layer over the river. Position the star copy layer to accurately reflect the stars in the original star layer, as shown in Figure 12.13.

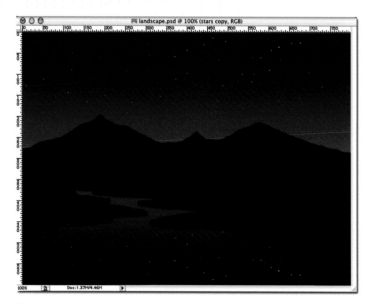

Figure 12.13: *The star copy layer positioned over the river layer.*

4. Hold down the CTRL key (CMD key: Macintosh), and click once on the river layer. A selection is created based on the shape of the river.
5. Choose Select, and choose Invert from the pull-down menu. The selection of the river reverses.
6. Select the star copy layer, and press the Delete key. The stars outside of the river are deleted, as shown in Figure 12.14.
7. Choose the Soft Light blending mode. The stars appear to reflect dimly on the surface of the river, as shown in Figure 12.15.
8. Save the landscape.psd file before proceeding to the next workshop.

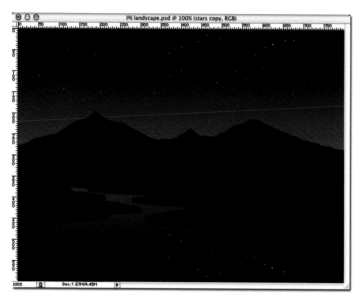

Figure 12.14: *The stars outside the river are removed from the star copy layer.*

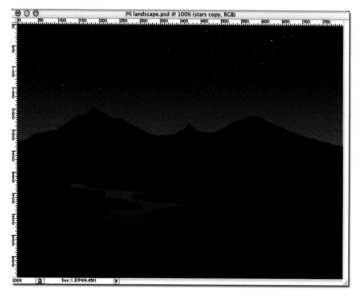

Figure 12.15: *The stars, reflecting softly off the river layer.*

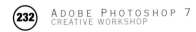

WORKSHOP 3 – HANGING
THE MOON IN THE SKY

No evening landscape would be complete without a heavenly body hanging in the night sky. To create a moon, planet, or whatever heavenly body you choose, open the landscape.psd file and perform these steps:

1. Click the Add a new layer icon, and rename the layer moon. Position the moon layer at the top of the Layers palette.
2. Select the Elliptical Marquee tool, and draw a circle (hold the Shift key) representing the diameter of the moon.
3. Select a color for the moon from the Swatches palette. In this example, I selected a Pastel Yellow color swatch.
4. Press Alt + Backspace (Option + Delete: Macintosh) to fill the selection with the selected color, as shown in Figure 12.16.

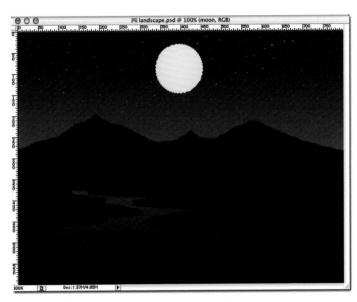

Figure 12.16: *The moon layer selection filled with a light pastel yellow.*

5. Select Filter - Artistic, and choose Sponge from the fly-out menu. Select a Brush Size of 2, a Definition of 12, and a Smoothness of 9. Click the OK button to apply the Sponge filter to the moon layer.
6. Press CTRL + F (CMD + F: Macintosh) to reapply the Sponge filter to the moon layer selection, as shown in Figure 12.17.

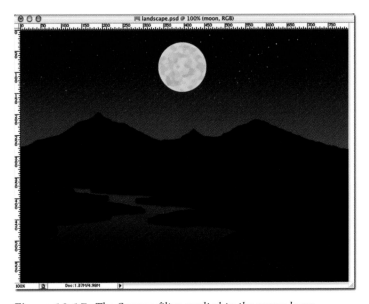

Figure 12.17: *The Sponge filter applied to the moon layer.*

7. Press CTRL + D (CMD + D: Macintosh) to deselect the Elliptical Marquee.
8. Click the Add layer style icon, located at the bottom of the Layers palette, and choose Outer Glow from the available options. Choose an Opacity of 20 percent, Size of 50 pixels, and select the Half Round Contour option. Click the OK button to apply the Outer Glow layer style to the moon layer, as shown in Figure 12.18.

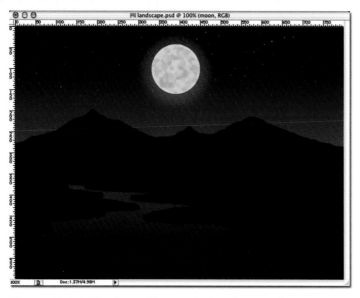

Figure 12.18: *The Outer Glow applied to the moon layer.*

Reflecting the Moon in the River

1. Click and drag the moon layer over the Add new layer icon. A copy of the moon layer is created.
2. Select Image - Transform, and choose Flip Vertical from the fly-out menu. The moon copy layer is flipped vertically.
3. Select the Move tool, and drag the moon copy layer over the river. Position the moon directly underneath the original moon image, as shown in Figure 12.19.
4. Reduce the Opacity of the moon copy layer to 50 percent.
5. Open the Outer Glow layer style for the moon copy layer, and reduce the opacity of the layer style to 10 percent. Click the OK button to apply the layer style to the moon copy layer, as shown in Figure 12.20.
6. Deactivate all layers (click on the eyeball icons) except the moon copy, and river layers.
7. Click the black triangle, located in the upper-right corner of the Layers palette, and select Merge Visible from the available options. The moon and river layers merge. Rename the layer moonriver, and reactivate the other layers, as shown in Figure 12.21.

Save the file before proceeding to the next workshop.

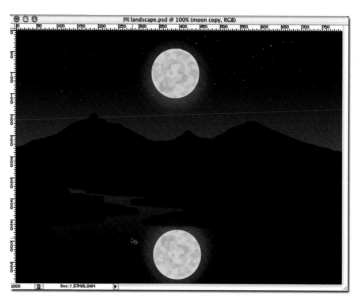

Figure 12.19: *The moon copy layer positioned in the area defined by the river.*

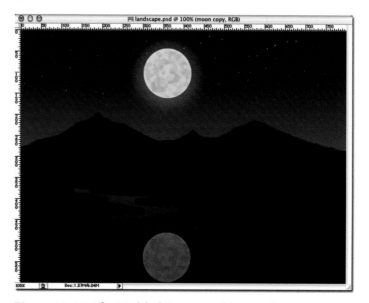

Figure 12.20: *The Modified Opacity and layer style options applied to the moon copy layer.*

Figure 12.21: *The moon layer merged with the river layer, creating moonriver.*

WORKSHOP 4 – ADDING DEPTH TO THE MOUNTAINS

The next step is to add a bit of depth to the image by visually separating the mountains from the foreground. Open the landscape.psd file and perform these steps:

1. Make the horizon layer the active layer.
2. Select the Magic Wand tool and click once in the foreground. The black areas of the horizon layer are selected, as shown in Figure 12.22.
3. Select the Lasso tool and create a selection marquee around the bottom of the image (underneath the mountains) while holding down the Alt/Option key. The selected areas are removed from the selection, as shown in Figure 12.23.
4. Select Image - Adjustments, and choose Levels from the fly-out menu. Change the Mid-tone Input Level to 1.20, and click the OK button to apply the Levels adjustment to the selected area of the horizon layer, as shown in Figure 12.24.
5. Select a deep purple or violet color from the Swatches palette.
6. Select Image - Adjustments, and choose Hue/Saturation from the fly-out menu. Choose the Colorize option, and change the Saturation value to 40 percent. Click the OK button to apply the Hue/Saturation adjustment to the selected area of the horizon layer, as shown in Figure 12.25.

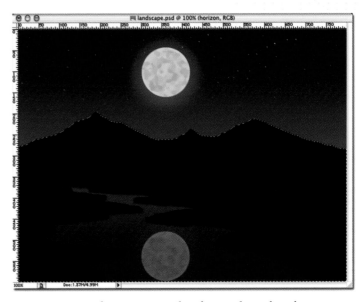

Figure 12.22: *The Magic Wand tool is used to select the foreground areas of the horizon layer.*

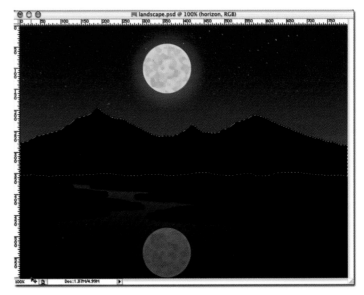

Figure 12:23: *The Lasso tool (combined with the Alt/Option key) successfully removed the unwanted areas of the selection.*

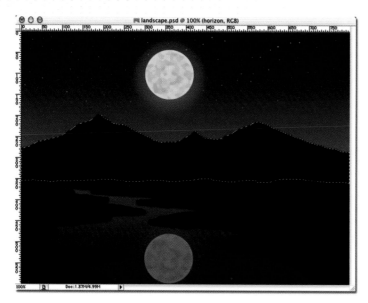

Figure 12.24: *The Levels Adjustment lightens the areas of the horizon layer controlled by the selection marquee.*

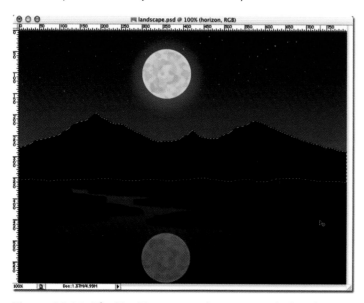

Figure 12.25: *The Hue/Saturation adjustment applied to the selected areas of the horizon layer.*

7. Press CTRL + J (CMD + J: Macintosh) to create a copy of the selected area of the horizons layer in a separate layer; name the new layer mountains.
8. Select Filter - Artistic, and choose the Sponge filter from the fly-out menu. Choose a Brush Size of 2, a Definition of 11, and a Smoothness of 10. Click the OK button to apply the Sponge filter to the mountains layer.
9. Reduce the Opacity of the mountains layer to 25 percent.
10. To complete the effect, select Filter - Blur, and select Gaussian Blur from the fly-out menu. Choose an Amount of 3 percent, and click the OK button to apply the Gaussian Blur filter to the mountains layer, as shown in Figure 12.26.

Save the file before proceeding to the next workshop.

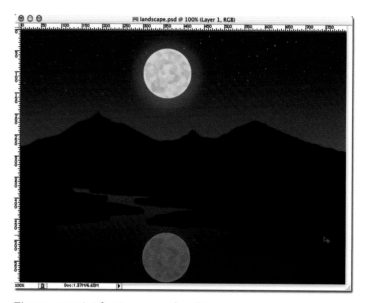

Figure 12.26: *The Gaussian Blur filter applied to the mountain image softens the effect of the Sponge filter.*

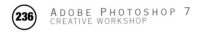

WORKSHOP 5 – ADD A COMET
TO THE NIGHT SKY

One more effect might be to add a comet streaking through the night sky. To add a comet to the list of nighttime elements, open the landscape.psd file and perform these steps:

1. Click the Add new layer button, and rename the layer comet. Position the comet layer at the top of the Layers palette.
2. Select a foreground color of white (press the letter D, then X).
3. Select the Paintbrush tool, and choose a 10-pixel, hard brush.
4. Click and draw a short white stroke (40 or 50 pixels long) in the night sky, as shown in Figure 12.27.

5. Select Filter - Blur, and choose Gaussian Blur from the pull-down menu. Choose a Radius of 5 pixels, and click the OK button to apply the Gaussian Blur to the comet layer.
6. Click the Add layer mask icon, located at the bottom of the Layers palette. A layer mask is added to the comet layer.
7. Select the Linear Gradient tool, and choose the Foreground to Background gradient option from the Options Bar.
8. Select the layer mask (not the image thumbnail), and click and drag the Gradient tool from the head of the comet to the tail. The white to black linear gradient will create a mask that slowly removes the rear portion of the blurred white line, creating the illusion of a comet and tail, as shown in Figure 12.28.

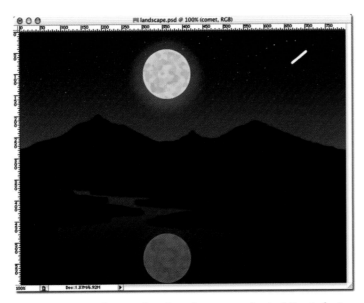

Figure 12.27: *The Paintbrush tool creates a short white stroke in the comet layer.*

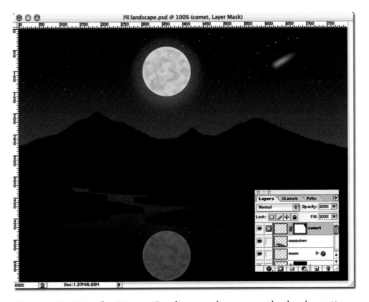

Figure 12.28: *The Linear Gradient tool removes the back portion of the white stroke, creating a comet and a tail.*

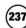

9. Click the Add new layer icon. A new layer is created directly above the comet layer. Rename the layer comet_head.
10. Select the Elliptical Marquee tool and create a small circular selection directly over the head of the comet, as shown in Figure 12.29.

Figure 12.29: *The Elliptical Marquee tool creates a small round selection.*

11. Press Alt + Backspace (Option + Delete: Macintosh) to fill the selected area with the current foreground color (white).
12. Press CTRL + D (CMD + D: Macintosh) to deselect the marquee.
13. Press CTRL + F (CMD + F: Macintosh) to apply the last filter (Gaussian Blur) to the white circle.
14. To complete the effect, change the Blending Mode of the comet_head layer to Overlay, and the Opacity of the comet layer (not the comet_head layer) to 80 percent, as shown in Figure 12.30.

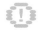 **If you need to reposition the comet, first chain the comet layer to the comet_head layer, and use the Move tool to reposition both layers.**

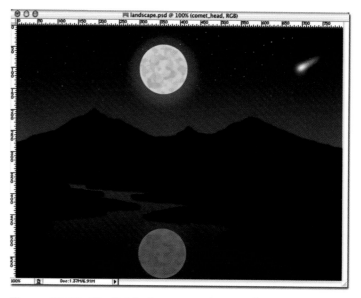

Figure 12.30: *The finished comet can be moved to any position in the night sky.*

WORKSHOP 6 – WORKING IN THE DAYLIGHT

In the previous workshops, you created a nighttime scene. In this workshop, you'll work in the daylight. To create a daytime scene, complete with a lake, create a new document (800 x 600, 72 ppi, RGB), and perform the following steps:

1. Press the letter D on your keyboard to default the foreground and background color swatches to black and white.
2. Select a nice daytime color from the Swatches palette. In this example, I selected a light blue.
3. Select the Rectangular Marquee tool and create a selection representing half of the document window.
4. Select the Linear Gradient tool, and drag from the bottom to the top of the selection, as shown in Figure 12.31.

Figure 12.31: *The Linear Gradient tool applied to the selected area of the Background layer.*

Figure 12.32: *The Lasso tool was used to create the mountains.*

5. Click the Add new layer icon, located at the bottom of the Layers palette, and rename the layer mountains.
6. Select the Lasso tool and create a set of distant mountains, as shown in Figure 12.32.
7. Choose a foreground and background color for the mountains. In this example the foreground color was R: 90, G: 89, B: 94, and the background color was R: 190, G: 190, B: 190.

Adding a Few Trees

1. Drag the Linear Gradient tool across the selection in the mountains layer until you see something similar to Figure 12.33.
2. Click the Add new layer icon, and rename the new layer trees. Position the trees layer at the top of the Layers palette.
3. Select the Lasso tool and draw a selection representing the trees in the foreground, as shown in Figure 12.34.

Figure 12.33: *The Linear Gradient tool applied to the selection in the mountains layer.*

Figure 12.34: *The Lasso tool creates a selection for the trees.*

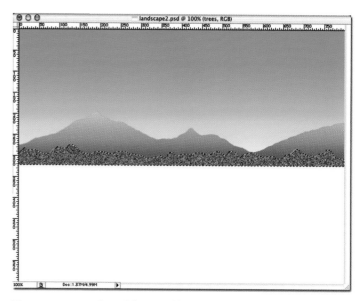

Figure 12.35: *The Add Noise filter applied to the trees layer.*

4. Select the Linear Gradient tool, and drag from the bottom to the top of the selection in the trees layer.
5. Select Filter - Noise, and choose Add Noise from the fly-out menu. Choose an Amount of 80 percent, Distribution of Uniform, and deselect the Monochromatic option. Click the OK button to apply the Add Noise filter to the trees layer, as shown in Figure 12.35.
6. Select Filter - Blur, and choose Gaussian Blur from the fly-out menu. Select a Radius of 3 pixels, and click the OK button to apply the Gaussian Blur filter to the trees layer.
7. Press CTRL + D (CMD + D: Macintosh) to deselect the Lasso marquee.
8. Select a bright green color from the Swatches palette.
9. Select Image - Adjustments, and choose Hue/Saturation from the fly-out menu. Choose the Colorize option, and change the Saturation value to 60 percent, and the Lightness value to –40 percent. This colorizes and darkens the trees. Click the OK button to apply the Hue/Saturation adjustment to the trees layer, as shown in Figure 12.36.
10. Press CTRL + J (CMD + J: Macintosh) to create a copy of the trees layer.

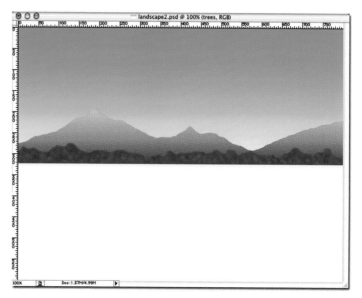

Figure 12.36: *The Hue/Saturation adjustment colorizes the trees layer.*

11. Select Edit - Transform, and choose Flip Horizontal. The trees copy layer is flipped left to right.
12. Select Image, Adjustments and choose Hue/Saturation from the fly-out menu. Choose the Colorize option, and change the Saturation value to 85 percent, and the Hue value to 80 percent. This lightens the trees. Click the OK button to apply the Hue/Saturation adjustment to the trees copy layer, as shown in Figure 12.37.

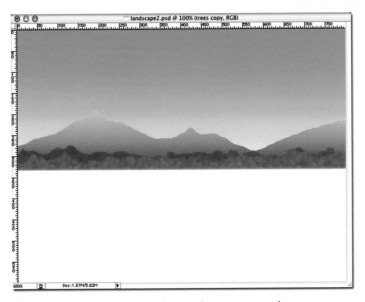

Figure 12.38: *The Move tool is used to reposition the trees copy layer, below the original trees layer.*

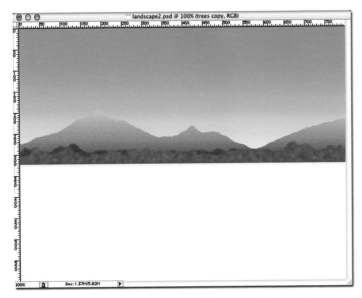

Figure 12.37: *The Hue/Saturation adjustment lightens the trees in the foreground.*

13. Select the Move tool and reposition the trees slightly below the original tree layer, as shown in Figure 12.38.

Creating Beachfront Property

1. Select the Background layer, and click the Add new layer icon. A new layer is created directly above the Background layer. Rename the layer beach.
2. Select the Lasso tool and create a selection for the beach, as shown in Figure 12.39.

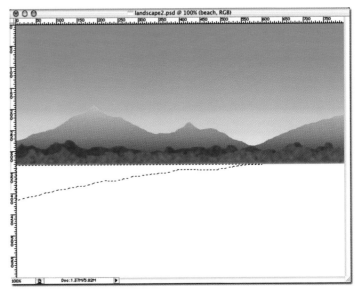

Figure 12.39: *The Lasso tool is employed to create some beachfront property.*

 Don't worry if the top of your selection does not match the bottom of the tree line. Since the beach layer is underneath the tree layers, it won't make any difference.

3. Select a light brown or sepia color from the Swatches palette.
4. Press Alt + Backspace (Option + Delete: Macintosh) to fill the selection in the beach layer with the foreground color.
5. Select Filter - Noise, and choose Add Noise from the fly-out menu. Choose an Amount of 25 percent, Distribution of Gaussian, and select the Monochromatic option. Click the OK button to apply the Add Noise filter to the beach layer, as shown in Figure 12.40.

6. Select Filter - Blur, and choose Gaussian Blur from the fly-out menu. Select a Radius of 1-pixel, and click the OK button to apply the Gaussian Blur filter to the beach layer.
7. Select Filter - Blur, and choose Motion Blur from the fly-out menu. Select an angle of 0 and a distance of 12 pixels. Click the OK button to apply the Motion Blur filter to the beach layer.
8. Select Image - Adjustments and choose Hue/Saturation from the fly-out menu. Choose the Colorize option, and change the Saturation value to 55 percent, the Hue value to 35 percent, and Lightness to 10 percent. Click the OK button to apply the Hue/Saturation adjustment to the beach layer, as shown in Figure 12.41.

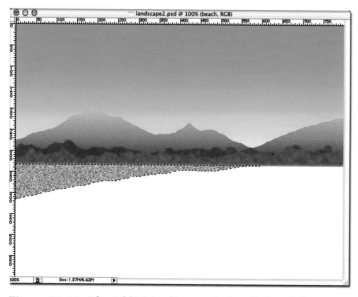

Figure 12.40: *The Add Noise filter applied to the beach layer.*

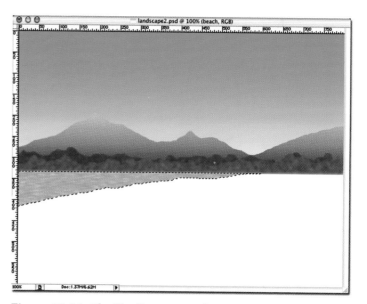

Figure 12.41: *The Hue/Saturation adjustment applied to the beach layer.*

Adding the Lake

This final step will add the lake to the image. You will have to flatten the image, so it might be a good time to stop, save the landscape.psd file, and work on a copy.

1. Open the landscape.psd file (or a copy).
2. Click on the black triangle, located in the upper-right corner of the Layers palette, and select Flatten Image from the available options.
3. Press CTRL + J (CMD + J: Macintosh) to create a copy of the flattened image in a new layer named Layer 1. Rename the layer lake.
4. Select the Magic Wand tool and click once in the white area of the image (the foreground). A selection is created based on the white areas of the document window.
5. Click the Add layer mask icon, located at the bottom of the Layers palette. A layer mask is added to the lake layer, as shown in Figure 12.42.

Figure 12.42: *The layer mask applied to the lake layer.*

6. Click on the small chain icon, located between the image thumbnail and layer mask thumbnail. This removes the link between the image and layer mask, and lets you move them independently.
7. Click once on the image thumbnail in the lake layer. The image (not the mask) is selected.
8. Select Edit - Transform, and choose Flip Vertical from the fly-out menu. The lake image is flipped from top to bottom.
9. Select the Move tool and position the lake image in the area defined by the layer mask, as shown in Figure 12.43.
10. Select Filter - Blur, and choose Motion Blur from the fly-out menu. Select an angle of 90 degrees and a distance of 15 pixels. Click the OK button to apply the Motion Blur filter to the lake layer, as shown in Figure 12.44.

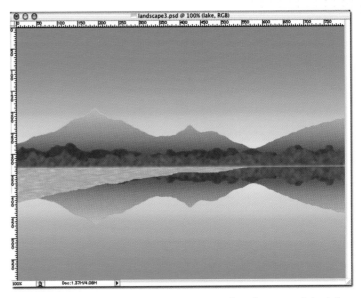

Figure 12.43: *The lake image repositioned in the area of the lake.*

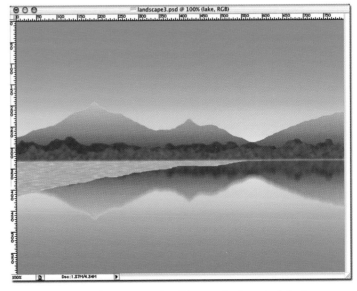

Figure 12.44: *The Motion Blur filter applied to the lake layer.*

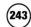

11. Select the lake layer.
12. Click the Add new layer icon. A new layer is added directly above the lake layer. Rename the layer blue.
13. Click your mouse on the lake layer mask, while holding down the CTRL key (CMD key: Macintosh). A selection is created based on the lake layer mask.
14. Select the blue layer, and click the Add layer mask icon. A layer mask is created in the blue layer.
15. Click once on the image thumbnail in the blue layer. The image (not the mask) is selected.
16. Select a light blue color from the Swatches palette and then press Alt + Backspace (CMD + Delete: Macintosh). The blue layer is filled with the selected color, and the layer mask confines the color to the area of the lake.
17. Reduce the Opacity of the blue layer to 30 percent. This will give the reflection a blue cast, as shown in Figure 12.45.

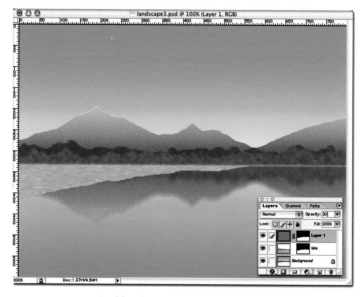

Figure 12.45: *The blue layer helps to colorize the lake with a shade of blue.*

18. Select the Lasso tool and make a selection that contains most, but not all, of the lake, as shown in Figure 12.46.

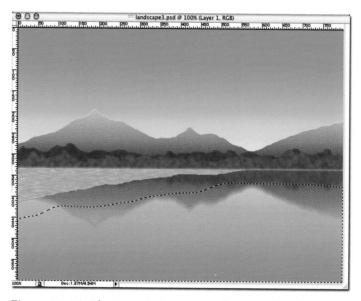

Figure 12.46: *The Lasso tool creates a selection within the lake.*

19. Choose Select, and choose Feather from the pull-down menu. Choose a Feather Radius of 15, and click OK to apply the Feather to the selection.
20. To complete the effect, select the lake layer, choose Filter - Distort, and select ZigZag from the fly-out menu. Select an Amount of 100 percent, set Ridges to 12, and pick the Out from Center Style. Click the OK button to apply the ZigZag filter to the image, as shown in Figure 12.47.

Figure 12.47: *The ZigZag filter adds a series of ripples to the surface of the lake.*

SHORTCUT KEYS

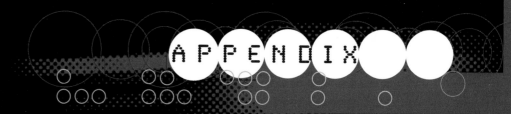

SHORTCUT KEYS

THE FOLLOWING IS A LIST OF SHORTCUTS KEYS AVAILABLE IN
PHOTOSHOP.

Operation	Macintosh	Windows
Accept crop	Double-click inside boundary or press Return	Double-click inside boundary or press Enter
Accept transformation	Double-click inside boundary or press Return	Double-click inside boundary or press Enter
Activate Don't Save or Don't Flatten button	Press D	Press D
Activate or deactivate color channel	Shift+click channel name in Channels palette	Shift+click channel name in Channels palette
Actual Pixels	CMD+Option+zero (0)	CTRL+ALT+zero (0)
Add channel mask to selection	CMD+Shift+click channel name	CTRL+Shift+click channel name
Add character outlines to a selection	Shift+click with type mask tool	Shift+click with type mask tool
Add a new color point on independent channel curves	CMD+Shift+click in image window	CTRL+Shift+click in image window
Add colors to Hue/Saturation range	Shift+click or drag in image window	Shift+click or drag in image window
Add corner to path	Click with pen tool or Option+click with freeform pen tool	Click with pen tool or ALT+click with freeform pen tool
Add corner to straight-sided selection outline	Option+click with lasso tool or click with polygonal lasso	ALT+click with lasso tool or click with polygonal lasso
Add cusp to path	Drag with pen tool, then Option+drag same point	Drag with pen tool, then ALT+drag same point
Add layer mask to selection	CMD+Shift+click layer mask thumbnail	CTRL+Shift+click layer mask thumbnail
Add new swatch to palette	Click in empty area of palette or Shift+Option+click on swatch	Click in empty area of palette or Shift+ALT+click on swatch
Add path to selection	CMD+Shift+click path name or Shift+Enter	CTRL+Shift+click path name or Shift+Enter on keypad
Add point in Curves dialog box	Click on graph line	Click on graph line
Add point to magnetic selection	Click with magnetic lasso tool	Click with magnetic pen tool
Add point to magnetic selection	Click with magnetic pen tool	Click with magnetic pen tool
Add smooth arc to path	Drag with pen tool	Drag with pen tool
Add specific color as new point on composite curve	CMD+click in image window	CTRL+click in image window
Add spot color channel	CMD+click page icon at bottom of Channels palette	CTRL+click page icon at bottom of Channels palette
Add to selection	Shift+drag or Shift+click with selection tool	Shift+drag or Shift+click with selection tool
Add transparency mask to selection	CMD+Shift+click layer name	CTRL+Shift+click layer name
Adjust "fuzziness" in Layer Options dialog box	Option+drag slider triangle	ALT+drag slider triangle
Adjust angle of light without affecting size of footprint	CMD+drag handle	CTRL+drag handle
Adjust Angle value (where offered) in 15° increments	Shift+drag in Angle wheel	Shift+drag in Angle wheel

Operation	Macintosh	Windows
Adjust size of footprint without affecting angle of light	Shift+drag handle	Shift+drag handle
Apply brushstroke around perimeter of path	Press Enter when paint or edit tool is active	Press Enter on keypad when paint or edit tool is active
Apply specific transformation in Free Transform mode	Control-click in image window	Right-click in image window
Apply zoom value but keep magnification box active	Shift+Return	Shift+Enter
Ascend one layer	Option+]	ALT+]
Ascend to top layer	Shift+Option+]	Shift+ALT+]
Auto Levels	CMD+Shift+L	CTRL+Shift+L
Bring Layer Forward	CMD+]	CTRL+]
Bring layer forward one level	CMD+]	CTRL+]
Bring Layer to Front	CMD+Shift+]	CTRL+Shift+]
Bring layer to front of file	CMD+Shift+]	CTRL+Shift+]
Bring Up dialog box with last-used settings	Option+choose command from Image >> Adjust submenu	ALT+choose command from Image >> Adjust submenu
Cancel crop	Press Escape	Press Escape
Cancel magnetic or freeform selection	Press Escape	Press Escape
Cancel polygon or magnetic selection	Press Escape	Press Escape
Cancel the current operation	CMD+period or Escape	Press Escape
Cancel transformation	Press Escape	Press Escape
Center-align text	CMD+Shift+C	CTRL+Shift+C
Change length and angle of measure line	Drag point at either end of measure line	Drag point at either end of measure line
Change opacity of active layer in 1% increments	Press two numbers in a row when selection tool is active	Press two numbers in a row when selection tool is active
Change opacity of active layer in 10% increments	Press number (1 through 0) when selection tool is active	Press number (1 through 0) when selection tool is active
Change opacity of floating selection	CMD+Shift+F	CTRL+Shift+F
Change opacity, pressure, or exposure in 1% increments	Press two numbers in a row	Press two numbers in a row
Change opacity, pressure, or exposure in 10% increments	Press number (1 through 0)	Press number (1 through 0)
Change quick mask color overlay	Double-click quick mask icon	Double-click quick mask icon
Change the preference settings	CMD+K	CTRL+K
Change unit of measure	Drag from X, Y pop-up in Info palette or double-click ruler	Drag from X, Y pop-up in Info palette or double-click ruler

Operation	Macintosh	Windows
Clear	Delete	Backspace or Delete
Clone contents of all visible layers to activate layer	CMD+Option+Shift+E	CTRL+ALT+Shift+E
Clone contents of layer into next layer down	CMD+Option+E	CTRL+ALT+E
Clone contents of linked layers to active layer	CMD+Option+E	CTRL+ALT+E
Clone light in Lighting Effects dialog box	Option+drag light	ALT+drag light
Clone path	Option+drag path with arrow or CMD+Option+drag with pen	ALT+drag path with arrow or CTRL+ALT+drag with pen
Clone selection	Option+drag selection with move tool or CMD+Option+drag with other tool	ALT+drag selection with move tool or CTRL+ALT+drag with other tool
Clone selection in 10-pixel increments	CMD+Shift+Option+arrow key	CTRL+Shift+ALT+arrow key
Clone selection in 1-pixel increments	CMD+Option+arrow key	CTRL+ALT+arrow key
Clone selection to different image	CMD+drag selection from one window and drop it into another	CTRL+drag selection from one window and drop it into another
Clone selection to new layer	CMD+J	CTRL+J
Close	CMD+W	CTRL+W or CTRL+F4
Close magnetic selection	Double-click with magnetic pen tool or click on first point in path	Double-click with magnetic pen tool or click on first point in path
Close magnetic selection with straight segment	Option+double-click or Option+Return	ALT+double-click or ALT+Enter
Close polygon or magnetic selection	Double-click with respective lasso tool or press Return	Double-click with respective lasso tool or press Enter
Color Balance	CMD+B	CTRL+B
Color Balance, with last settings	CMD+Option+B	CTRL+ALT+B
Constrain marquee to square or circle	Press Shift while drawing shape	Press Shift while drawing shape
Constrain movement vertically or horizontally	Press Shift while dragging selection	Press Shift while dragging selection
Constrained distort for perspective effect	CMD+Shift+drag corner handle	CTRL+Shift+drag corner handle
Constrained distort for symmetrical perspective effect	CMD+Shift+Option+drag corner handle	CTRL+Shift+ALT+drag corner handle
Convert arc to corner	CMD+Option+click point with arrow or Option+click with pen	CTRL+ALT+click point with arrow or ALT+click with pen
Convert arc to cusp	CMD+Option+drag handle with arrow or Option+drag with pen	CTRL+ALT+drag handle with arrow or ALT+drag with pen
Convert channel mask to selection outline	CMD+click channel name in Channels palette or CMD+Option+number (1 through 0)	CTRL+click channel name in Channels palette or CTRL+ALT+number (1 through 0)
Convert corner or cusp to smooth arc	CMD+Option+drag point with arrow or Option+drag with pen	CTRL+ALT+drag point with arrow or ALT+drag with pen
Convert floating selection to new layer	CMD+Shift+J	CTRL+Shift+J

Operation	Macintosh	Windows
Convert layer mask to selection outline	CMD+click layer mask thumbnail or CMD+Option+backslash (\)	CTRL+click layer mask thumbnail or CTRL+ALT+backslash (\)
Convert layer's transparency mask to selection outline	CMD+click layer name in Layers palette	CTRL+click layer name in Layers palette
Convert path to selection outline	CMD+click path name in Paths palette or press Enter when selection or path tool is active	CTRL+click path name in Paths palette or press Enter on keypad when selection or path tool is active
Convert selection to new layer and leave hole behind	CMD+Shift+J	CTRL+Shift+J
Copy	CMD+C or F3	CTRL+C or F3
Copy empty selection outline to different image	Drag selection from one window into another with selection tool	Drag selection from one window into another with selection tool
Copy Merged version of selection to Clipboard	CMD+Shift+C	CTRL+Shift+C
Create adjustment layer	CMD+click page icon at bottom of Layers palette	CTRL+click page icon at bottom of Layers palette
Create channel mask filled with black	Click page icon at bottom of Channels palette	Click page icon at bottom of Channels palette
Create channel mask filled with black and set options	Option+click page icon at bottom of Channels palette	ALT+click page icon at bottom of Channels palette
Create channel mask from selection outline	Click mask icon at bottom of Channels palette	Click mask icon at bottom of Channels palette
Create channel mask from selection outline and set options	Option+click mask icon at bottom of Channels palette	ALT+click mask icon at bottom of Channels palette
Create duplicate image from active state	Click ... box icon at bottom of History palette	Click ... box icon at bottom of History palette
Create guide	Drag from ruler	Drag from ruler
Create layer mask filled with black	Option+click mask icon	ALT+click mask icon
Create layer mask filled with white	Click mask icon at bottom of Layers palette	Click mask icon at bottom of Layers palette
Create layer mask from selection outline	Click mask icon	Click mask icon
Create layer mask that hides selection	Option+click mask icon	ALT+click mask icon
Create new brush shape	Click in empty area of Brushes palette	Click in empty area of Brushes palette
Create new layer and bypass blend options	Click page icon at bottom of Layers palette or CMD+Shift+Option+N	Click page icon at bottom of Layers palette or CTRL+Shift+ALT+N
Create new layer and set blend options	Option+click page icon at bottom of Layers palette or CMD+Shift+N	ALT+click page icon at bottom of Layers palette or CTRL+Shift+N
Create snapshot from active state	Click page icon at bottom of History palette	Click page icon at bottom of History palette
Curves	CMD+M	CTRL+M
Curves, with last settings	CMD+Option+M	CTRL+ALT+M
Cut	CMD+X or F2	CTRL+X or F2
Cut letter-shaped holes into a selection	Option+click with type mask tool	ALT+click with type mask tool

Operation	Macintosh	Windows
Cycle between standard, freeform, and magnetic pen tools	Shift+P	Shift+P
Cycle through all marquee tools (including crop tool)	Option+click marquee tool icon	ALT+click marquee tool icon
Cycle through blend modes	Shift+plus (+) or Shift+minus (-) when selection tool is active	Shift+plus (+) or Shift+minus (-) when selection tool is active
Cycle through brush modes	Shift+plus (+) or Shift+minus (-)	Shift+plus (+) or Shift+minus (-)
Cycle through brush shapes	Press bracket, [or]	Press bracket, [or]
Cycle through color bars	Shift+click color bar	Shift+click color bar
Cycle through eraser styles	Option+click eraser tool icon or Shift+E	ALT+click eraser tool icon or Shift+E
Cycle through focus tools	Option+click focus tool icon or Shift+R	ALT+click focus tool icon or Shift+R
Cycle through full screen and normal window modes	F	F
Cycle through lasso tools	Option+click lasso tool icon or Shift+L	ALT+click lasso tool icon or Shift+L
Cycle through rubber stamp options	Option+click rubber stamp tool icon or Shift+S	ALT+click rubber stamp tool icon or Shift+S
Cycle through toning tools	Option+click toning tool icon or Shift+O	ALT+click toning tool icon or Shift+O
Darken with the dodge tool or lighten with the burn tool	Option+drag	ALT+drag
Deactivate path	Click in empty portion of Paths palette	Click in empty portion of Paths palette
Decrease type size 10 pixels	CMD+Shift+Option+less than (<)	CTRL+Shift+ALT+less than (<)
Decrease type size 2 pixels	CMD+Shift+less than (<)	CTRL+Shift+less than (<)
Decrease value by 1 (or 0.1)	Down arrow	Down arrow
Decrease value by 10 (or 1)	Shift+down arrow	Shift+down arrow
Delete color sample	Option+click on target with color sampler tool	ALT+click on target with color sampler tool
Delete curve point	CMD+click point	CTRL+click point
Delete last point added with magnetic lasso tool	Delete	Backspace
Delete last point added with standard or magnetic pen tool	Delete	Backspace
Delete Lighting Effects light	Press Delete	Press Delete
Delete selected 3D Transform shape	Delete	Backspace
Delete shape from Brushes palette	CMD+click brush shape	CTRL+click brush shape
Delete swatch from palette	CMD+click swatch	CTRL+click swatch
Desaturate	CMD+Shift+U	CTRL+Shift+U
Descend one layer	Option+[ALT+[
Descend to background layer	Shift+Option+[Shift+ALT+[

Operation	Macintosh	Windows
Deselect all points	CMD+D	CTRL+D
Deselect everything	CMD+D	CTRL+D
Dip into the foreground color when smearing	Option+drag with smudge tool	ALT+drag with smudge tool
Duplicate layer to new layer	Drag layer name onto page icon or CMD+A, CMD+J	Drag layer name onto page icon or CTRL+A, CTRL+J
Disable last layer effect	Option+double-click on *f*	ALT+double-click on *f*
Disable layer mask	Shift+click layer mask thumbnail	Shift+click layer mask thumbnail
Disable specific layer effect	Option+choose command from Layer >> Effects submenu	ALT+choose command from Layer >> Effects submenu
Display crosshair cursor	Caps Lock	Caps Lock
Display Fill dialog box	Shift+Delete or Shift+F5	Shift+Backspace or Shift+F5
Display last used Preferences dialog box panel	CMD+Option+K	CTRL+ALT+K
Display Options palette	Return or double-click tool icon	Enter or double-click tool icon
Display or hide Actions palette	F9	F9
Display or hide all palettes, and toolbox, and status bar	Tab	Tab
Display or hide Brushes palette	F5	F5
Display or hide Color palette	F6	F6
Display or hide grid	CMD+quote (")	CTRL+quote (")
Display or hide guides	CMD+semicolon (;)	CTRL+semicolon (;)
Display or hide Info palette	F8	F8
Display or hide Layers palette	F7	F7
Display or hide palettes except toolbox	Shift+Tab	Shift+Tab
Display or hide rulers	CMD+R	CTRL+R
Distort image	CMD+drag corner handle	CTRL+drag corner handle
Draw freehand path segment	Drag with freeform pen tool or Option+drag with magnetic pen tool	Drag with freeform pen tool or ALT+drag with magnetic pen tool
Draw out from center with marquee tool	Option+drag	ALT+drag
Duplicate image and bypass dialog box	Option+choose Image >> Duplicate	ALT+choose Image >> Duplicate
Duplicate previously performed operation	Option+click on item in History palette	ALT+click on item in History palette
Duplicate selection and freely transform	CMD+Option+T	CTRL+ALT+T
Duplicate selection and replay last transformation	CMD+Shift+Option+T	CTRL+Shift+ALT+T
Edit all colors in Hue/Saturation dialog box	CMD+tilde (~)	CTRL+tilde (~)
Edit blend options for layer	Double-click layer name in Layers palette	Double-click layer name in Layers palette
Edit brush shape	Double-click brush shape	Double-click brush shape

Operation	Macintosh	Windows
Edit guide color and grid increments	CMD+double-click guide	CTRL+double-click guide
Edit layer effect	Double-click on *f*	Double-click on *f*
Edit predefined color range	CMD+1 through CMD+6	CTRL+1 through CTRL+6
Edit shape with pan camera or trackball	Press E or R	Press E or R
Edit text layer	Double-click on T in Layers palette or Control-click with type tool	Double-click on T in Layers palette or right-click with type tool
Enter or exit quick mask mode	Press Q	Press Q
Exit Type Tool dialog box	Enter or CMD+Return	Enter on keypad or CTRL+Enter
Expand leading 10 pixels	CMD+Option+down arrow	CTRL+ALT+down arrow
Expand leading 2 pixels	Option+down arrow	ALT+down arrow
Fade Filter	CMD+Shift+F	CTRL+Shift+F
Feather the selection	CMD+Option+D or Shift+F6	CTRL+ALT+D or Shift+F6
Fill	Shift+Delete or Shift+F5	Shift+Backspace or Shift+F5
Fill from history	CMD+Option+Delete	CTRL+ALT+Backspace
Fill layer with background color but preserve transparency	Shift+CMD+Delete	Shift+CTRL+Backspace
Fill layer with foreground color but preserve transparency	Shift+Option+Delete	Shift+ALT+Backspace
Fill selection on any layer with background color	CMD+Delete	CTRL+Backspace
Fill selection on background layer with background color	Delete	Backspace or Delete
Fill selection or layer with foreground color	Option+Delete	ALT+Backspace
Fill selection with source state in History palette	CMD+Option+Delete	CTRL+ALT+Backspace
Filter, repeat last	CMD+F	CTRL+F
Filter, repeat with new settings	CMD+Option+F	CTRL+ALT+F
Fit image on screen	CMD+zero (0) or double-click hand tool icon	CTRL+zero (0) or double-click hand tool icon
Freely transform selection or layer	CMD+T	CTRL+T
Fully collapse palette	Option+click collapse box or double-click panel tab	ALT+click collapse box or double-click panel tab
Gamut Warning	CMD+Shift+Y	CTRL+Shift+Y
Go directly to layer that contains specific image	CMD+Option+Control-click image with any tool	CTRL+ALT+right-click image with any tool
Grid, show or hide	CMD+quote (")	CTRL+quote (")
Group neighboring layers	Option+click horizontal line in Layers palette or CMD+G	ALT+click horizontal line in Layers palette or CTRL+G

Operation	Macintosh	Windows
Group with previous layer	CMD+G	CTRL+G
Guides, show or hide	CMD+semicolon (;)	CTRL+semicolon (;)
Hide edges	CMD+H	CTRL+H
Hide path	CMD+Shift+H	CTRL+Shift+H
Hide toolbox and status bar	Tab, Shift+Tab	Tab, Shift+Tab
Hue/Saturation	CMD+U	CTRL+U
Hue/Saturation, with last settings	CMD+Option+U	CTRL+ALT+U
Image Size	F11	F11
Increase or reduce magnetic lasso width	Press bracket, [or]	Press bracket, [or]
Increase or reduce magnetic pen width	Press bracket, [or]	Press bracket, [or]
Increase selected Option+box value by 1 (or 0.1)	Up arrow	Up arrow
Increase type size 10 pixels	CMD+Shift+Option+greater than (>)	CTRL+Shift+ALT+greater than (>)
Increase type size 2 pixels (or points)	CMD+Shift+greater than (>)	CTRL+Shift+greater than (>)
Increase value by 10 (or 1)	Shift+Up arrow	Shift+Up arrow
Insert point in path	Click segment with pen tool or Option+click with remove point tool	Click segment with pen tool or ALT+click with remove point tool
Inverse Selection	CMD+Shift+I or Shift+F7	CTRL+Shift+I or Shift+F7
Invert	CMD+I	CTRL+I
Kern apart 1/10 em	CMD+Option+right arrow	CTRL+ALT+right arrow
Kern apart 2/100 em	Option+right arrow	ALT+right arrow
Kern together 1/10 em	CMD+Option+left arrow	CTRL+ALT+left arrow
Kern together 2/100 em	Option+left arrow	ALT+left arrow
Layer Via Copy	CMD+J	CTRL+J
Layer Via Cut	CMD+Shift+J	CTRL+Shift+J
Left-align text	CMD+Shift+L	CTRL+Shift+L
Levels	CMD+L	CTRL+L
Levels, with last settings	CMD+Option+L	CTRL+ALT+L
Lift background color from color bar	Option+click color bar	ALT+click color bar
Lift background color from image	Option+click with eyedropper	ALT+click with eyedropper
Lift background color from Swatches palette	Option+click swatch	ALT+click swatch
Lift foreground color from color bar at bottom of Color palette	Click color bar	Click color bar
Lift foreground color from image	Option+click with paint tool or click with eyedropper	ALT+click with paint tool or click with eyedropper

Operation	Macintosh	Windows
Lift foreground color from Swatches palette	Click swatch	Click swatch
Link layer with active layer	Click in front of layer name	Click in front of layer name
Lock or unlock guides	CMD+Option+semicolon (;)	CTRL+ALT+semicolon (;)
Lower baseline shift 10 pixels	CMD+Shift+Option+down arrow	CTRL+Shift+ALT+down arrow
Lower baseline shift 2 pixels	Shift+Option+down arrow	Shift+ALT+down arrow
Magnify to custom zoom ratio	CMD+spacebar-drag or CMD+drag in Navigator palette	CTRL+spacebar drag or CTRL+drag in Navigator palette
Magnify view in Text Tool dialog box	CMD+plus (+)	CTRL+plus (+)
Measure angle between two lines (protractor option)	Option+drag endpoint	ALT+drag endpoint
Measure distance and angle	Drag with measure tool	Drag with measure tool
Merge all visible layers	CMD+Shift+E	CTRL+Shift+E
Merge Down	CMD+E	CTRL+E
Merge Visible	CMD+Shift+E	CTRL+Shift+E
Move a panel out of a palette	Drag panel tab	Drag panel tab
Move cropping boundary	Drag inside boundary	Drag inside boundary
Move entire layer	Drag with move tool or CMD+drag with other tool	Drag with move tool or CTRL+drag with other tool
Move entire layer in 10-pixel increments	CMD+Shift+arrow key	CTRL+Shift+arrow key
Move entire layer in 1-pixel increments	CMD+arrow key	CTRL+arrow key
Move guide	Drag guide with move tool or CMD+drag with other tool	Drag guide with move tool or CTRL+drag with other tool
Move Hue/Saturation range to new location	Click in image window	Click in image window
Move image in Free Transform mode	Drag inside boundary	Drag inside boundary
Move marquee as you draw it	Press spacebar	Press spacebar
Move measure line	Drag measure line	Drag measure line
Move selected points	Drag point with arrow tool or CMD+drag with pen tool	Drag point with arrow tool or CTRL+drag with pen tool
Move selection	Drag with move tool or CMD+drag with other tool	Drag with move tool or CTRL+drag with other tool
Move selection in 10-pixel increments	CMD+Shift+arrow key	CTRL+Shift+arrow key
Move selection in 1-pixel increments	CMD+arrow key	CTRL+arrow key
Move selection outline in 10-pixel increments	Shift+arrow key when selection tool is active	Shift+arrow key when selection tool is active
Move selection outline in 1-pixel increments	Press arrow key when selection tool is active	Press arrow key when selection tool is active
Move selection outline independently of its contents	Drag with selection tool	Drag with selection tool

Operation	Macintosh	Windows
Move shadow when Effect dialog box is open	Drag in image window	Drag in image window
Move transformation origin	Drag crosshair target	Drag crosshair target
New	CMD+N	CTRL+N
New Layer	CMD+Shift+N	CTRL+Shift+N
New, with default settings	CMD+Option+N	CTRL+ALT+N
Nudge selected curve point	Press arrow key	Press arrow key
Numeric Transform	None	None
Open	CMD+O	CTRL+O
Page Setup	CMD+Shift+P	CTRL+Shift+P
Paint or edit in a straight line	Click and then Shift+click	Click and then Shift+click
Paste	CMD+V or F4	CTRL+V or F4
Paste image behind selection	CMD+Shift+Option+V	CTRL+Shift+ALT+V
Paste image into selection	CMD+Shift+V	CTRL+Shift+V
Paste Into	CMD+Shift+V	CTRL+Shift+V
Permanently delete item from palette that includes trash can	Option+click trash can	ALT+click trash can
Play script	CMD+double-click on item in Actions palette	CTRL+double-click on item in Actions palette
Preferences	CMD+K	CTRL+K
Preferences, last panel	CMD+Option+K	CTRL+ALT+K
Preserve transparency of active layer	Press slash (/)	Press slash (/)
Preview CMYK	CMD+Y	CTRL+Y
Preview how image sits on printed page	Click preview box	Click preview box
Print	CMD+P	CTRL+P
Raise baseline shift 10 pixels	CMD+Shift+Option+Up arrow	CTRL+Shift+ALT+Up arrow
Raise baseline shift 2 pixels	Shift+Option+Up arrow	Shift+ALT+Up arrow
Redo	CMD+Z	CTRL+Z
Redo undone operation	CMD+Shift+Z	CTRL+Shift+Z
Remove point from path	Click point with pen tool or Option+click with insert point tool	Click point with pen tool or ALT+click with insert point tool
Repeat filter with different settings	CMD+Option+F	CTRL+ALT+F
Repeat filter with last-used settings	CMD+F	CTRL+F
Replace swatch with foreground color	Shift+click swatch	Shift+click swatch
Replay last transformation	CMD+Shift+T	CTRL+Shift+T
Reselect	CMD+Shift+D	CTRL+Shift+D

Operation	Macintosh	Windows
Reset options inside corrective filter dialog boxes	Option+click Cancel button or Option+Escape	ALT+click Cancel button
Reset to Normal blend mode	Shift+Option+N	Shift+ALT+N
Reset to Normal brush mode	Shift+Option+N	Shift+ALT+N
Resize cropping boundary	Drag boundary handle	Drag boundary handle
Resize image	Drag boundary handle	Drag boundary handle
Resize with respect to origin	Option+drag boundary handle	ALT+drag boundary handle
Restore selection after deselecting	CMD+Shift+D	CTRL+Shift+D
Retain areas where character outlines and selection intersect	Shift+Option+click with type mask tool	Shift+ALT+click with type mask tool
Retain intersected portion of selection	Shift+Option+drag or Shift+Option+click with selection tool	Shift+ALT+drag or Shift+ALT+click with selection tool
Retain intersection of channel mask and selection	CMD+Shift+Option+click channel name	CTRL+Shift+ALT+click channel name
Retain intersection of layer mask and selection	CMD+Shift+Option+click layer mask thumbnail	CTRL+Shift+ALT+click layer mask thumbnail
Retain intersection of path and selection	CMD+Shift+Option+click path name or Shift+Option+Enter	CTRL+Shift+ALT+click path name or Shift+ALT+Enter on keypad
Retain intersection of transparency mask and selection	CMD+Shift+Option+click layer name	CTRL+Shift+ALT+click layer name
Reverse the selection	CMD+Shift+I or Shift+F7	CTRL+Shift+I or Shift+F7
Revert	Click first item in History palette or press F12	Click first item in History palette or press F12
Revert around perimeter of path	Press Option+Enter when eraser tool is active or Enter when history brush is active	Press ALT+Enter on keypad when eraser tool is active or Enter when history brush is active
Revert image with magic eraser	Option+drag with eraser	ALT+drag with eraser
Revert to saved image	F12 or click first item in History palette	F12 or click first item in History palette
Right-align text	CMD+Shift+R	CTRL+Shift+R
Rotate cropping boundary	Drag outside boundary	Drag outside boundary
Rotate image (always with respect to origin)	Drag outside boundary	Drag outside boundary
Rulers, show or hide	CMD+R	CTRL+R
Sample color in image	Click with color sampler tool	Click with color sampler tool
Save	CMD+S	CTRL+S
Save a Copy	CMD+Option+S	CTRL+ALT+S
Save As	CMD+Shift+S	CTRL+Shift+S
Save flattened copy of layered image	CMD+Option+S	CTRL+ALT+S
Save path for future use	Double-click Work Path item in Paths palette	Double-click Work Path item in Paths palette
Scroll image with hand tool	Spacebar drag or drag in Navigator palette	Spacebar drag or drag in Navigator palette

Operation	Macintosh	Windows
Scroll left or right one screen	CMD+Page Up or CMD+Page Down	CTRL+Page Up or CTRL+Page Down
Scroll left or right slightly	CMD+Shift+Page Up or CMD+Shift+Page Down	CTRL+Shift+Page Up or CTRL+Shift+Page Down
Scroll preview box in corrective filter dialog boxes	Drag in preview box or click in image window	Drag in preview box or click in image window
Scroll up or down exactly one frame in Filmstrip file	Shift+Page Up or Shift+Page Down	Shift+Page Up or Shift+Page Down
Scroll up or down one screen	Page Up or Page Down	Page Up or Page Down
Scroll up or down slightly	Shift+Page Up or Shift+Page Down	Shift+Page Up or Shift+Page Down
Select 3D cube, sphere, or cylinder tool	Press M, N, or C	Press M, N, or C
Select All	CMD+A	CTRL+A
Select arrow (direct selection) tool	Press A or press and hold CTRL when pen tool is active	Press A or press and hold CTRL when pen tool is active
Select blend mode	Shift+Option+letter	Shift+ALT+letter
Select brush mode	Control-click with paint or edit tool or Shift+Option+letter	Right-click with paint or edit tool or Shift+ALT+letter
Select crop tool	Press C	Press C
Select entire path	Option+click path with arrow or CMD+Option+click with pen	ALT+click path with arrow or CTRL+ALT+click with pen
Select everything	CMD+A	CTRL+A
Select insert or remove point tool	Press plus (+) or minus (-)	Press plus (+) or minus (-)
Select insert point tool	Press plus (+)	Press plus (+)
Select measure tool	Press U	Press U
Select move tool	Press V or press and hold Cmd	Press V or press and hold Ctrl
Select multiple curve points	Shift+click point	Shift+click point
Select multiple points in path	Shift+click point with arrow or CMD+Shift+click with pen	Shift+click point with arrow or CTRL+Shift+click with pen
Select next curve point	CMD+tab	CTRL+tab
Select None	CMD+D	CTRL+D
Select pen tool	Press P	Press P
Select pencil, painbrush, or airbrush	Press N, B, or J	Press N, B, or J
Select previous curve point	CMD+Shift+tab	CTRL+Shift+tab
Select remove point tool	Press minus (-)	Press minus (-)
Select state to revert to with history brush	Click in front of item in History palette	Click in front of item in History palette
Select word in Text Tool dialog box	Double-click on word	Double-click on word

Operation	Macintosh	Windows
Select word to left or right	CMD+Shift+left or right arrow	CTRL+Shift+left or right arrow
Send layer backward one level	CMD+[CTRL+[
Send layer to back, just above the background layer	CMD+Shift+[CTRL+Shift+[
Sharpen with the blur tool or blur with the sharpen tool	Option+drag	ALT+drag
Skew image	CMD+drag side handle	CTRL+drag side handle
Skew image along constrained axis	CMD+Shift+drag side handle	CTRL+Shift+drag side handle
Skew image along constrained axis with respect to origin	CMD+Shift+Option+drag side handle	CTRL+Shift+ALT+drag side handle
Skew image with respect to origin	CMD+Option+drag side handle	CTRL+ALT+drag side handle
Snap guide to ruler tick marks	Press Shift while dragging guide	Press Shift while dragging guide
Snap palette to edge of screen	Shift+click palette title bar	Shift+click palette title bar
Snap to Grid	CMD+Shift+quote (")	CTRL+Shift+quote (")
Snap to Guides	CMD+Shift+semicolon (;)	CTRL+Shift+semicolon (;)
Specify an area to clone	Option+click with rubber stamp	ALT+click with rubber stamp
Specify new color bar	Control-click color bar or CMD+click for dialog box	Right-click color bar or CTRL+click for dialog box
Step backward	CMD+Option+Z	CTRL+ALT+Z
Step forward	CMD+Shift+Z	CTRL+Shift+Z
Subtract channel mask from selection	CMD+Option+click channel name	CTRL+ALT+click channel name
Subtract colors from Hue/Saturation range	Option+click or drag in image window	ALT+click or drag in image window
Subtract from selection	Option+drag or Option+click with selection tool	ALT+drag or ALT+click with selection tool
Subtract layer mask from selection	CMD+Option+click layer mask thumbnail	CTRL+ALT+click layer mask thumbnail
Subtract path from selection	CMD+Option+click path name or Option+Enter	CTRL+ALT+click path name or ALT+Enter on keypad
Subtract transparency mask from selection	CMD+Option+click layer name	CTRL+ALT+click layer name
Switch between arrow tools in 3D Transform dialog box	Press V or A, or CMD+Tab	Press V or A, or CTRL+Tab
Switch between independent color and mask channels	CMD+1 through CMD+9	CTRL+1 through CTRL+9
Switch between layer effects in Effects dialog box	CMD+1 through CMD+5	CTRL+1 through CTRL+5
Switch between layer effects outside dialog box	Control-click on *f* in Layers palette	Right-click on *f* in Layers palette
Switch focus from image to layer mask	CMD+backslash (\)	CTRL+backslash (\)
Switch focus from layer mask to image	CMD+tilde (~)	CTRL+tilde (~)

Operation	Macintosh	Windows
Switch to composite color view	CMD+tilde (~)	CTRL+tilde (~)
Switch to first shape in Brushes palette	Shift+[Shift+[
Switch to last shape in Brushes palette	Shift+]	Shift+]
Switch to lower-right corner	Press End	Press End
Switch to upper-left corner	Press Home	Press Home
Symmetrically distort opposite corners	CMD+Option+drag corner handle	CTRL+ALT+drag corner handle
Tighten leading 10 pixels	CMD+Option+Up arrow	CTRL+ALT+Up arrow
Tighten leading 2 pixels	Option+Up arrow	ALT+Up arrow
Toggle between rectangular and elliptical marquees	Shift+M	Shift+M
Toggle display of menu bar in full screen modes	Shift+F	Shift+F
Toggle grid magnetism	CMD+Shift+quote (")	CTRL+Shift+quote (")
Toggle guide magnetism	CMD+Shift+semicolon (;)	CTRL+Shift+semicolon (;)
Toggle horizontal guide to vertical or vice versa	Press Option while dragging guide	Press Alt while dragging guide
Toggle link between layer and layer mask	Click between layer and mask thumbnails in Layers palette	Click between layer and mask thumbnails in Layers palette
Toggle quick mask color over masked or selected area	Option+click quick mask icon in toolbox	ALT+click quick mask icon in toolbox
Transform Again	CMD+Shift+T	CTRL+Shift+T
Transform selection or layer numerically	None	None
Undo	CMD+Z or F1	CTRL+Z
Undo operation prior to last one	CMD+Option+Z	CTRL+ALT+Z
Undo or redo last operation	CMD+Z	CTRL+Z
Undo to specific point	Click on item in History palette	Click on item in History palette
Ungroup layers	CMD+Shift+G	CTRL+Shift+G
Ungroup neighboring layers	Option+click dotted line separating the two layers or CMD+Shift+G	ALT+click dotted line separating the two layers or CTRL+Shift+G
Unlink all layers from active layer	Option+click on the brush icon of the active layer	ALT+click on the brush icon of the active layer
Unlink layer from active layer	Click on chain icon in front of layer name	Click on chain icon in front of layer name
View channel mask as an overlay	Click first visibility icon in Channels palette or press tilde (~)	Click first visibility icon in Channels palette or press tilde (~)
View layer mask as overlay	Shift+Option+click layer mask thumbnail or press backslash (\)	Shift+ALT+click layer mask thumbnail or backslash (\)
View layer mask independently of image	Option+click layer mask thumbnail in Layers palette or press backslash (\) then tilde (~)	ALT+click layer mask thumbnail in Layers palette or press backslash (\) then tilde (~)

Operation	Macintosh	Windows
View quick mask independently of image	Click first visibility icon in the Channels palette or press tilde (~)	Click first visibility icon in Channels palette or press tilde (~)
View single layer by itself	Option+click visibility icon in Layers palette	ALT+click visibility icon in Layers palette
View size and resolution of image	Option+click preview box	ALT+click preview box
Zoom In	CMD+plus (+)	CTRL+plus (+)
Zoom in plus change the window size to fit	CMD+plus (+)	CTRL+ALT+plus (+)
Zoom in without changing the window size	CMD+spacebar-click or CMD+Option+plus (+)	CTRL+spacebar-click or CTRL+plus (+)
Zoom Out	CMD+minus (-)	CTRL+minus (-)
Zoom out and change the window size	CMD+minus (-)	CTRL+ALT+minus (-)
Zoom out without changing window size	Option+spacebar-click or CMD+Option+minus (-)	ALT+spacebar-click or CTRL+minus (-)
Zoom preview box in filter dialog boxes	CMD+click and Option+click	CTRL+click and ALT+click
Zoom to 100%	CMD+Option+zero (0) or double-click zoom tool icon	CTRL+ALT+zero (0) or double-click zoom tool icon

INDEX

P

V

vector images, 2–3
Vertical Distortion feature, 209–210
Vertical input field, 66
View menu
 Rulers, 69
 Rulers command, 80
view shortcut keys, 259–260
viewing folders, 21
Vivid Light blending mode, 29

W

warp effects
 in text, 208–211
 Text Warp feature, 181
Warp Text option, 208
Washed Watercolor Paper pattern, 212
Watercolor pattern, 194
wave effects, 76

Wet Edges command, 30
Wind command (Filter menu), 220
Window menu
 Documents command, 155
 Workspace command, 31
wood textures, creating, 36–39
 grain of, changing, 39–40
 knotholes, adding, 41–42
 rich wood textures, 42–44
 wooden text, 44–45
workspaces, creating, 31

Z

ZigZag command (Filter menu), 221
zoom shortcut keys, 260
Zoom tool, 109, 111, 117, 120, 124–125
ZSoft PCX (.pcx) file format, 15–16